CW00545076

Continental
DIVIDE

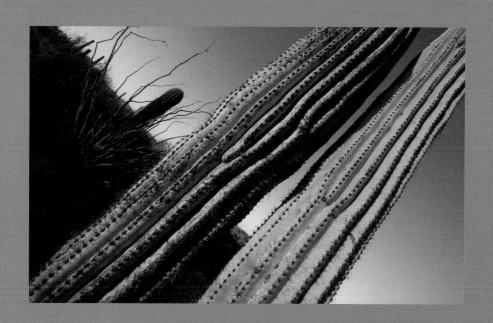

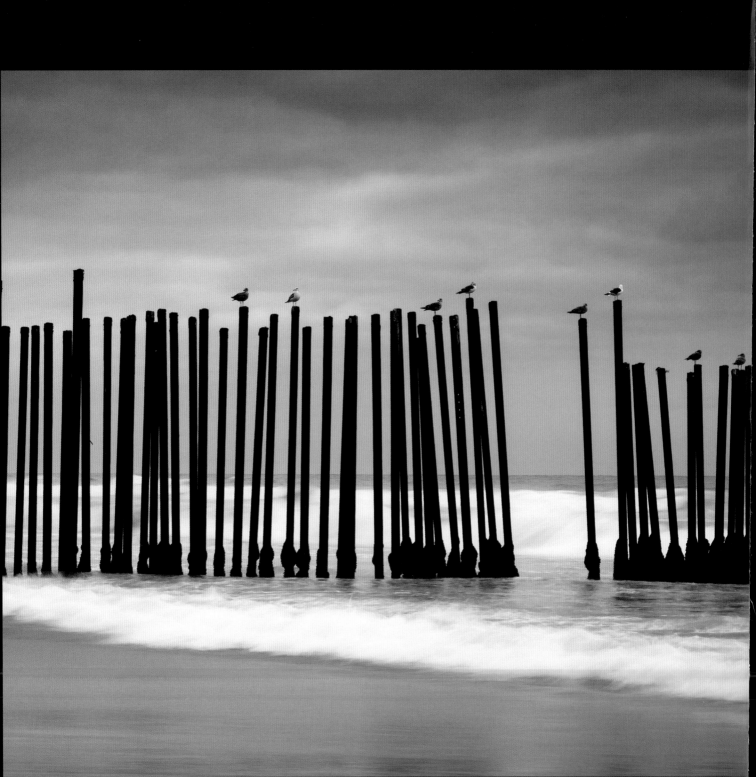

Continental
DIVIDE

Wildlife, People, and the Border Wall

Krista Schlyer

Foreword by Jamie Rappaport Clark

TEXAS A&M UNIVERSITY PRESS | College Station

(Previous page) *The US-Mexico border wall at the Pacific Coast, separating Tijuana from San Diego.*

Copyright© 2012

by Krista Schlyer

Manufactured in China by

Everbest Printing Co., through

FCI Print Group

All rights reserved

First edition

This paper meets the requirements
of ANSI/NISO Z39.48–1992
(Permanence of Paper).
Binding materials have been chosen for durability.

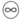

LIBRARY OF CONGRESS CATALOGING-IN-PUBLICATION DATA

Schlyer, Krista, 1971–
Continental divide : wildlife, people, and the border wall /
 Krista Schlyer ; foreword by Jamie Rappaport Clark.—1st ed.
 p. cm.
 Includes bibliographical references and index.
 ISBN 978-1-60344-743-0 (book/flexbound : alk. paper)—
 ISBN 1-60344-743-1 (book/flexbound : alk. paper)—
 ISBN 978-1-60344-757-7 (ebook)—
 ISBN 1-60344-57-1 (ebook)
1. Ecology—Mexican-American Border Region—Pictorial works. I. Title.
QH104.5.M39S48 2012
577.0972—dc23
2012016468

Unless otherwise indicated, photographs by Krista Schlyer

For the bison

of Janos-Hidalgo,

long may they roam.

For John Doe 07–177,

may he rest in peace.

And for borderlands hero

Raúl Grijalva,

may he never give up.

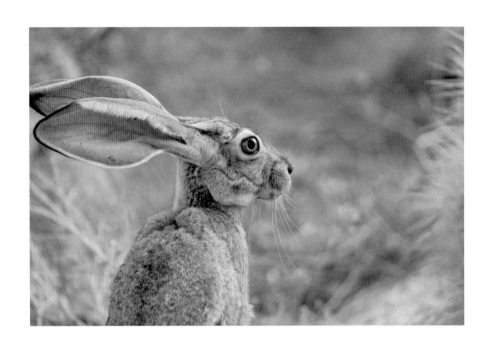

Contents

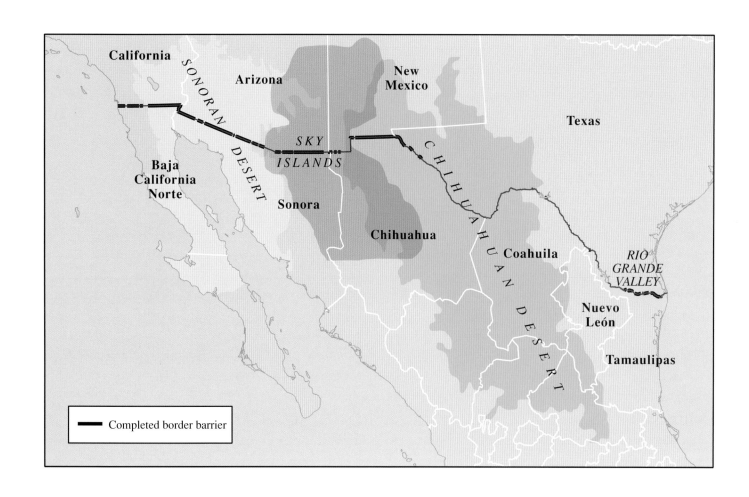

California

Arizona

New
Mexico

Texas

SONORAN

Baja
California
Norte

DESERT

*SKY
ISLANDS*

CHIHUAHUAN DESERT

Sonora

Chihuahua

Coahuila

*RIO
GRANDE
VALLEY*

Nuevo
León

Tamaulipas

—— Completed border barrier

Foreword

There is an old saying that a picture is worth a thousand words. In *Continental Divide: Wildlife, People, and the Border Wall*, Krista Schlyer goes far beyond the power of pictures to share an eye-opening exposé of the unfortunate and unacceptable treatment of the southern border region of our country. Through her eloquent words and spectacular photographs, Krista shares a compelling story that few have heard: a story of the human, economic, and environmental tragedy resulting from the border wall and our nation's dysfunctional immigration policies.

Those that believe the desert is devoid of life need read no further than the first chapter to be overwhelmed and awed by the extraordinary description of the web of life that is the border region—from the amazing wildlife and plant communities to the people who have lived their lives with a foot planted in both countries for centuries. Our nation's borders are just political boundaries, but life flows back and forth over this entire border like water.

Krista's journey started with a camera, but what she saw through her lens moved her to action. Krista mobilized dozens of other nature photographers like herself to join together on the border for a RAVE (Rapid Assessment Visual Expedition), a "visual expedition to places where regular reporters do not go and where the stories that matter to our planet are being told." Sponsored by Defenders of Wildlife, the Sierra Club, and the International League of Conservation Photographers, the RAVE resulted in a traveling exhibit that went from the halls of Congress to Wyoming and California, helping to educate the country on the impacts of the border wall.

The RAVE and Krista's eloquent depiction of the desert are enough to transform anyone who has not visited this region into an admirer of

this mysterious and magical landscape. But Krista is not satisfied with admirers, she wants advocates. So she has gone far beyond her articulate description of the desert to educate us on the politics that have led us to a battle on our border.

Her exploration of the political history of this region proves that man and politics are harsher and more unforgiving than anything that Mother Nature has dished out in this searing desert climate. Clearly our treatment of this region and the people and wildlife that have shared it for centuries has been a bipartisan disaster and an embarrassing disappointment.

Once the political history is unraveled, one has to wonder what our country's leaders value most of all: hate, fear, and money; or family, moral responsibility, stewardship, and our own children's future?

As a former director of the US Fish and Wildlife Service and the current president of Defenders of Wildlife, an advocacy group that led the charge to protect our nation's treasured wildlife and natural resources from the punishment that the wall has brought, I am disturbed by what our country has done.

On the one hand, we made a promise to ourselves to conserve, protect, and cherish our wildlife and other natural resources. We created a myriad of national wildlife refuges, parks, and monuments to protect the amazing diversity of wildlands and wildlife that make up our border with Mexico. We support laws such as the Endangered Species Act, the Clean Water Act, the Clean Air Act, and the Antiquities Act to protect our wildlife, special places, life-nurturing natural resources, and historic treasures. Yet, this same country is willing to destroy all that we have committed to treasure and protect. We have bulldozed 100-year-old cactus, gouged roads through mountain wilderness, and fenced rolling rivers. We have passed legislation to make the region into a police state, sacrificing all that we treasure, all that Congress has passed laws to protect.

And for what? To keep our neighboring countrymen from crossing the border looking for a better life? There has to be a better way.

There's still time to undo the destruction we have caused. Lawmakers on both sides of the aisle have expressed the need for immigration reform, knowing that the wall is not the answer. I certainly agree; we need a different game plan for this region. Share this book with your elected officials; share it with your friends and neighbors. Be part of the solution.

It's time to learn from the mistakes of the past. We need to hear a future US president repeat the words spoken by President Ronald Reagan in Berlin: "Tear down this wall!"

—Jamie Rappaport Clark
President of Defenders of Wildlife

Acknowledgments

This book came together over a period of five years with the help and support of many people. I owe a great deal of appreciation to Jack Dykinga and Rurik List, for their tremendous insights and unwavering support from the beginning. Mark Lukes, Dinah Bear, Billy Moore, Michael Degnan, Matt Clark, Noah Kahn, Ana Cordova, Eduardo Ponce, Rodrigo Sierra, and many others have been a tremendous help in so many ways, from education about the intricacies of policy and borderlands ecology, to providing inspiration for continuing the work despite strong political headwinds. Thank you to Dan Millis for all his help on the manuscript; and to Brian Segee, whose legal work and publication *On the Line* were an inspiration.

I would also like to thank the many residents of the borderlands who have helped me with my work by providing a place to stay, a meal, a tour, and their stories, specifically Betty Perez and Susan Thompson, Nancy Brown, Bill Odle and Ellen Logue, Joe and Valer Austin, Noel Benavides, William Hurt, Sandy Lanham, Nelida Barajas, and many others. And also all those in the conservation community who have given me support, including the Defenders of Wildlife, Instituto de Ecologia, Sky Island Alliance, Lighthawk, Cuenca Los Ojos, and the Sierra Club, who have shown critical leadership on this issue. Thanks to the fabulous photographers who participated in the Borderlands RAVE, and the support of the International League of Conservation Photographers. And thanks so much to Texas A&M University Press and my editor Shannon Davies for believing in this book from the start and for all the positive energy the publishing team put into every step of the process.

Finally, thank you Bill Updike, for all your support and encouragement, your critical eye for photography and writing, and for your unyielding friendship.

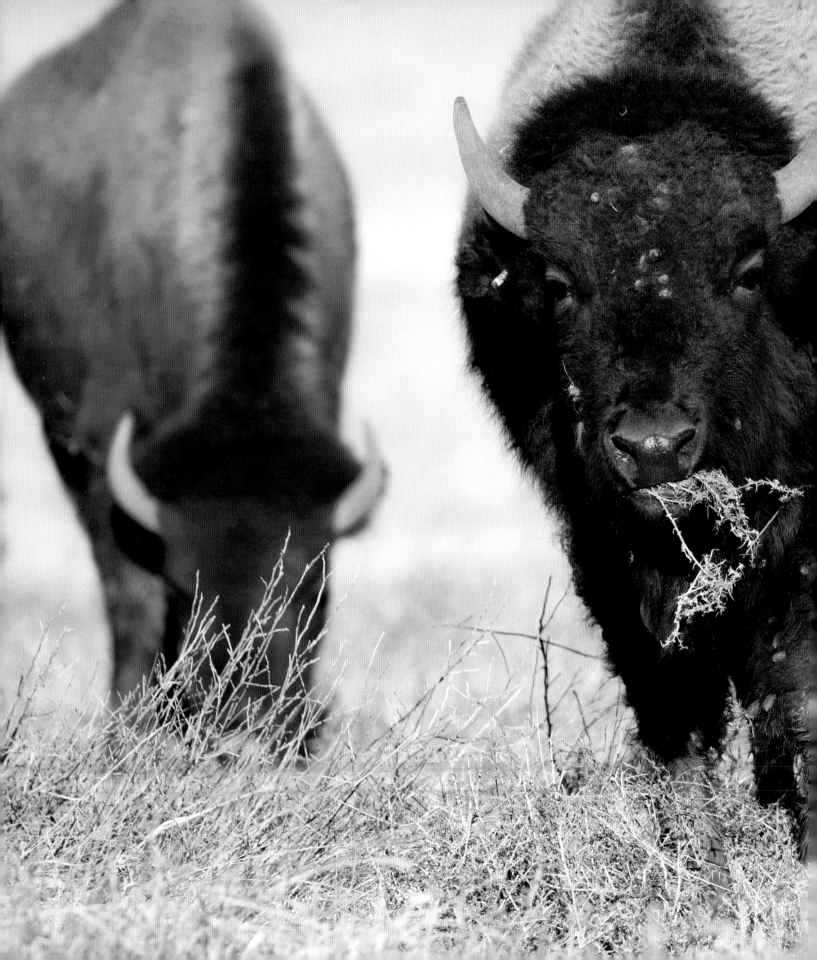

Bison in Janos, Chihuahua.

Introduction

In early spring 2008, two young bison bulls jumped a sagging three-string barbed wire fence separating Chihuahua, Mexico, from New Mexico in the United States. On both sides of the international line lay an unbroken grassland valley scoured almost bare by a prolonged drought, which announced itself meanly on the dusty hides stretched taught over bison bones.

D. H. Lawrence once wrote, he "never saw a wild thing sorry for itself," and this ragtag band of bison was no exception. They had been eking out an existence in an unforgiving land for almost a century, weathering the seasons of famine and plenty, pursuing one all-consuming preoccupation that prompted their every move: survival.

Bison are creatures of simple needs, requiring only some grass, reliable water, and space to roam; a hardiness that enabled them to migrate by the millions as lords of the vast prairies of North America for millennia before European settlers arrived. But needs are needs and survival is serious business in a landscape now scored by roads, fences, and other obstacles foreign to the natural contours of the prairie.

The haggard bison barely paused in their crossing that day. It was a simple leap over a fence their herd had broken down a hundred times, a known inconvenience encountered during frequent travels between the pond where they had drunk that morning, and a reliable patch of pasture for grazing. The bulls' herd had found this location dozens of years earlier, and since then had relied on it for the two main staples of its survival. The fact that there was an international boundary between pond and pasture meant nothing to them. They made the jump, and headed off toward dinner.

Meanwhile, a few thousand miles away, a roomful of politicians sat tossing a political rotten tomato called immigration, everyone tak-

ing care not to soil their hands, while engineers sketched out rough plans, and construction companies procured concrete and steel, and the United States began to raise its great wall—a wall that if it comes to fruition along the entire 2000-mile border, will divide not only two nations and their people, but an entire continent of creatures like the bison, already taxed to the breaking point by the business of survival.

History is filled with admonitions for the folly of walls, and the earth is littered with crumbling reminders of our endeavors to divide the landscape. Structures made of brick, steel, and concrete do not ultimately solve problems of political and economic origin, and often they create a whole suite of unintended consequences. But chronic economic disparities, historical amnesia, and other habitual maladies of humanity persist, and absent the will to make substantive changes, we turn to walls.

This book tells the story of a region at the crossroads of this age-old equation, a largely unknown place at the knees of North America where the United States meets Mexico. Here the presence of both political and natural boundaries creates a unique blend of north and south where the melodies of northern cardinals and tropical green jays float upon the warm South Texas breeze; where the perfume of creosote speaks of the passing of desert rain while high in the mountains, the boughs of Douglas firs cradle winter's first snow. Here is a landscape that has seen the birth of jaguars, the death of Spanish missionaries, the budding of saguaro cactus, the persecution and dogged endurance of native peoples, and the footsteps of a million migrants recorded in the smoldering sands of the Devil's Road. Here is a place where Spanish kings abdicated sovereignty to drug lords, one cruel century to the next.

In the borderlands, theories of smart international policy collide with rock hard reality, and the laws of supply and demand tumble violently with forces of poverty and despair. Within this turbid mix, the complex vibrant character and rich history of the borderlands is obscured by a news media preoccupied with violence and criminality, and a politics of sound bites and insincerity carving wedges from the

fears of a nation. And, consequently, the scales are tipping toward walling person from person, nation from nation, and a landscape from itself.

This is a book about the US-Mexico border wall and immigration policy, but more importantly it is about the land, wildlife, and people that have found themselves at the front lines of a turning point in North American history, confronted with political winds that favor the symbolism of steel and concrete over substantive policy reform. Suddenly divided, they grapple with powerlessness against a government that has, in an unprecedented move, revoked its own laws in a rush to construct a massive but ultimately impotent political symbol through the heart of one of the continent's richest and rarest ecological and cultural regions.

Tragedy has become a defining characteristic of the twenty-first century borderlands: not simply the tragedy of failed governmental policies triggering drug wars, overwhelming human poverty and migration, and cultural and environmental degradation on a massive scale; but also, the great tragedy of misinformation that has drained the public of the will to demand real solutions for the region. The informational muddle has left the borderlands in a perpetual and seemingly inescapable downward spiral. News media depictions of the borderlands characterize a fraction of the scope of life on the border and generally ignore all that is good, leaving a residual image of ugliness and violence in a barren and severe land. This does not describe the borderlands I have seen with my eyes and documented with my camera.

As a journalist I am trained to identify and avoid inaccuracies, and I know how difficult the attainment of pure accuracy can be. At times mistakes in the news media are accidental and unavoidable, but when incomplete accounts and erroneous characterizations become the normative basis for covering a whole region, a region at the mercy of federal policy and public opinion, the repercussions can be tragic. Such is the case for the borderlands. I don't begrudge the news media its faults; the job is not an easy one. But for me, this story is personal. Prior to 2007, my work as a photographer and writer had centered on wildlife

of the Southwestern United States. Many of my subjects were imperiled, and many were residents of the borderlands. Though I had known of the destructive impacts of immigration policy on the region, and of ongoing discussions about constructing a border wall, I hadn't understood the catastrophic impact it could have until I saw it with my own eyes. I was there when those bison crossed the international border, watching from a research plane a couple of hundred feet above them. Afterward, conversations with landowners on both sides of the border—in Hidalgo County, New Mexico, and the Janos region of Chihuahua—revealed that the herd's main water and food sources were on opposite sides of the international line. This information transformed my intellectual ruminations on immigration policy into a concrete understanding of the life and death impact of border policy on wildlife.

A border wall here, or any significant barrier, would destroy one of the main survival mechanisms of this rare wild herd of bison. And if it could impact this species so profoundly, what would it mean for the many thousands that live along this 2000-mile border?

The purpose of my work since seeing those bison has been to give the prevailing borderlands picture some context. I have met and talked with hundreds of borderlands residents; I have observed, photographed and studied hundreds of borderlands plant and animal species; I have myself lived in and walked the borderlands; and I have studied the root causes of the current predicament—an immigration policy that has not been significantly altered for more than 25 years, while the geo-political and economic forces that create migration to this country have changed drastically.

In 2009, I led an expedition in the borderlands with 12 members of the International League of Conservation Photographers to document the wild beauty of the region. I have worked with conservation scientists and non-profits including Defenders of Wildlife, the Sierra Club, the Sky Island Alliance, Cuenca los Ojos, the Ecological Institute in Mexico City, and a network of individuals and government agencies in Mexico and the United States to disseminate information about the

6

danger currently posed to borderlands ecosystems. I began this work because of those bison, and because the more I have learned about the nature of the borderlands, the more I have come to love the region and its residents; and the more I learned about the politics and history of the situation, the more confounded I was about the absurdity of it all. Collaboration between Joseph Heller and Lewis Carroll could not have concocted a more outlandish fiction than the reality of the borderlands.

During my study of the region, I have fallen as Alice into a wonderland where every thing and every one seems to exist against all reason, where beauty and life spring out of a brown hard crust of ground; where rivers live in trees during the day and their beds at night; where implausible forms of life can exist in suspended animation for a century until fickle desert rains find them; and where bighorn sheep carry maps of desert water in their brains. It is also a place where people are told they are illegal on land they have occupied for millennia; where languages blend at the edges of cultures like watercolors on wet paper; where south and north meet, mingle and merge; where drought, flood, disaster, death and violence, but also stillness, perfection, and beauty paint the existence of everyone, from the smallest of creatures in an ephemeral pool to the very mountains themselves.

The future of this magical land and all who have ever loved or needed it, lies in the hands of a roomful of people two thousand miles away, most of whom have never walked the shallow stretches of the Rio Grande or awoke to the call of coyotes across the grassland dawn, and a public to whom the fragile threads of connection that tie us all to the fate of borderlands remain invisible. This book was written in the hope that a few of those threads may become illuminated, and a few more people may come to understand just what we are sacrificing for our continental divide in the borderlands.

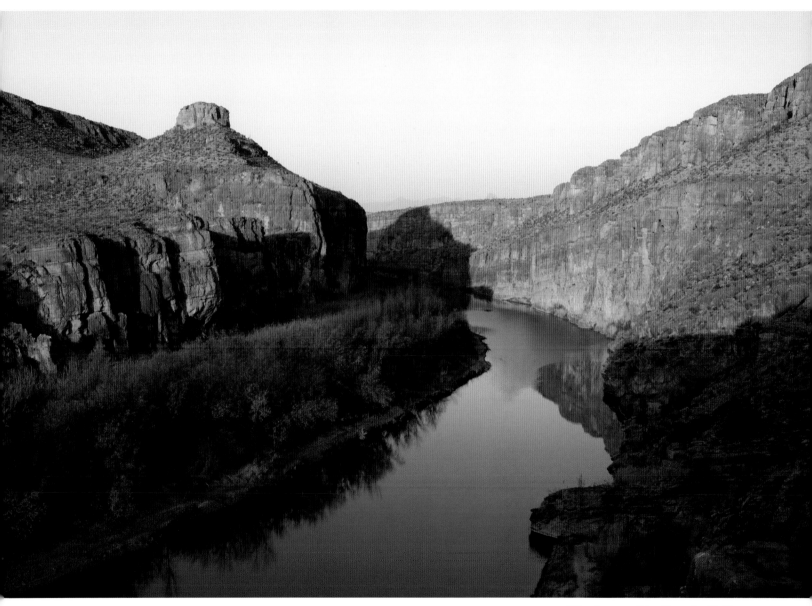

The Lower Rio Grande Valley is home to diverse plant and animal communities.

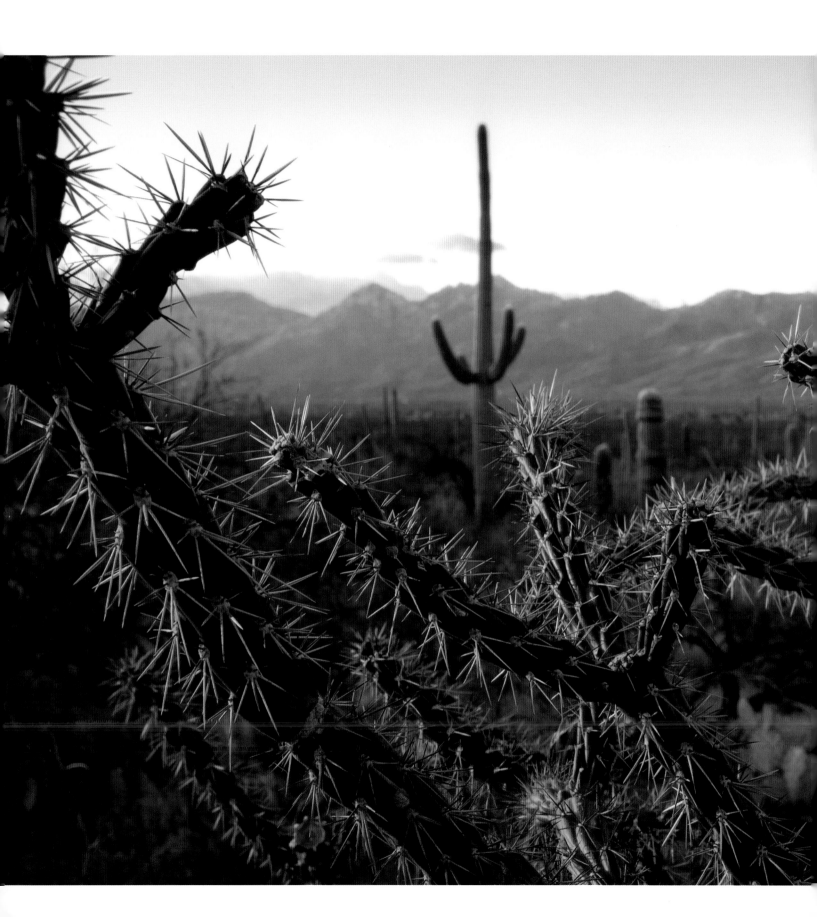

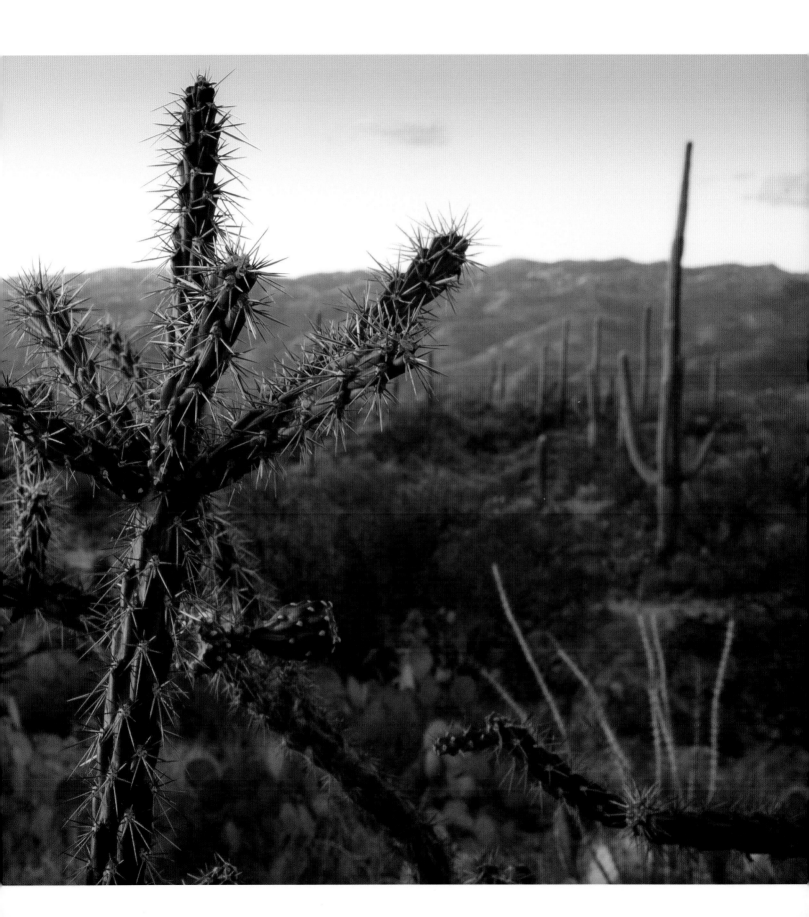

DESERT

At scorching noon the summer desert smells of choking dust. The July sun boils on bare skin, making it scream for shade, and everything, from cactus to reptile to human creature, shrinks under its searing stare. Nothing moves under the burdensome heat haze simmering above the desert floor. So silent is the land, so vast and still and blisteringly hot, that standing unprotected upon this landscape, it is literally painful to exist.

But July noon is, like any moment in time, fleeting. On that same day, at about 5:00 P.M., as the sun begins its descent over the Pacific, clouds start to gather in great cottony clumps that shatter the monochromatic desert sky. As they cover the face of the departing sun, a cool shadow spreads over the land, prompting a lizard to venture out from under a protective boulder. He cocks his head from side to side, while a white-winged dove begins to coo softly. A jackrabbit pads out from under the shade of a mesquite tree, nosing around for seeds while the gathering clouds begin to darken and agitate. People hiding in their cool houses and offices glance out windows and open doors, and sigh, as the very ground beneath them seems to sigh in relief. A great crack! rips through the now-humid air and the sky releases a long-awaited treasure upon the land. The rain comes, first in a scattered pattering of large drops on the dry ground that sizzle and steam, and then in a torrent of a month's moisture that had been hoarded in the oppressive blue of

(Previous page) *Sunset in the Sonoran Desert with cholla and saguaro cactus.*

the oceanic summer sky. The deluge lasts for an hour before the clouds break, and, as the sun sinks beyond the hem of the horizon, the sky ignites in pastel flame, and a golden-hued desert swells with satisfaction and life, smelling of sweet creosote and noisy with the song of grateful creatures once again at ease in the world. It is a moment a desert dweller can best appreciate, but anyone can understand as the unique brand of beauty that follows the harshest of pain.

The cycles of desert life can flow from torturous to sweet in an instant, urged on by the whim of a wind, the whisper of a God, or the rhythm of some perfect cosmic order. Whatever first cause set this symphony afire, it is to be revered as the genesis of astounding communities of perseverant creatures that exist precisely because of the merciless character of this land. This collection of life forms could not coexist anywhere else on the planet except this one place—the Sonoran Desert, land of rainbows and rattlesnakes, wildflowers and withering death, in all its sublime and wretched perfection.

This desert, which occupies the borderlands from southeastern California to central Arizona, is the product of a simmering process of time and chance, a single immeasurably long dance of a restless planet and its shifting climate. Earth's wayfaring crust set in motion the long, laborious becoming of the Sonoran 200 million years ago, when the Pacific Plate began to collide with and slide under the North American Plate. Mountains of earth arose from the crashing chaos while volcanoes spewed fire upon the land. Then, more recently, about fifteen million years ago, the Pacific Plate began moving northwest, pulling the crumpled crust apart and creating faults like the San Andreas and Cerro Prieto, while splitting mountains into ranges separated by broad valleys. The mountain ranges molded by the shifting planet acted as any massive textures would, creating long shadows on the land of the Southwest, blocking not only light, but also moisture. The Sierra Nevada and Sierra Madre mountain ranges cast a rain shadow over the region, walling off clouds of moisture that form over the oceans, and wringing them dry before allowing passage eastward.

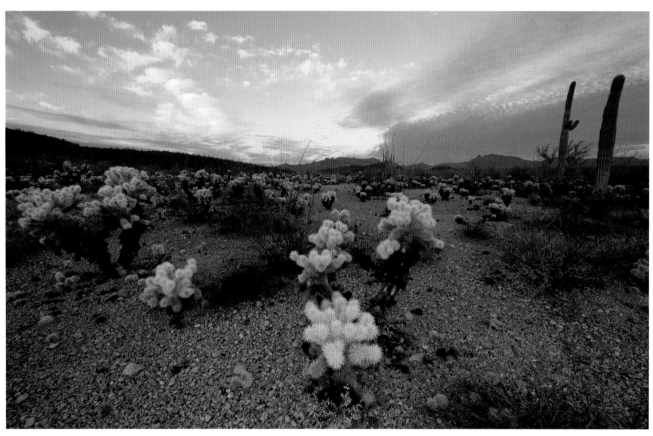

Teddy bear cholla in Organ Pipe Cactus National Monument.

The meandering of the Pacific Plate also yanked Baja California away from mainland North America, and continues to drag it and southern California to the northwest, at a rate of about two inches per year. The formational eons of Earth's shifting and reshaping created—and continue to create—our world in a great breaking violence so immense and seemingly timeless that we cannot even perceive it with our naked human eyes. Instead of the continual creation, though, we see the resulting landscape, the mountains, the desert, and its inhabitants, and we occasionally feel the deep quaking rumblings of our planet's ongoing metamorphoses. The perspective of a small creature in an infinitely large world has its limits: like ants trying to understand the significance of a Senate filibuster or a pocket mouse trying to decipher the Dead Sea Scrolls, we humans see the Milky Way and grapple with

the eternal inscrutability of being a speck of dust on a speck of dust in an infinity of specks of glittering dust.

Trying to comprehend our place in such a vast constellation of life may take as long as it took the Sierra Nevada to form. It was only 300 years ago that European cultures first gained an accurate picture of the results of Earth's movements in western North America. This first, slight glimpse came in 1698 when Father Eusebio Kino of Spain climbed Pinacate Peak in the Sonoran Desert and saw that California was in fact a part of mainland North America, not a great, vast island as had been previously believed.

Since that time, modern science has collected volumes of information to build on Kino's early understanding of the western borderlands. It is now known that the region sits at the confluence of four different ecosystems: the Rocky Mountains, the Sierra Madre, the Sonoran Desert, and the Chihuahuan Desert. So varied are the topographical and climatic conditions here, that a person can encounter in this one spot on Earth what otherwise would take a journey of thousands of miles to see. All of the world's major biomes, from tundra to tropics, can be found here, within an incredible diversity of habitats, from lowland sand dunes to mountaintop coniferous forests.

Despite the prevailing rain shadow that covers much of the region, the Sonoran Desert is one of the wettest and lushest deserts on Earth; it has two separate rainy seasons that provide up to sixteen inches of rain per year. The summer rains (which residents call monsoons) collect as humid fronts over the Gulf of Mexico and Gulf of California. If they are big enough to transcend the mountains, they often arrive in the desert as violent deluges that quench the extreme drought of hot summer months. Winter rains are softer, longer weather systems that originate in the Pacific and produce daylong gentle rains and cloud-cover, nourishing plant communities and igniting profusions of spring wildflowers. These two wet seasons provide for a rich diversity of life that is not possible in other arid regions in North America, and they sustain several thousand species of plants, 500 species of birds, and 120 mammal species, including jaguar, bighorn sheep, and black bear.

But perhaps the most iconic resident of this desert is one that has roots rather than legs and moves imperceptibly slowly as the climate of the desert demands—the saguaro cactus.

The status of desert icon is not idly achieved. Few creatures or plants can stand erect in the face of the Sonoran sun. In fact, most plants cower low to the ground, and animals seek shelter during the sun's blistering summer apex. In the desert, hiding is a perfectly respectable strategy. The sun here is simply not to be trifled with.

While hiking with insufficient water in the heat of summer, I myself have been reduced to crawling through parched streambeds and dousing my flaming skin with the only water-ish stuff I could find—a brown fluid containing higher concentrations of dirt and microscopic creatures than H_2O. When I emerged, every hair on my body was so coated in muck that I looked like a balding chimpanzee. A friend of mine, driven momentarily mad from the insane heat, once ate a map when he got lost on a backcountry bike trail outside of Tucson. In summertime, only fools and immortals stand and face the destroyer God of the desert. Saguaro cacti most definitely fall into the latter category. Even in the extreme mid-day heat, a heat that can easily exceed 110 degrees Fahrenheit, saguaros stand erect with arms raised to the sun as if to say, "Yeah? That's all you got?"

As adaptable as they are, a saguaro seed needs a very particular alignment of climatic and habitat conditions to enter the world. A sprout can only emerge after several consecutive years of good rains, and, once sprouted, it will die if the temperature lingers below freezing. And while adult saguaros can cope with the intense desert sun, sprouts will wither without the protection of a shade plant to nurse them to maturity. These giants of the desert are so fragile in their infancy, and conditions that favor their survival come so rarely, that a century may pass with only a few new generations of saguaros.

Once sprouted, a saguaro may take a decade to grow to the height of a human thumb, but eventually, a successful sprout can weigh almost 5000 pounds and reach sixty feet tall, towering above the rest of the des-

(At right) *Saguaro cacti provide shelter and food for a whole community of desert creatures.*

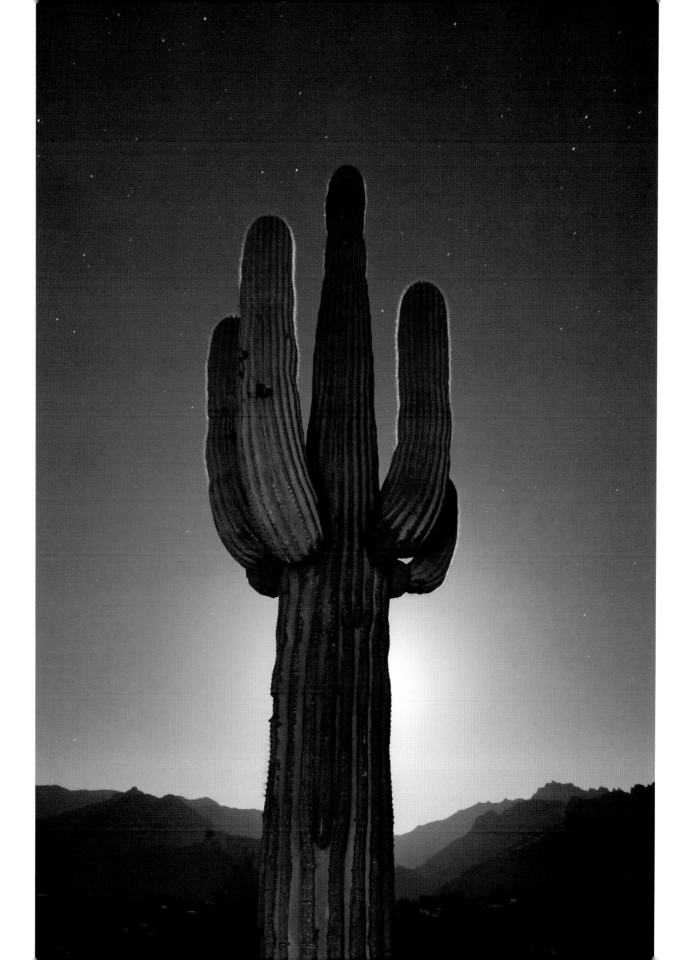

ert plant community. These charismatic cacti are the giant sequoia of the desert, a striking presence that makes a Sonoran horizon unlike any other on Earth.

As the central Sonoran Desert's chief endemic species, a saguaro's survival benefits a whole community of surrounding plants and animals. Western white-winged doves migrate to the borderlands region specifically to feed on the fruit and seeds of the saguaro. This dove population is almost entirely dependent on the saguaro for nutrients and moisture during its breeding season, so much so that the bird times its migration to coincide with the summer flowering and fruiting of the saguaro. In turn, the dove helps the cactus reproduce and travel, by acting as both a pollinator for saguaro flowers and a seed disperser, carrying saguaro seeds to new locations where growing conditions may favor the specific needs of a sprout.

As the dove and saguaro work in concert for survival, so does a whole suite of other species that are both supportive of and supported by the saguaro, including bats and insects, woodpeckers, owls, raptors, and rodents.

Iconic as it is, the saguaro is only one of 300 cactus varieties in the Sonoran Desert. These plants are specially adapted to lands of scarce rainfall; they store their own moisture rather than depend on the soil to do it for them. Wary of thirsty desert creatures that lack this ability, cacti use spines as a defense against predators. But, for a plant, there are both welcome and unwelcome predators. Cacti seductively court some herbivores and pollinators with exquisite flowers and fruits. A cactus that can appear most of the year as a dust-collecting amorphous green jug may have radiant, delicate flowers of deep red, orange, or pink to attract pollinators during the day, while others offer fragrant and luminous white blooms to attract night pollinators like moths and bats. Cactus fruit is a juicy staple for desert creatures like the javelina, a resident of the borderlands along most of its 2000-mile length.

Though originally creatures of the tropics, javelinas as a species have altered their habits to survive in the borderlands. This hairy pig-

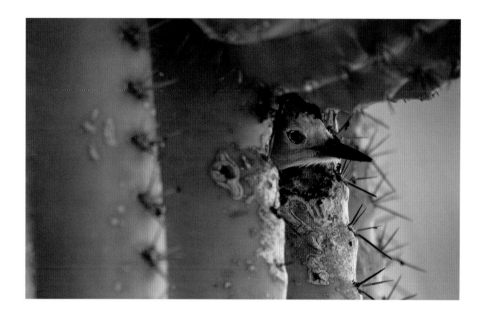

A Gila woodpecker in a saguaro cactus cavity.

like species has been so successful at adapting to the Sonoran Desert habitat that it has insinuated itself as a key player in ecosystem dynamics. Without them, a whole suite of large predators would suffer—creatures like the jaguar, mountain lion, and wolf all depend on javelina for food. And the ecosystem relies on these omnivores just as much on the other end of the biotic spectrum. Over long years of coexistence, javelinas and cacti have become existentially intertwined. Because a mainstay of the javelina's diet is cactus fruit, wherever traveling bands of javelinas go, they deposit packages of seeds and fertilizer, enabling cactus plants to find new hospitable territory.

Other desert species live a more solitary, independent existence, interacting for the most part with only soil and rain. The Ajo lily has been a resident of the Sonoran Desert for thousands of years, though you can visit the desert a hundred times and never see one. This desert bulb lives most of its life deep below the surface of the ground, where it is cool and hidden from hungry rodents. Darkness and quiet under the earth can last for long years. But the Ajo lily patiently waits until winter rains have been plentiful before it emerges in spring from sandy soil, into a spike of pale green that can grow and grow, up to six feet tall.

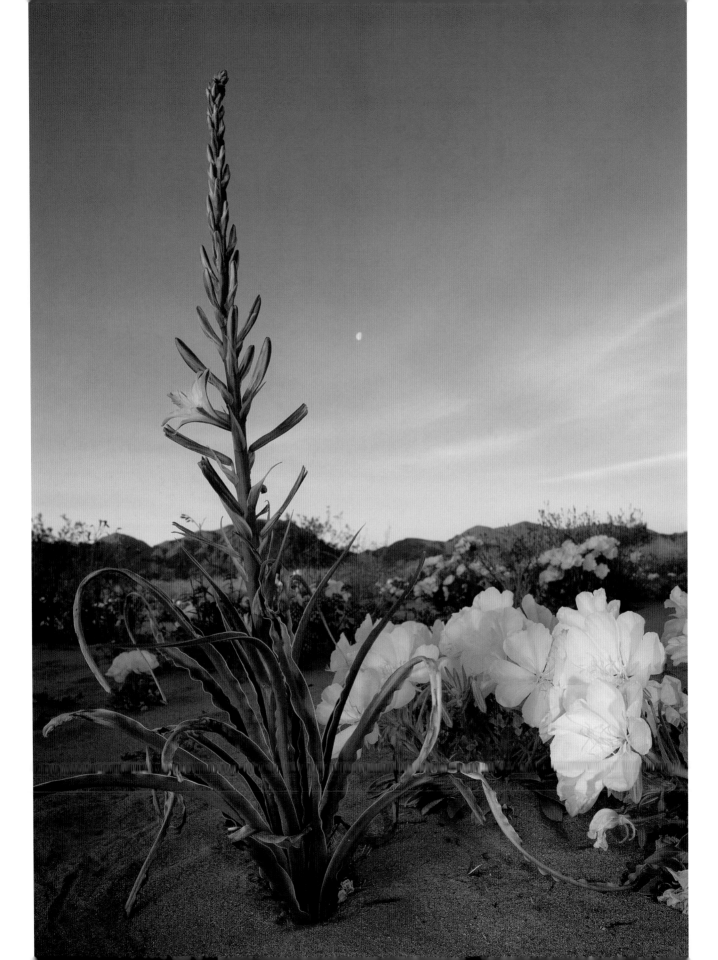

Suddenly conspicuous to the world, the plant produces one final burst of ostentatious beauty, a delicate white horn of a flower, trumpeting the arrival of spring.

When winter rains have been kind to the desert, Ajo lilies may arrive amid a sea of desert primrose, sand verbena, lupine, and marigold spreading a colorful, fragrant carpet at the feet of saguaros, along the ridges of desert dunes, and stretching to the mountain foothills. The spring bloom transforms the desert with otherwise unknown colors and scents that will last only a few short weeks, and may come only once in a decade.

Desert wildflowers like the Ajo lily evolved to adapt to a land where it is possible for many months or years to pass without rain. They developed a strategy for ephemeral life—with long periods of dormancy during which they patiently wait out the heat and killing dry. It is a strategy that many desert residents must employ, both animal and plant, because the ground surface temperature can reach 160 degrees Fahrenheit and only rarely be tempered by a cooling rain. One of the most common and intuitive responses to the heat is just to get the hell out of it. In the shade, it may be only 108 degrees, while below the earth, a foot or more deep, temperatures dip into the 80s.

Taking advantage of this shelter from Sonoran extremes, the desert tortoise, one of the most endearing desert residents, cannot be seen much of the year. The tortoise usually hibernates in winter, emerging to munch on wildflowers when the morning frost has quit the landscape. These lumbering ancients, even when young, appear as wrinkled and dusty as fossils, as though they may have personally weathered the last three ice ages. As a species, their presence in this desert may date back twenty million years, and over those long years they have evolved special physiological adaptations that help them survive. Tortoises' urinary bladders store large amounts of water, which they can access as needed; their burrows and rocky nooks retain humidity, so they rarely need to drink. Though scientists don't know exactly how it works, tortoises also have such an acute understanding of the land and weather

Ajo lily and desert primrose at dawn.

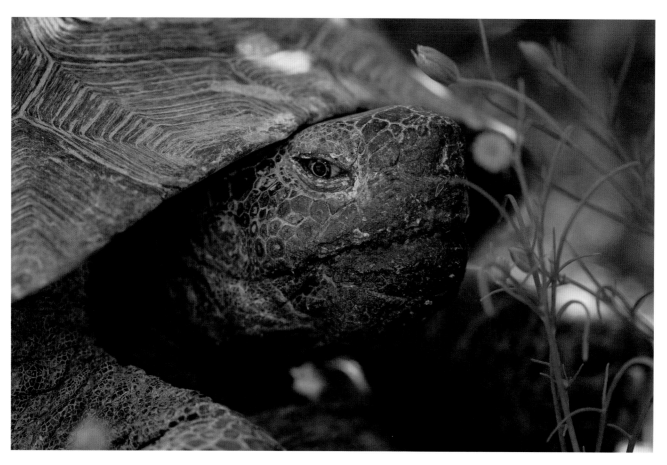

A desert tortoise.

that they know not only when rain is coming, but also where it will collect on the ground. They have been observed waiting at depressions in the ground in advance of rain, before there is even a cloud in the sky. Once the puddle fills, they replenish their bladders and go on about their business.

A tortoise's first response to danger is often to bolt inside its shell, but when challenged, it will joust with other tortoises, and sometimes creatures much, much larger. I once witnessed a young tortoise charging a man in an all-out sprint. The tortoise had just spent half an hour being manhandled by scientists trying to fit him with a radio transmitter. His only achievable protest during that affront was to flail his legs and stretch out his neck in defiance. After the scientists let him go, he

huffed off toward his burrow, but when one of the scientists followed, the tortoise turned on his heel and charged. It was both ridiculous and inspiring. The tortoise only weighed about five pounds, and watching any tortoise run is amusing. But seeing a creature willing to defend his burrow by fighting a giant who just glued a radio to his back is to witness the extreme courage and fortitude it takes to survive in the desert.

Many other desert creatures, including ground squirrels and snakes, are similarly attached to their underground homes, and they keep out of sight for much of the time. The Gila monster, one of only two poisonous lizards in the world, spends 95 percent of its life underground, making it one of the most strangely beautiful creatures that most human eyes will never encounter.

But stranger and more mysterious creatures than Gila monsters make their home in the borderlands stretches of the Sonoran Desert. Whole communities of life here center their existence on the brief appearance of ephemeral pools that fill when summer rains arrive. These are creatures so extraordinary and wonderful, that they are perhaps the closest thing to magic in an age of reason. Fairy shrimp and tadpole shrimp, also known as *triops*, are residents along much of the arid borderlands from California to Texas, but they live an existence so far out of time and sight that their lives go unnoticed by the universe at large. In a handful of desert dust, or packed in a crust of mud stuck to the leg of a bobcat, or even floating on a strong desert breeze, the embryos of these creatures can abide in a state that mimics death for years, or even decades. In their suspended state, they wait, indifferent to heat, cold, and drought, until enough rain comes to form shallow pools. From these pools, as if from air, luminous fairy shrimp and tiny, horseshoe crab-shaped triops emerge within less than a day of the rain. Instant life: just add water. For all their waiting in torpid suspense, when they come to life in the momentary moisture, they live only for a short time—a few weeks or months—just long enough to frantically mate, lay eggs, and return again to dust.

These ephemeral creatures are joined by a whole community of oth-

ers, including beetles and frogs, whose life cycles are tied to the life-span of water pooled for the briefest moment upon the parched Sonoran earth. Just one of these pools may contain twenty different species during the few weeks or months that it holds water. All of these creatures exist in a blink of human time, just as we exist in a blink of the ages of the Earth. And all of us are linked, in our own time frames, to the presence of water.

Ephemeral desert communities can arise anywhere. But in the desert, the most complex collections of life lay in and around rocky pools called *tinajas.* As author Craig Childs described in his book *The Secret Knowledge of Water,* these pools are so essential to all walks of life in the desert that they were one of the first features of the landscape to be mapped. Some tinajas (a Spanish term for "earthen jar") are large enough to hold water for years, even when there is little rain. Others are minute, only large enough to supply sips of water for bobcats and big-horn over a few days time.

In the southwestern corner of Arizona, one of history's most reliable tinajas lies in the lap of the Tinajas Altas mountain range. When full, this group of nine pools can hold 20,000 gallons of water, though in the driest seasons only a few of the pools hold any water at all. Those that do constitute a celestial body around which the life of the surrounding landscape revolves. One may not always see the full diversity of biotic life that gravitates to them—in the desert, most life is lived out of sight, under ground, or by shadow of night. But at the edges of tinajas, the traffic of the desert community can be found in scents and textures left on rock and sand.

One winter morning, while exploring the lowlands around the Tinajas Altas pools, I came across a series of tracks in a dry, sandy wash. One set of footprints, belonging to a small rodent, was followed closely by bobcat tracks. These depressions in sand told a story, one I sensed would not end happily for the mousey character. But, too intrigued to turn away from tragedy, I followed the tracks for a distance of about one hundred feet. At that point the two tracks quickened briefly, then merged in a tumble of sandy chaos. From there, the bobcat tracks walked on alone. Messages

and signs like this are the language of life in the desert, so seemingly silent but ever alive. And they are plentiful around the extraordinary desert pools of the Tinajas Altas.

The rainy season and the contours of the land that determine where water will linger meter the pulse of wild creatures who have honed their senses to the smell, taste, and sound of the lifeblood of the desert.

Most of the year, the Couch's spadefoot toad lies hidden beneath the earth, waiting, waiting, waiting for the sound of water. Pat . . . Pat . . . Tap . . . Tap . . . Tap. Percussive summer raindrops summon the spadefoot to burrow out of the ground and charge toward the nearest place where water congregates. At the nearby pool, the spadefoot sings a song of summer love, bursting into a mating call like the bleating of a goat that can be heard a mile away. These first moments, after a year of repose or longer, are followed by an explosion of feeding, breeding, and growing as fast as possible before the spadefoot's precious pool evaporates. This pool represents all there ever was, all there is, or ever will be for the spadefoot; it is his universe, his own fragile thread of connection to eternity. Within this pond, which may exist for only a few weeks, the spadefoot's entire life and future lie, his only hope of creating a new generation of little spadefeet to bear his genes into the future.

The Couch's spadefoot, under tremendous pressure to make the fleeting moments of the rainy season count, has developed an ingenious adaptation. Rather than run the risk that the pool will dry before the young are mature enough to survive outside it, Couch's spadefoot eggs can hatch with lightning speed, sometimes in as little as fifteen hours. Further enhancing its chances for survival, the spadefoot tadpole is capable of accelerating its growth rate based on the evaporation rate of its pool. If the water is evaporating rapidly, the tadpole can mature very quickly, in as little as seven or eight days. If the pool is more long-lived, the tadpole can pace its growth more slowly. When the water is gone, it's gone. The toads that have survived will flee the dry, hot desert surface and burrow back underground into mucus cocoons that will sustain them until the next warm rainy season arrives.

Desert toads and frogs are all faced with a similar challenge: only a

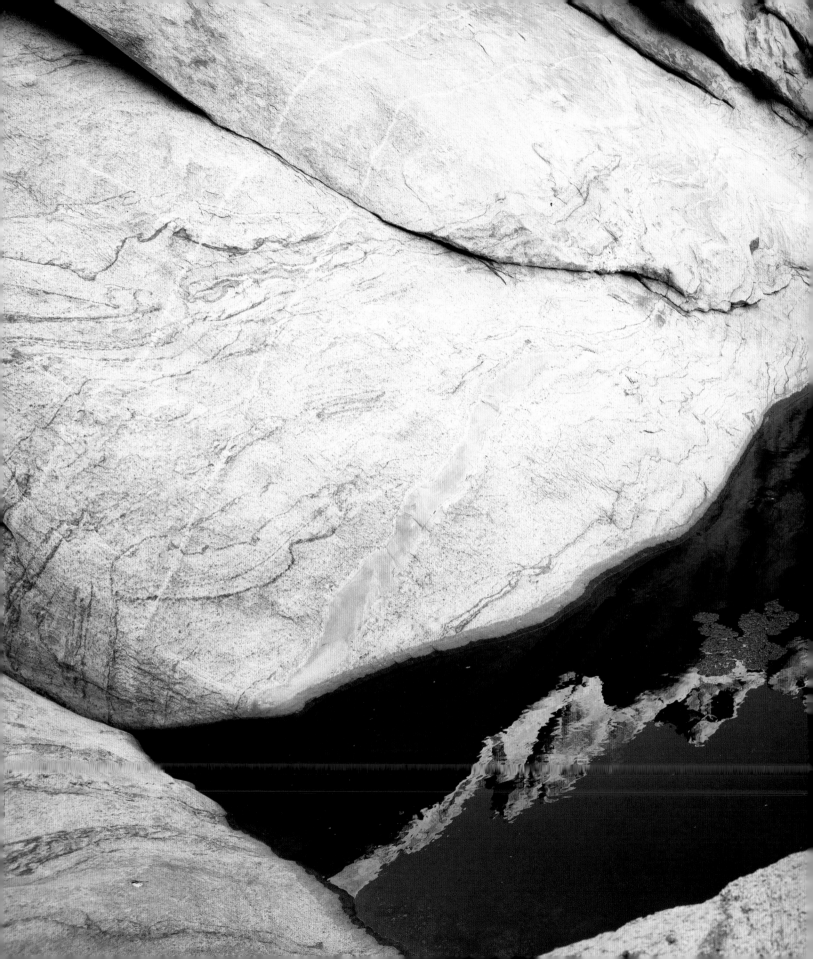

Watering holes like this one in the Tinajas Altas Mountains are rare in the Sonoran Desert, and essential to wildlife on both sides of the international border.

brief period of time exists each year when the conditions are right for their peculiar brand of life and reproduction. After a summer rainstorm, a single pool may house seven different toad species. The Sonoran Desert toad, largest of all the toads native to the United States, can grow to eight inches long and weigh about two pounds. When monsoon rains come, this toad finds its pool, coos out a soft mating call, and begins eating almost anything within reach, including insects, small snakes, and scorpions. It must latch frantically on to mates in hopes of creating the next generation before time runs out and the pool dries up. God willin' and the creek *do* rise. The Sonoran Desert toad does not possess the rapid maturation adaptation that the Couch's spadefoot has, so if monsoons are weak or the season short, every last tadpole may dry up, leaving no offspring to survive the season. If conditions are especially bad, some toads may skip a breeding year altogether, rather than face the likely loss of an entire generation. Instead, they remain safely underground until conditions improve the following summer.

Other creatures of the desert are not content to live lives so closely tied to the fickle appearance of water. These extraordinary life forms choose endurance and dogged determination over ephemerality. Perhaps the most tenacious of these organisms is the creosote bush, which lives in a perpetual staring contest with the sun, to the death. No living creature can withstand the heat and dry of the summer desert sun without impact—even the mountains seem to blanch under its lingering stare. For the creosote, the bite of the sun can be injurious, causing the creosote to drop many of its waxy, water-retaining leaves, but the stoic plant endures, hunkering down and waiting for rain during the relentless months or even years of drought. Inevitably, the stubborn plant exhausts the sun with its patience, and when the rain comes, the creosote's limbs and leaves spring forth again, along with small bright golden flowers. The victory is heralded by the sweetest scent—an olfactory hymn in praise of the prodigal desert rain's return.

Creosote oils traveling on a moist breeze are the essence of a celebration of life continued. Appropriately so, as continuity defines the

creosote. These plants are so hardy and adaptive, they can live for centuries and even millennia—one known creosote plant is believed to have existed since the end of the last ice age. Scientists believe this creosote plant near California's Lucerne Valley may be the oldest known living organism on the planet—it is 11,700 years old. This ancient creosote was perhaps one of the first generations of its kind to grow in the region and, over its incomprehensibly long life, this one organism has dug its determined roots into ground traveled by the feet of wooly mammoths and tapirs, and, many years later, by the lighter footsteps of pronghorn and pocket mice as the climate warmed and dried.

The creosote's long life is owed to its ability to split its root crown and continue growing from the split. The plant essentially rebirths itself every century or so, a practice that has allowed the creosote to thrive in a climate of great extremes, and even to dominate, to the benefit of many other species. In some locations in the Sonoran Desert, the creosote bush blankets the viewscape for miles. Beneath it, where shade is assured and a century of fallen leaves have mulched and nourished the ground, whole communities of creatures thrive.

One of the desert's other great survivors, the kangaroo rat, gathers seeds beneath the creosote. The rodent stuffs each precious morsel into fur-lined pouches in his cheeks, little expandable grocery bags that will secure his forage until he is ready to hop back to his burrow. Able to metabolize water from food, the kangaroo rat doesn't need much beyond these seeds. What he needs, the desert provides. He knows which plant's seeds contain the most moisture, and he stores his stash in the most humid sections of his burrow.

The creosote, kangaroo rat, and this whole community of desert species are quintessential desert survivors. One study of drought-resistant communities in the Lower Colorado River Valley found that after three years with almost no rain, scraggly creosote were the only plants visible. While other life forms were not immediately observed, they were found to persevere in the spare shade of the creosote and the cooler earth beneath the desert ground. Pocket mice, kangaroo rats, ants, rock

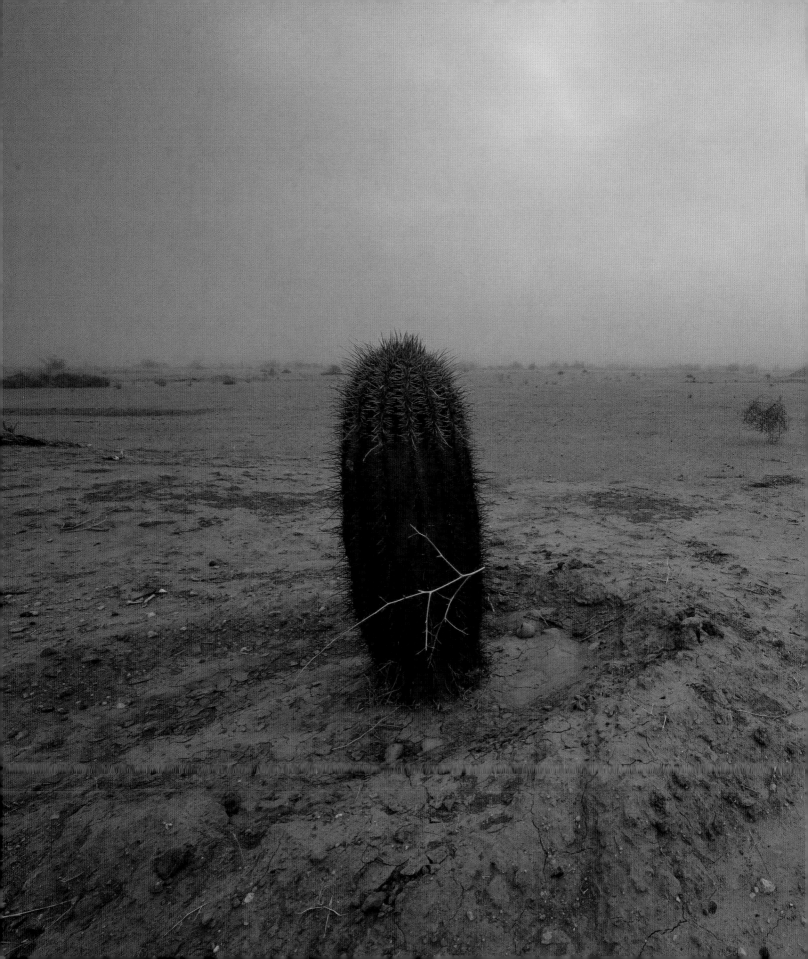

Land cleared of desert plants is slow to recover and prone to dust storms.

wren, and black-throated sparrows survived on seeds that can last for years on desert soil.

Given their longevity and tenacity, adapting a dependence on the creosote is about as good a bet as you'll find in the desert. But as hardy as this plant is, it is not without vulnerability. Creosote produce many seeds, but most fail to germinate, so the plant rarely produces offspring from seed. This reproductive challenge leaves the creosote highly vulnerable to land disturbances, and it can take decades for them to return to areas that have been cleared by human machinery. Because it is one of the key plant species in a Sonoran landscape, the loss of creosote roots leaves the desert soil vulnerable to wind erosion. Much of the pristine desert in central and southern Arizona has been lost to grazing, agriculture, and other development, and on dry, windy days the region can be smothered under a cloud of desert dust.

Most desert landscapes are extremely slow to recover from disturbance, in part because the seeds of most desert plants are reluctant to germinate, and they often wait for the rare extended rainy spells that can help them survive as fragile desert sprouts.

Though vulnerable as seedlings, mature desert trees and shrubs, can, like the creosote, employ a whole range of drought-survival mechanisms. The desert agave has the ability to slow its metabolism based on available moisture—if rainfall is plenty, the agave can grow more rapidly, but if not, it will grow slowly to retain moisture. The agave's smartly metered life, carefully adjusting to the feast or famine cycles of nature, ultimately ends in one go-for-bust expenditure of beautiful energy—a cluster of flowers perched atop a stalk that can tower fifteen feet into the desert sky. The agave's bloom is perhaps all the more exquisite for what it represents. Most agave species devote all of their energy to producing a bloom—every last bit. Once in its lifetime, the plant blooms, and then it dies.

Agave flowers may release more than 50,000 seeds, and it seems like a good enough gamble to stake your life on, that at least a few of those seeds will sprout into a new generation of agaves. But in fact,

(At right) *A palo verde tree acting as a nurse plant for a young saguaro.*

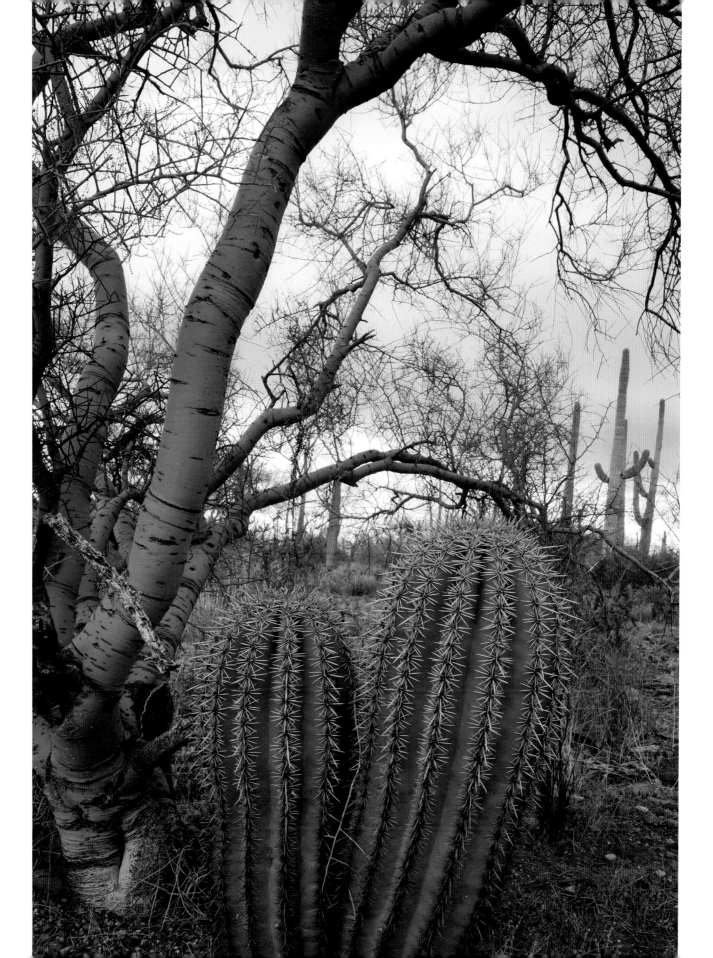

most are eaten by rodents and ants, and the remaining seeds, unless rainfall conditions are right, will remain unsprouted on the ground. Having been around the block for a few millennia, agaves do not rely on their seeds for reproduction. Rather, they form most new plants by sending out runners and assisting the attached offspring for years with umbilical-like infusions of nutrients and water until the child plant has established itself.

A helping hand can mean a lot in the desert. The survivability of many desert plants and animals is boosted by the landscape's own Red Cross brigade of nurse plants. Mesquite, palo verde, acacia, and iron-wood trees, all members of the legume family, fix nitrogen essential to other desert plants, contribute nutrients to the soil from their fallen leaves, and shelter fragile seedlings of other plants. Some seedlings, like those of the saguaro, cannot survive in full sun exposure, so they rely on nurse plants like ironwood trees to give them partial shade during their vulnerable youth.

Desert trees are critical to biodiversity in the drier regions of the borderlands, but they are by no means the full diversity of tree that can be found in the Sonoran region. Riparian and mountain areas of the desert create unique communities of species that could not exist on the dry flats of the desert. Along the San Pedro River, cottonwood, willow, and walnut trees cast cool shade for millions of migratory birds who take respite there during their exhausting annual journeys. More than 380 different bird species can be seen in this one riparian corridor spanning the international border between Sonora, Mexico, and Arizona. Many of these are tropical species that can be seen nowhere else in the United States outside the borderlands. In addition to an astounding diversity of birds, the corridor is also home to more than eighty mammal species, including javelina, bobcat, jaguar, black bear, coatimundi, and fox, who depend on the waters of the San Pedro, one of the last undammed rivers in the American Southwest.

Human development in the San Pedro watershed over the past half-century has resulted in a drastic depletion of water, reducing the river's

flow. But the San Pedro remains alive, if elusive, and ongoing conservation efforts have begun to mend the wounded ecology of the river. The San Pedro's status as one of the key riparian habitats remaining in the Southwest prompted the Bureau of Land Management (BLM) to prioritize restoration of this ecosystem and to shepherd the return of the American beaver to the southern US portion of the river, which lies within the BLM's National Landscape Conservation System. Long extirpated from its waters, the beaver again tinkers as a streambed architect, altering river flows in ways that benefit many other species.

Like many desert streams, the San Pedro does not flow all the time, and when it does flow, it can disappear for long stretches above ground, leaving little evidence of its existence aside from the verdant plant life along its banks.

Within this riparian corridor, and in other perennial desert streams, trees and stream coexist so seamlessly that they operate almost as separate organs of a single entity. During the day, when temperatures are hottest and trees are photosynthesizing, they pull water from the stream and release it to the air through evapotranspiration. A stream can actually go dry during the day. At night, when the trees no longer need so much moisture, they return the river to itself, releasing water back to the streambed where it can rest for the night.

Many ephemeral streams, though they do not flow above ground all along their length or all year-round, or even all day long, may retain enough water to sustain small pools or moist areas that are home to rare and extraordinary species of fish. Sonoran suckers, Gila chub, monkey spring pupfish, phantom shiners, and others have been here since before the last ice age, and they have held on with special adaptations that allow them to live in arid-land streams. The longfin dace waits patiently during the dry daytime hours, tucked safely away under patches of moss or fallen leaves, which remain moist when the water table sinks. Once night comes and trees release moisture back to the stream, the dace flutters out of hiding, seeking out insects and algae to eat. This dace is not alone. There is a whole court of stream creatures

that, like other desert inhabitants, are all but invisible during the day, but come to life like dryads in the night.

Some 100 species of freshwater fish are native to the Sonoran Desert, and almost without exception these uniquely adapted desert fish are in trouble. Many have weathered a long decline due to loss of habitat as wells have sunk the water table and dried up streams and rivers. The drying of the perennial streams and underground rivers essential to desert life goes unnoticed by most people, simply because our daily lives and comforts are not directly impacted. It is only when we look for what is no longer there that we are confronted by its absence.

Consider the Colorado River, flowing from the mountains of Colorado through the Sonoran Desert to its delta at the Gulf of California. Historically, the Colorado carved through its riverbed as a great force of nature, its moods and movements creating ecosystems both minute and immense. The river gouged the red rock of Arizona into a Grand Canyon, one of the most massive land features on Earth. And it scoured and scraped the land all along its raging path, 1500 miles from headwaters to delta, marching to the sea with the debris of a continent. Near the Gulf at the river's southern end, the wind stole back some of the land and lay it down in the desert. This tug-of-war between land and river and wind over thousands of years formed whole dune ecosystems like the Algodones Dunes, a 1000-square mile ridge of quartz sand spanning the borderlands.

Despite the gargantuan legacy it left on the land, the southern reach of the Colorado River is now no more than a feeble relic of the past. Today, due to dams, agricultural diversions, and urban use of water, the Colorado barely contains enough water to reach its delta. But the habitats it created persist, as do the communities of species that evolved within them—creatures like burrowing owls, tiny birds that live underground and feed on insects and reptiles; and fringe-toed lizards, who can swim beneath dune sand to escape surface temperatures that can reach 180 degrees Fahrenheit.

The scorching dunes of the western borderlands sit in stark biologi-

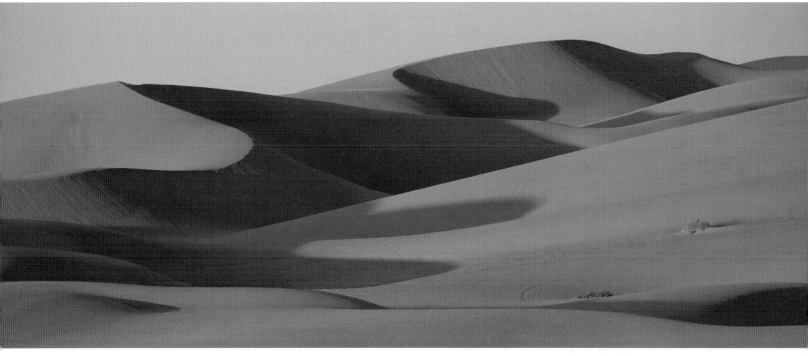

The Algodones Dunes.

cal contrast to the sky island ecosystems that punctuate its higher altitudes. The term "sky island" describes the distinctive ecological communities found on mountains in warm, arid lands. In such a landscape, cooler mountain slopes and peaks become biologically isolated within seas of lowland desert and grassland, creating conditions favorable to the rise of endemic species. For instance, the Mount Graham red squirrel, a unique subspecies of mountain-dwelling squirrel, has adapted to live in the high elevations of the Pinaleño Mountains of southern Arizona. For this squirrel, trying to cross the sea of grassland that surrounds Mount Graham would be akin to swimming through miles of ocean with the fool's hope of finding a suitable island of habitat. Millennia in isolation have made this squirrel species unique in all the world—and the squirrel's entire world depends on this one island in the borderlands sky.

The Pinaleño range contains five different eco-regions and, according to the Nature Conservancy, it represents the largest diversity of

habitat types within the shortest vertical distance of any mountain range in North America. Diversity like this is made possible on mountain ranges throughout the US-Mexico borderlands because, in general, temperatures decline three degrees for each 1000-foot gain in elevation. Mountaintops also intercept clouds, so elevated ground gets slightly more rainfall than the surrounding arid lowlands. What may seem like slight differences in terms of temperature can become dramatic when traveling up mountain slopes in the Sonoran Desert region. A sky island odyssey can begin in creosote and cactus, with temperatures at 115 degrees, and end at 10,000 feet in coniferous forests with temperatures well below 100.

The transition of just a few miles vertically can be like traveling the distance between the southwestern desert and northern Canada, distant locations where plant and animal life vary dramatically. Within this span of altitude, more than 3000 plant species, more than half of North America's bird species, and more than one hundred different mammals can be found. And in addition to diversity engendered by elevation changes, the borderlands sky islands are the only mountain complex in the world that bridge the temperate and subtropical latitudes, allowing the tropical flora and fauna of the Sierra Madre to mingle with their temperate cousins from the Rocky Mountains. The resulting sky island biological communities contain a diversity of species richer than any other place in the United States.

Some of these sky island residents, particularly large mammals like mountain lions, black bear, and wolves, rely on their ability to travel wild corridors *between* mountains in order to maintain genetic diversity. Because so many corridors have been severed by human development, wildlife conservation efforts in the region have begun to concentrate on saving and reestablishing pathways for sky island species, including the highly endangered jaguar.

Scientists and local residents have documented jaguars in the borderlands regularly over the past few decades. These jaguars are believed to be critically dependent on a larger population of jaguars in the Sierra

Madre habitat in the southern reaches of the borderlands in Mexico. Open migration corridors are the only means for young jaguars looking for new territory to find habitat in the United States, and similarly, for the few jaguars in the United States to find mates from the more southerly population in Mexico. Their future depends on their ability to roam.

While jaguars cut a high profile, they are not the only species faced with a similar essential need: the ability to move freely to adapt to changing conditions. Unlike politically imposed boundaries, natural boundaries do not begin and end at a single straight line. Instead, they gradually blend and overlap and move fluidly with the changing climates of Earth. Where a blending of eco-regions occurs, as it does frequently in the borderlands, the creatures of the desert coexist with the creatures of the tropics, the mountains, and the grasslands. Moving eastward along the borderlands from the Sonoran Desert, the great presence of the saguaro and organ pipe cactus diminishes, but prickly pear cactus, agave, and mesquite remain—along with a whole universe of creatures, many of them sheltered beneath the hypnotic undulations of an ocean of grass.

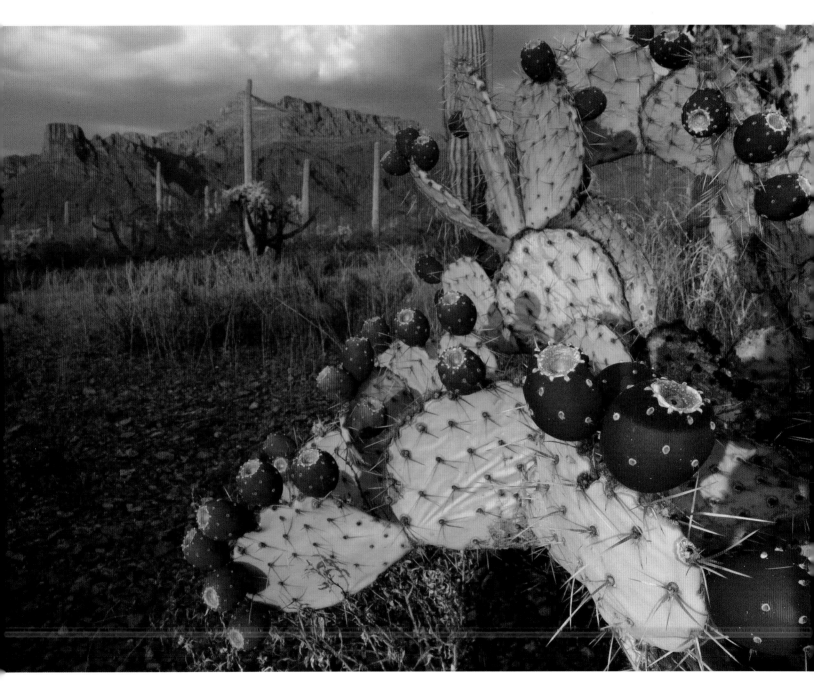

*A prickly pear cactus with
fruit in Organ Pipe Cactus
National Monument.*

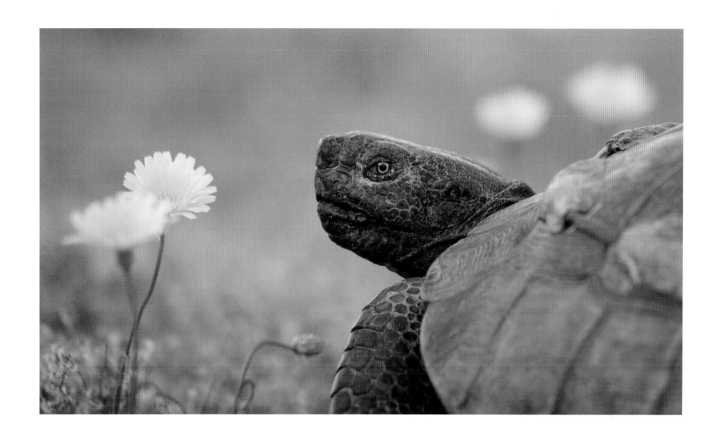

Desert tortoise with desert dandelion.

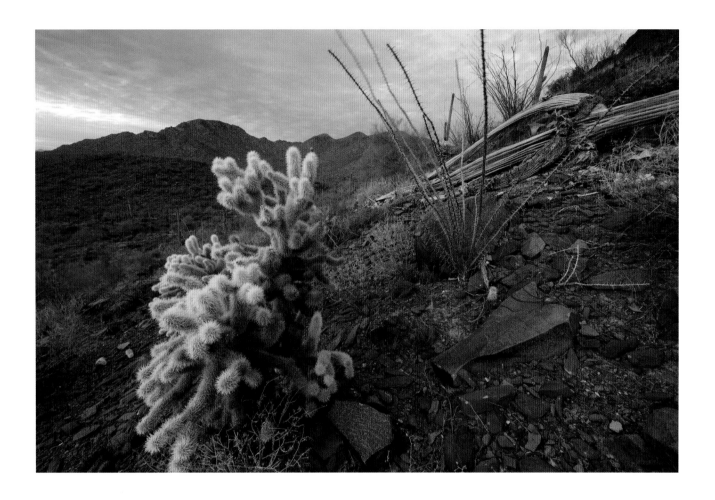

Teddy bear cholla on a
mountainside in the desert.

Mountains reflected in a desert pool.

*Close-up on prickly pear
cactus.*

Close-up on barrel cactus.

44

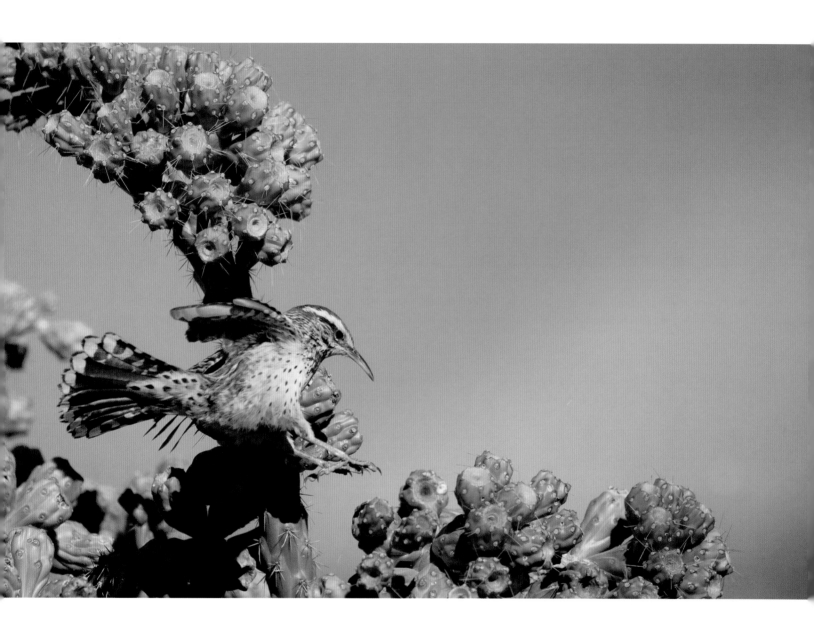

*Cactus wren hopping onto
cholla cactus.*

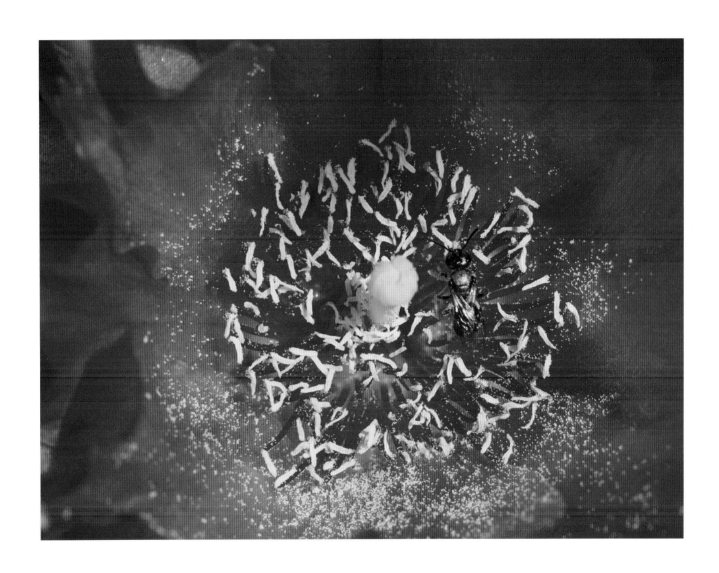

A prickly pear flower with pollinator.

(At left) *The bloom on a cholla cactus.*

A Gila monster in northern Mexico.

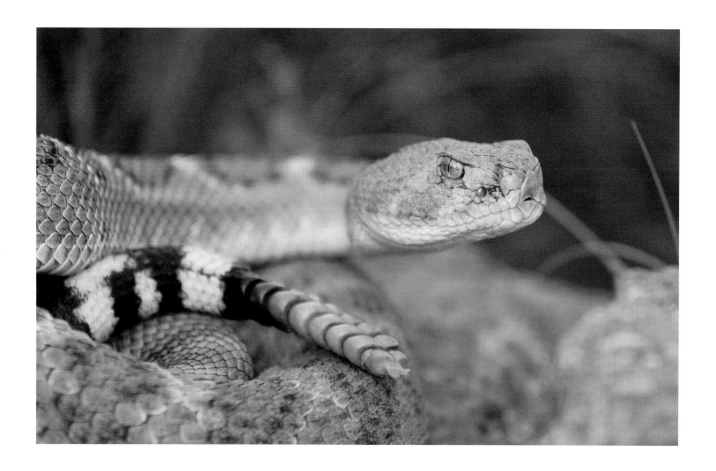

*A western diamondback
rattlesnake.*

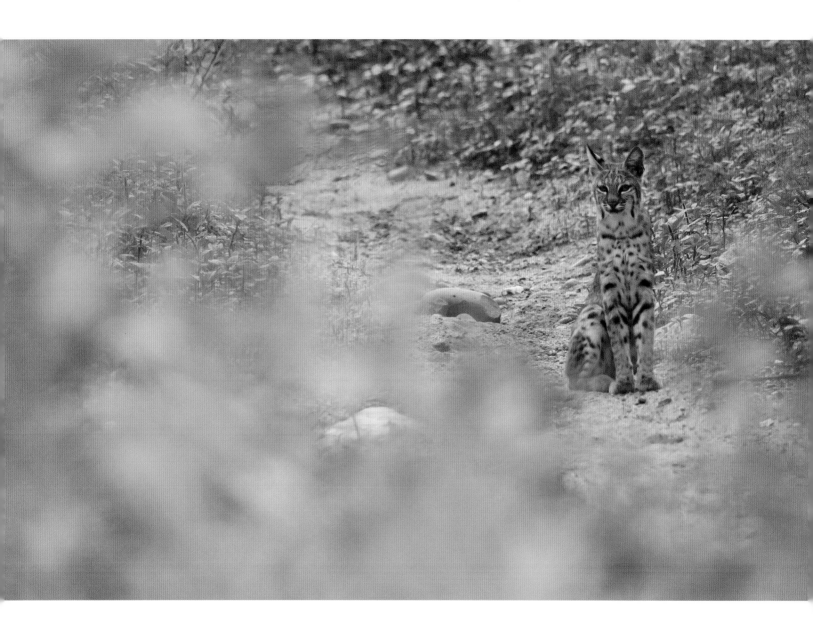

*A bobcat in the foothills
of the Santa Catalina
Mountains.*

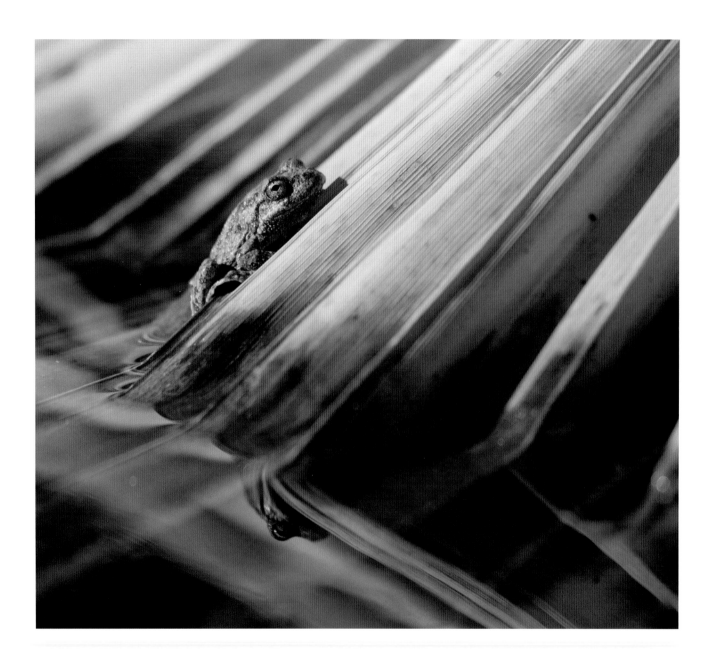

Toad in a desert pool.

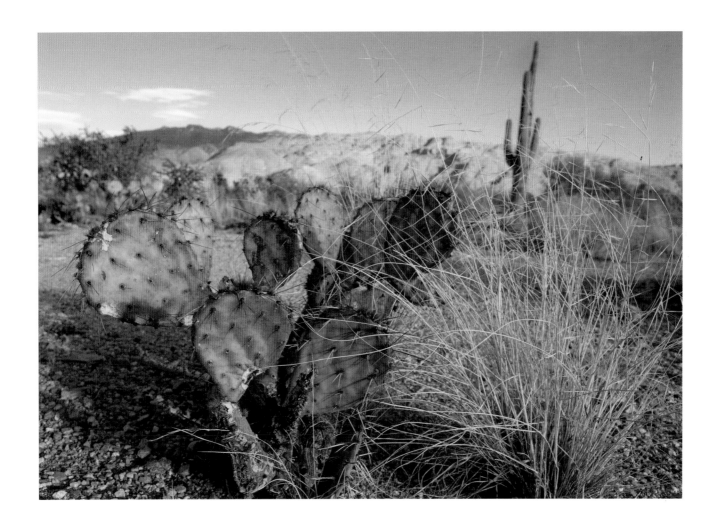

(Following page) *Sunset in the Cabeza Prieta Mountains.*

Prickly pear cactus with saguaro in the background.

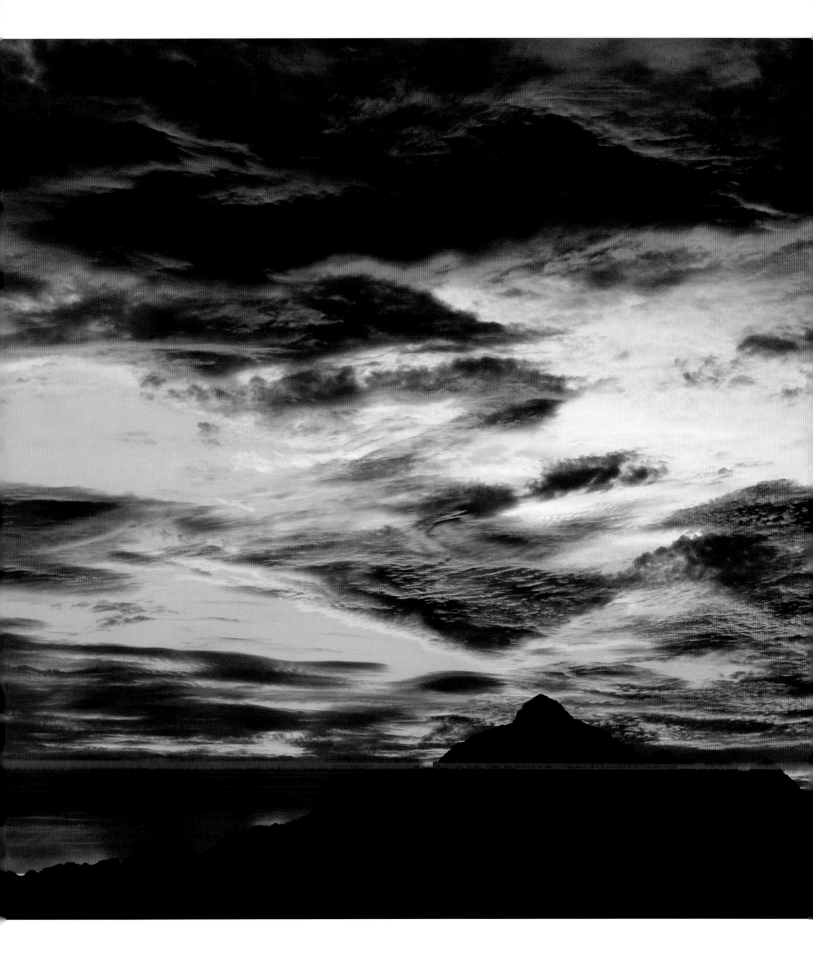

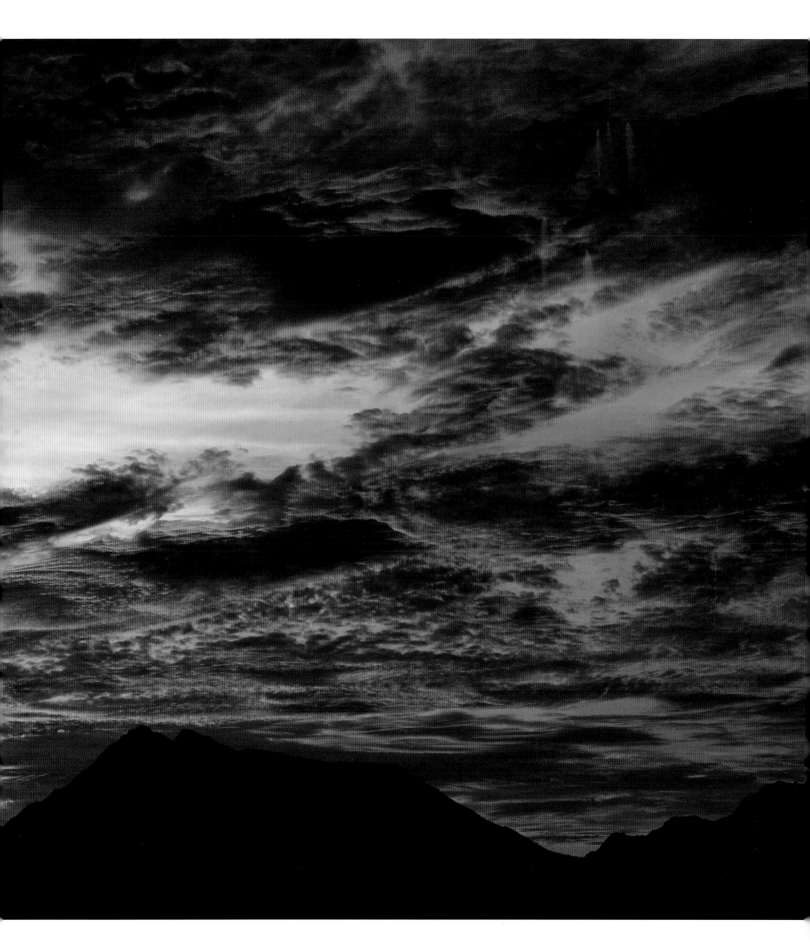

(At right) *The Cajon Bonito, a desert stream in northern Sonora, Mexico.*

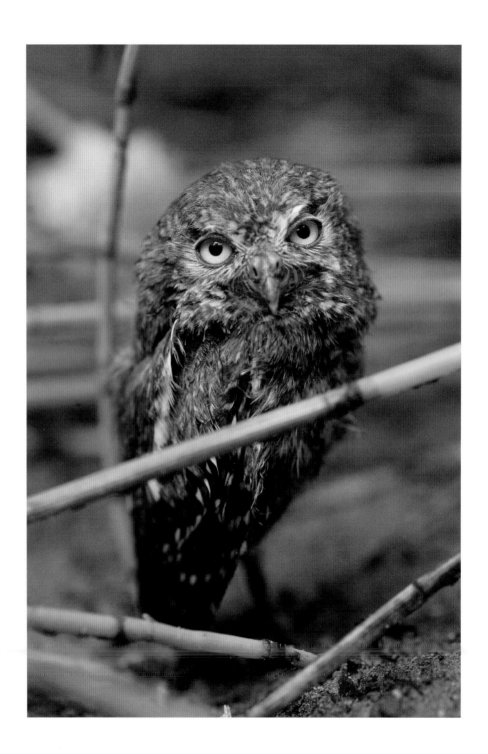

An elf owl.

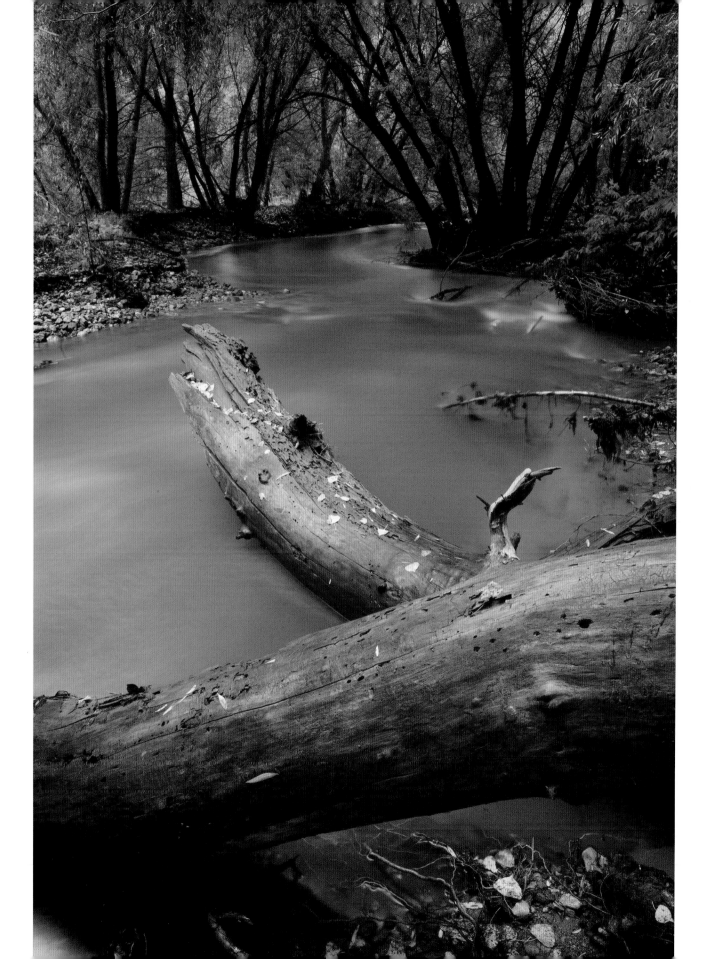

A mud turtle.

Borderlands sky island habitat, one of the most biologically diverse locations on the continent.

*A cottonwood tree in a
borderlands riparian area.*

A great horned owl at the San Pedro River.

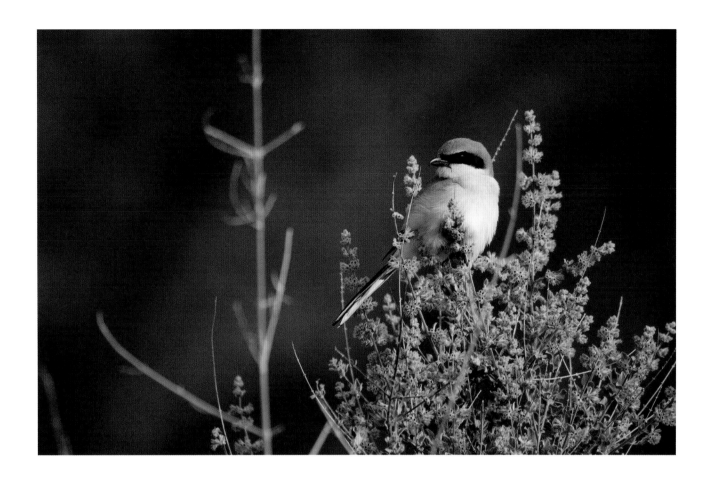

A loggerhead shrike.

A frog in a desert stream.

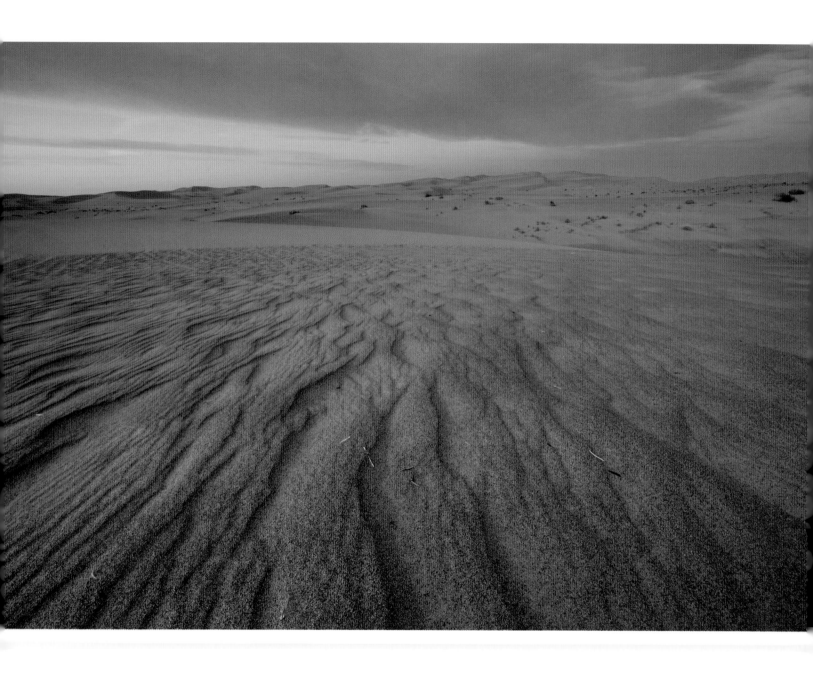

The Algodones Dunes in
southeastern California.

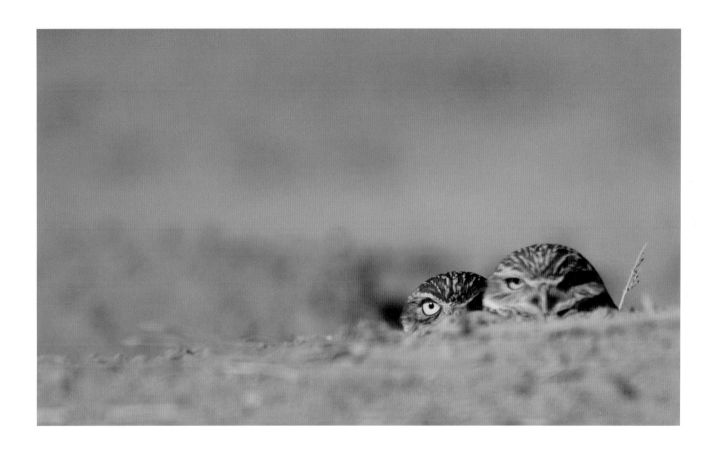

Burrowing owls in the
Imperial Valley in California.

An agave plant in the foothills of the Huachuca Mountains.

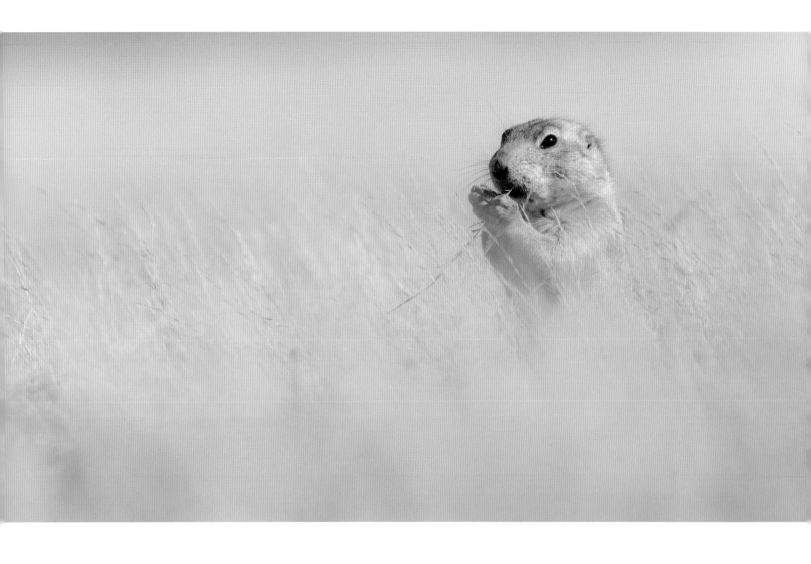

(Following page) *Grasslands and bison in Janos, Chihuahua.*

A prairie dog in Chihuahua, Mexico.

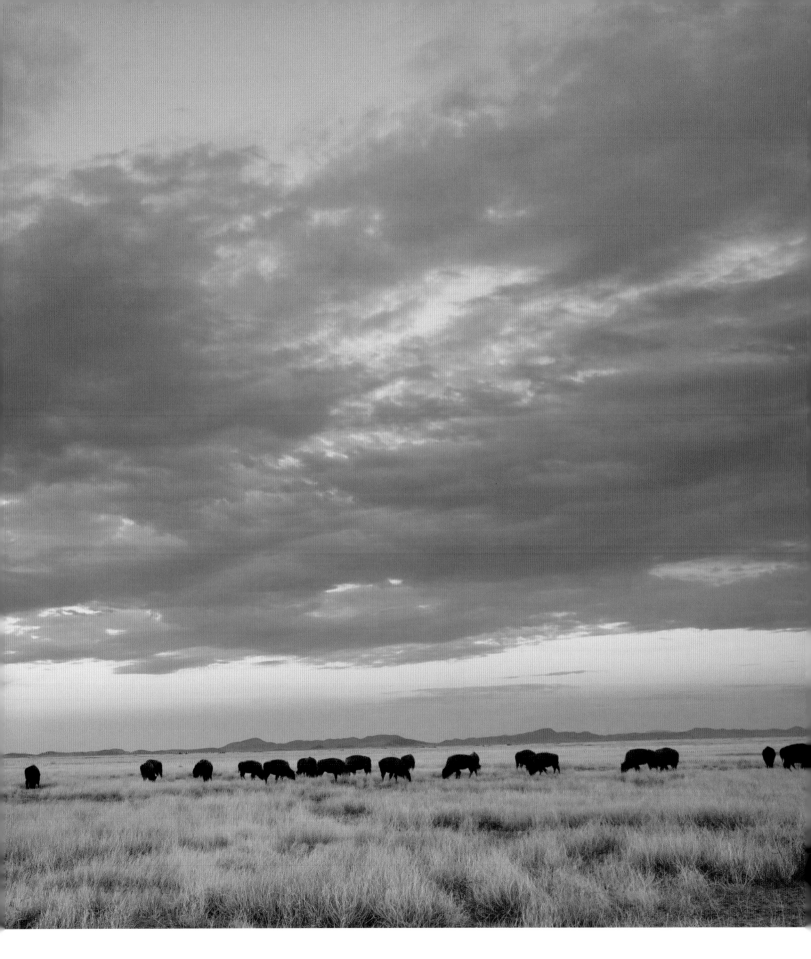

GRASSLANDS

Early morning in late April, a coyote croons a few half-hearted yelps from the depths of a grassland dream, while under the chilled veil of darkness the Chihuahuan Desert slumbers. Or so it would seem. Like so much of the borderlands, what you see at first glance is often only a fraction of the whole.

An eastward look along the border from the southeastern fringe of the Sonoran Desert in Arizona suggests a monoculture of endless grass dominating the land for miles and miles and endless, sky-filled miles. Pale blond grass seas stretch to every horizon and mountain foothill, jostled into rolling waves by a wind untroubled by trees. But the uniformity of the vision belies its complexity. Within that sea lies a rich diversity of grass species—black, blue, and slender grama, sacaton, dropseed, fluff grass, and many others. And somewhere, from beneath the swaying earth, voices can be heard—agitated, insistent squeaky voices, speaking about something of apparently grave importance. When you are a small rodent and chief prey species for an ecological community, every conversation bears an edge. Prairie dogs often sound like they are upset about something, and at this time of year they have plenty to fret about. Listening in on their conversation is a kit fox, who may be in a nearby burrow or crouched on the ground above, hungry but

willing to wait. Raptors patrol the sky on noiseless wings, alert for opportunity. And even more worrisome, somewhere inside the prairie dogs' complex burrow home, perhaps still snuggled in a puppy pile, lays a litter of toddlers, most still so helpless they can't walk out of the burrow without falling over their own feet. The pups' parents have much to mull over and discuss, and they have a sophisticated vocabulary with which to do so—one of the most complex of any mammal known to science. Researchers have observed prairie dogs using different "words" for a tall human with a yellow shirt and a short human with a green shirt, as well as separate warnings for coyote, red-tailed hawk, and other animals. And perhaps there are words for, "Stay indoors! The pups are clumsy and that fox looks hungry!"

These clever rodents share their underground home with a whole world of other creatures that for the most part go unnoticed by those that dwell in the sea of grass above ground. It is a world that once tunneled beneath the great expanse of North America's Great Plains, stretching thousands of miles to the north—a Serengeti savannah where prairie dogs were both king and canned tuna. This keystone prairie species was and is a critical prey animal for predators like the golden eagle, badger, fox, and the endangered black-footed ferret. Prairie dogs were also the primary architect of the universe of burrows that housed much of the subterranean grassland kingdom that supported the many species that walked or flew above ground—everything from pronghorn to falcons.

That wild kingdom has all but vanished from the continent. Memories, relics, and scattered remnants are all that linger. But in the rare locations where prairie ecosystems remain, a glimmer of hope exists for the species that call this landscape home. In the borderlands of Chihuahua, Mexico, a critical prairie remnant endures, complete with its chatty-Cathy king. These little grazers help keep the land clear of shrubs so that grasses can dominate, and their burrowing aerates the soil while their waste fertilizes it,

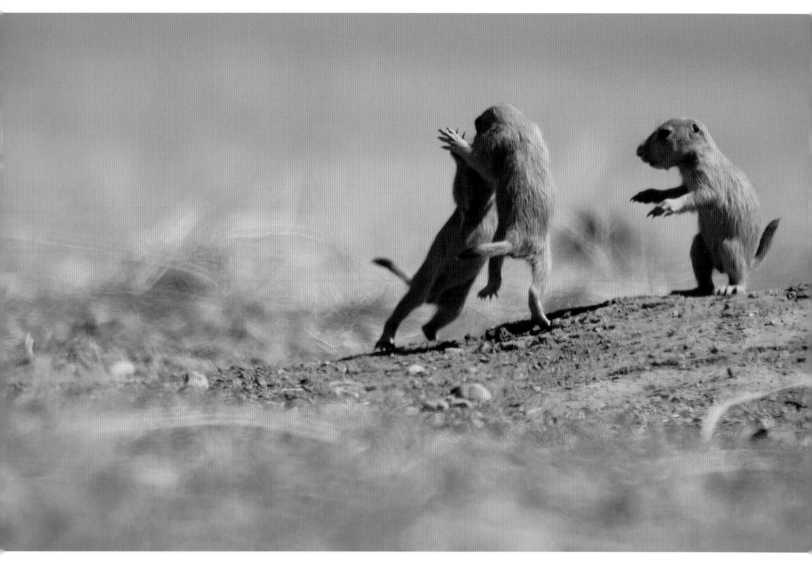

Prairie dog pups playing.

creating a healthier grassland. So beneficial are these rodents, that scientists estimate 140 species are likely to be negatively impacted by the loss of prairie dogs from a grassland—make that 141, including humans. Their burrows also loosen soils compacted by cattle and help the ground absorb water better, thereby decreasing erosion and improving water and air quality.

Prairie dogs are landscape architects, groundskeepers, and home-

builders; they provide building blocks for the creation and health of the prairie ecosystem, and they have been here for many millennia, natives of the landscape in a way that is almost beyond reckoning for humans. In general, we as a species are takers. We use, degrade, and deplete, making the land less habitable for other species. On the contrary, keystone species like prairie dogs are an army of tiny, tinkering restoration biologists. They are so much a part of the land that returning them to it can actually help resuscitate a failing ecosystem.

In northern Chihuahua, the continent's largest remaining prairie dog colony works to resurrect the grasslands community, providing the basic building blocks for a diverse collection of prairie species. Burrowing owls, long-billed curlews, kit foxes, coyotes, porcupines, and badgers inhabit this grassland. Researchers here are working to restore the critically endangered black-footed ferret and the fabled American bison.

There is perhaps no ecological story more tragic in North America than that of the bison—reduced from tens of millions to a few hundred by the early twentieth century. Historically, the massive presence of bison sculpted the Great Plains, such that whole biotic communities evolved their habits around the movements of bison herds. The influence of these millions of enormous grazers—the pounding of their hooves on the ground, the rich fertilizer left in their waste—set bison apart from other species. Like prairie dogs, they were not just a species present on the land, they were one of the forces that shaped both the land and the creatures that evolved to live upon it.

Since the decimation of the bison population, only a few wild herds have been returned to the landscape—a total of about 5000 individuals. The future success of bison restoration remains questionable, in large part because there is little open grassland left to restore them to. One wild bison population has been eking out an existence along the US-Mexico border in the Playas Valley for

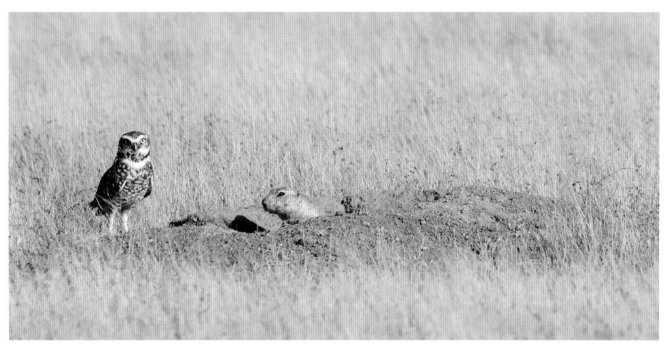

Burrowing owls are one of the species that benefit from prairie dog burrows.

the past eighty years. This location, along with the surrounding Chihuahuan grasslands of both nations, offers one of the most promising places for the restoration of bison to their ecological functions. If bison could be returned in sufficient numbers, the broken ecology of a system all but dead in North America could be repaired in this one rare spot on Earth. In 2009, the Mexican government designated these grasslands a biosphere reserve, giving scientists, the governments of Mexico and the United States, and non-profit organizations a chance to mend the integrity of this remote remnant of prairie.

Biosphere protections and national park designations along the borderlands in Texas and the Mexican states of Chihuahua and Coahuila have inspired unprecedented international cooperation on protection of the Chihuahuan grasslands, sky islands, and migration corridors of the region. Private individuals, non-profits, and borderlands governments are piecing together a workable eco-

system for mountain lions, bighorn sheep, mule deer, black bear, and many other species that have historically roamed the sky islands and flatlands of the Chihuahuan Desert. As a group, these people have managed to secure the return of the black bear to Big Bend National Park in Texas by increasing the ability of the species to travel between the Sierra del Carmen range in Mexico and the Chisos Mountains in the United States. Participants in this conservation effort made a conscious decision to place their efforts precisely here, a location that scientists have declared one of the most biodiverse on the continent.

Sandwiched between the western and eastern Sierra Madre ranges, the Chihuahuan Desert and its species have benefited from the relative absence of large-scale human development. This vast landscape is largely unpopulated along the border stretching from eastern Arizona and Sonora to the Rio Grande Valley. Because of its remoteness and a history of ranching and subsistence farming, wild communities erased from much of the continent continue to hold on here. Grasslands in North America have declined to such an extent they are now considered a critically imperiled ecosystem, in fact, one of the most endangered on Earth. Even grassland regions that have escaped agriculture and other development have suffered from fire suppression, the removal of natural grazers like bison and prairie dogs, and overgrazing by domestic animals. Many grassland regions also now face mounting threats from climate change. As the climate warms and dries, grasslands are transitioning into desert, a shift that can already be seen in the advance of woody plants like mesquite and creosote over what was once open prairie.

Without healthy habitat, grassland creatures currently face a grim prognosis. At least fifty-five grassland species are considered threatened or endangered by the US Fish and Wildlife Service. Grassland-dependent birds are declining more than any other group of North American birds. The borderlands contain some of the last

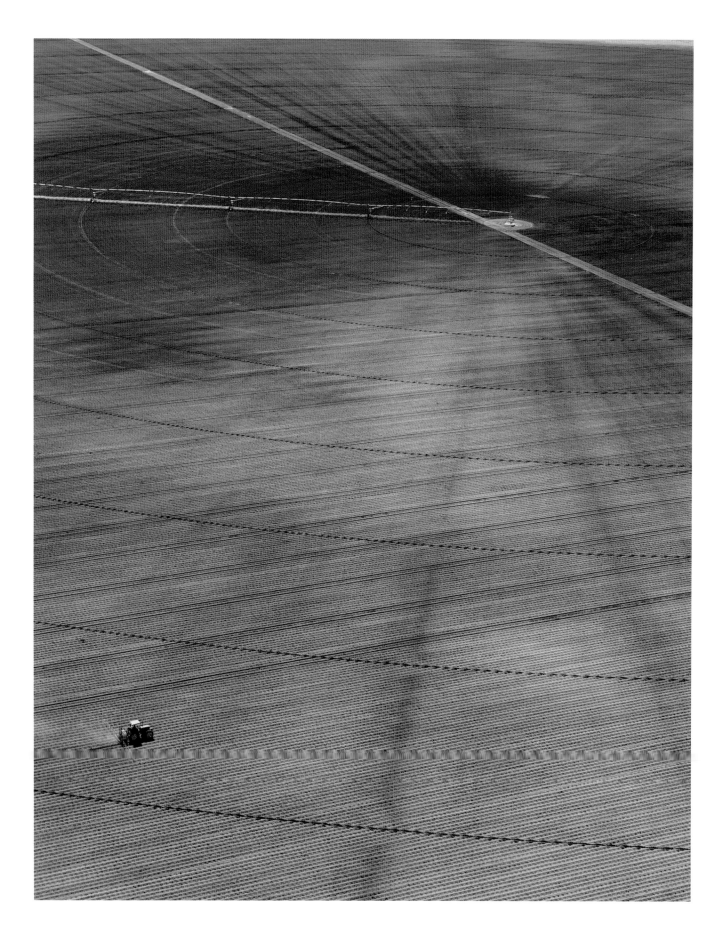

patches of this historically expansive Eden, and some of the last, best hope for grassland conservation.

Chihuahuan grassland seas and sky islands also contain riches of a more intangible nature. At the nexus of southern New Mexico, Texas, and northeastern Chihuahua, the Rio Grande becomes the borderline of the United States and Mexico. A bit further south, the river makes an abrupt turn to the northeast within the deep wrinkles of Earth known as the Chisos Mountains and the Sierra del Carmen. One of the most remote places in either nation, the Big Bend of the Rio Grande occurs in the deep shaded recesses of a rock-walled corridor, beneath a night sky unblemished by urban light pollution. A place of seemingly austere emptiness, this arid region is in fact filled with life. On the riverbanks and within the foot-hills and mountains that tower over the Chihuahuan Desert, black bear, mountain lion, deer, a colorful assortment of birdlife, turtles, fish, and many other wild creatures make their homes. And most of them are residents that travel at will across the Rio Grande and thus between two nations as their survival needs dictate.

On a journey to Big Bend National Park in 2011, I stood on the US bank of the Rio, looking inward on the Santa Elena Canyon, a cathedral of towering stone walls carved by a once-mighty river. Santa Elena's left canyon wall is Mexico. Her right wall, not twenty feet away, is the United States. From where I stood, the walls appeared to merge at the vanishing point within the canyon. At the top edge of this convergence, jagged topography creates what appears to be a crevasse in a solid wall of rock, but is really just a bend in the top edge of the river corridor, a small wedge of space between the United States and Mexico. On this visit I had risen several hours before dawn and perched myself at the opening of Santa Elena to wait for the moment when the full moon would set just before first light appeared from the rising sun on the oppo-site horizon. That morning, all alone on the sandy edge of the Rio Grande, I watched moonlit ripples bob on the dark water, dancing

(At left) *Irrigation has allowed cash crops like potatoes and soy to replace grasslands in Chihuahua.*

(Following page) *The moon settling into the Santa Elena Canyon, between Mexico and the United States.*

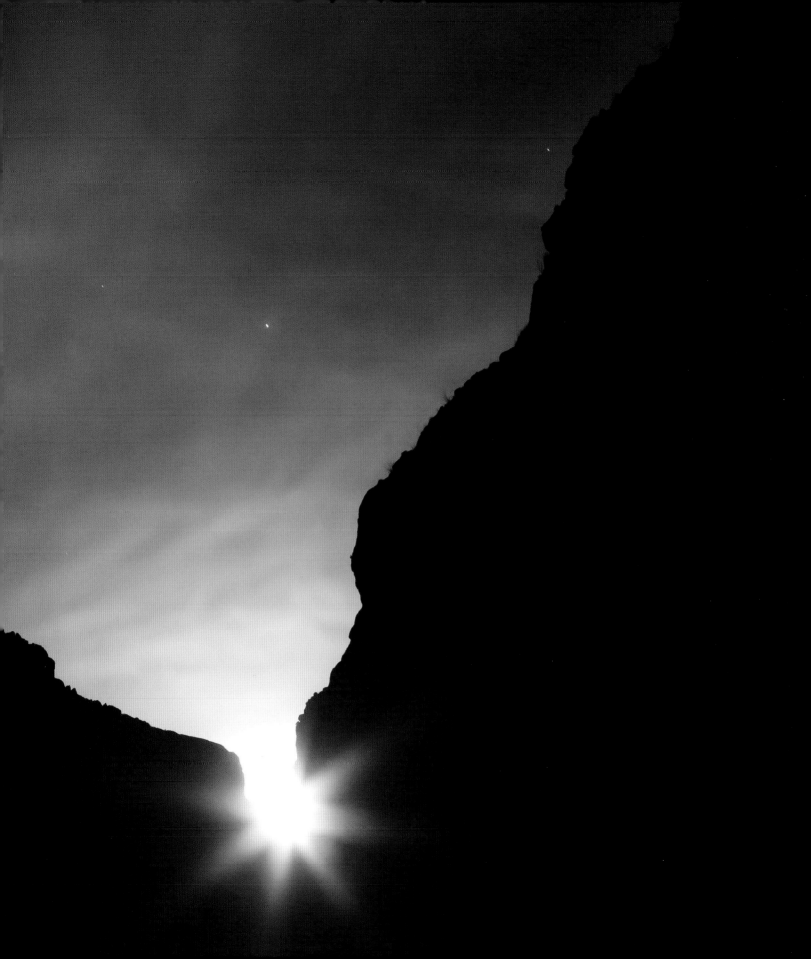

their way toward the Gulf of Mexico. Then, the great round orb of light began to slip into the hairline crack between two nations, and when it had descended between the rocky cliffs of the United States and Mexico, the moon's illumination burst into fractured light. Beams of pale moonlight streamed to the sky, to the river, to the canyon walls, indiscriminately illuminating earth, water, and sky on either side of this intellectual boundary. The seemingly choreographed departure, ordered to the most minute detail of time and space, ended as the moon disappeared behind the Sierra del Carmen and the last bits of light were withdrawn into the darkness of the canyon.

As witness to this phenomenon, I can only describe it as . . . perfect. A mile away the moon would not appear to settle into this cleft, though it would still reflect on the surface of the Rio. A few thousand miles away, in Washington, DC, the moon would be visible, but not in the context of Santa Elena Canyon, or the Rio Grande, or the borderlands, or Mexico. Context is everything.

Down on the banks of the Rio, I begin to wonder where I am. Is this the United States, and is that Mexico across a river I could almost jump? There isn't a sign of human development anywhere within visible reach of this almost inaudible river glittering with starlight. In this serene starlit moment, I do not recognize the borderlands of television news and political tirades. Fear is infectious; a virus whose only cure may be perceiving reality with one's own eyes and ears.

A coyote howls as the eastern horizon begins to glow. A small catlike shadow approaches the river's edge upstream, pauses for a moment, and then swims across the placid water to Mexico. And, as the first fiery arc of the sun breaks the horizon, a hatchling bird nestled in a tree on the north bank of the Rio cries for its breakfast. There is no sound as lonely as the disconsolate bleat of a hatchling bird in the wilderness. My heart counts the beats, one, two,

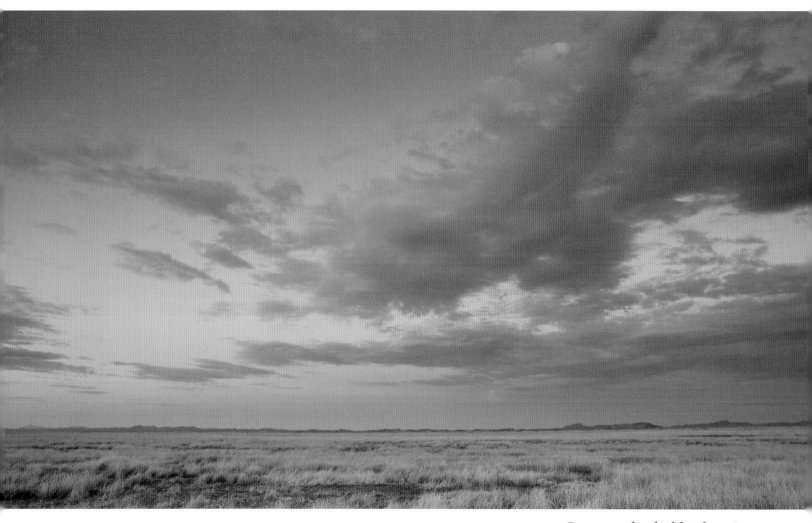

three, as the helpless creature wails through the silence, begging for a response. It doesn't have to wait long. The reassuring answer is as swift as an echo off the canyon wall. From the south side of the river, the hatchling's foraging mom has alighted on a shrub in Mexico. "I'm coming!" she sings.

Open grasslands, like these in Janos, Chihuahua, are some of the last relatively intact grasslands on the continent. As global warming continues to cause droughts in this region, diverse species—from pronghorn to bison and kit fox—may need to move northward in order to survive.

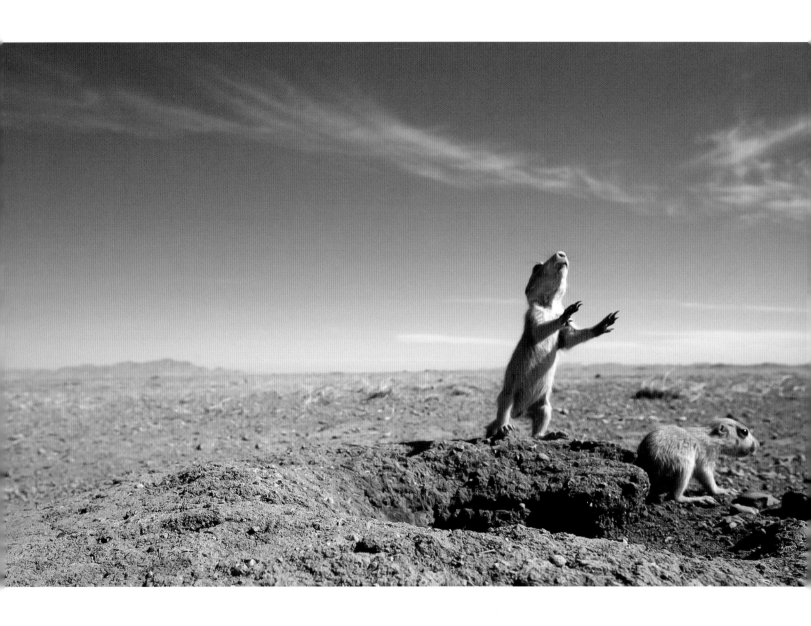

Prairie dogs are considered a keystone species, beneficial to nearly 150 other species.

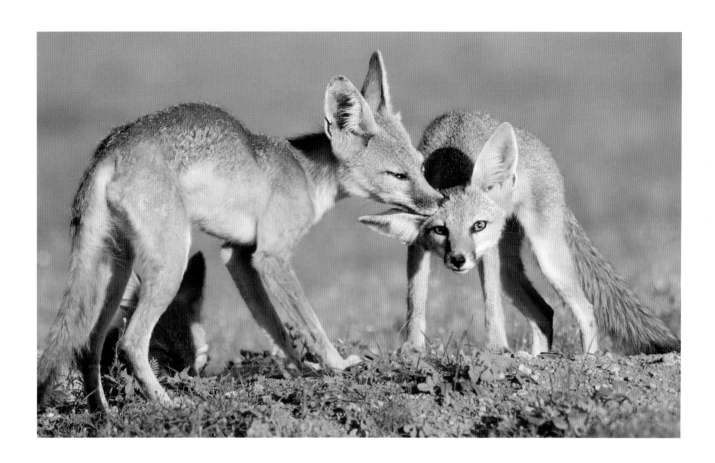

One of the many species that benefits from prairie dogs are kit foxes.

82

The Chihuahuan Desert harbors one of North America's last intact grassland ecosystems.

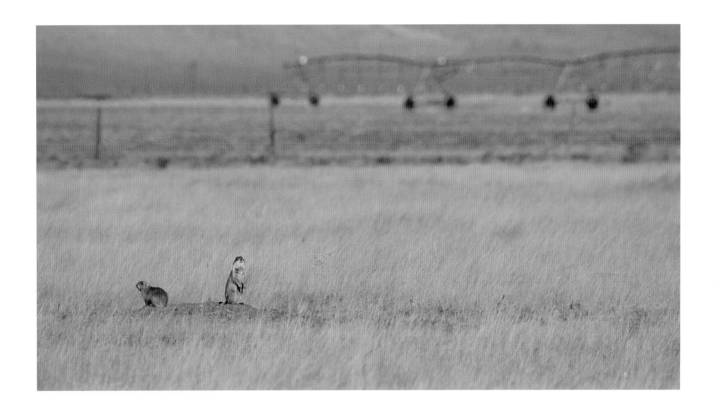

(Following page) *Plains bison never rebounded from their near extinction in the early 20th century. This herd in the borderlands represents one of the few remaining wild herds.*

Prairie dogs, bison, and other grassland species have already lost much of their North American habitat to agriculture.

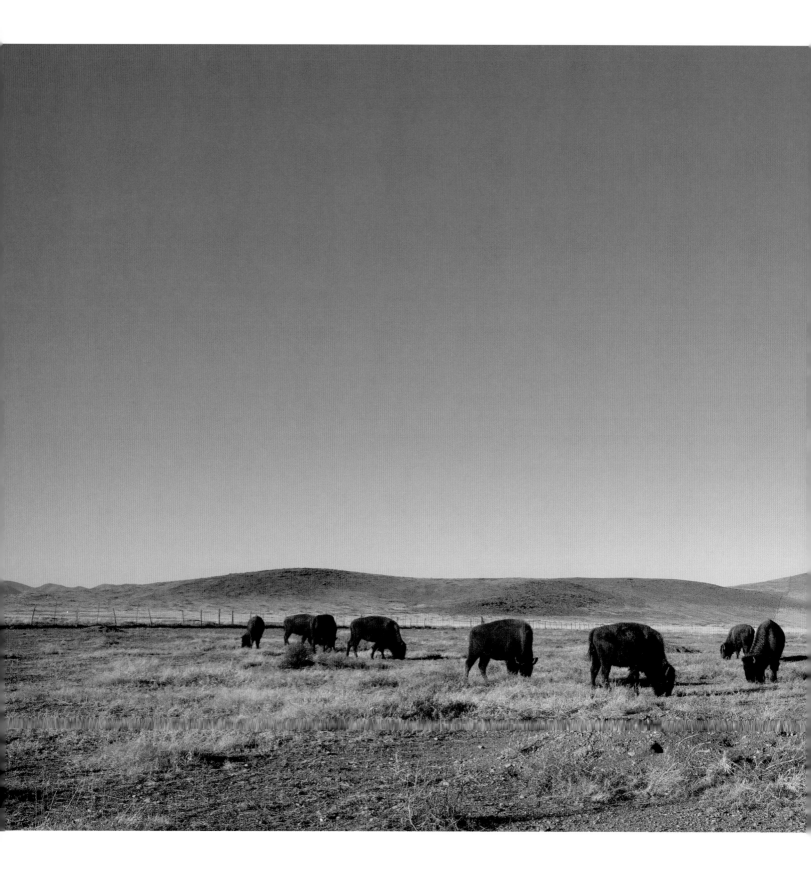

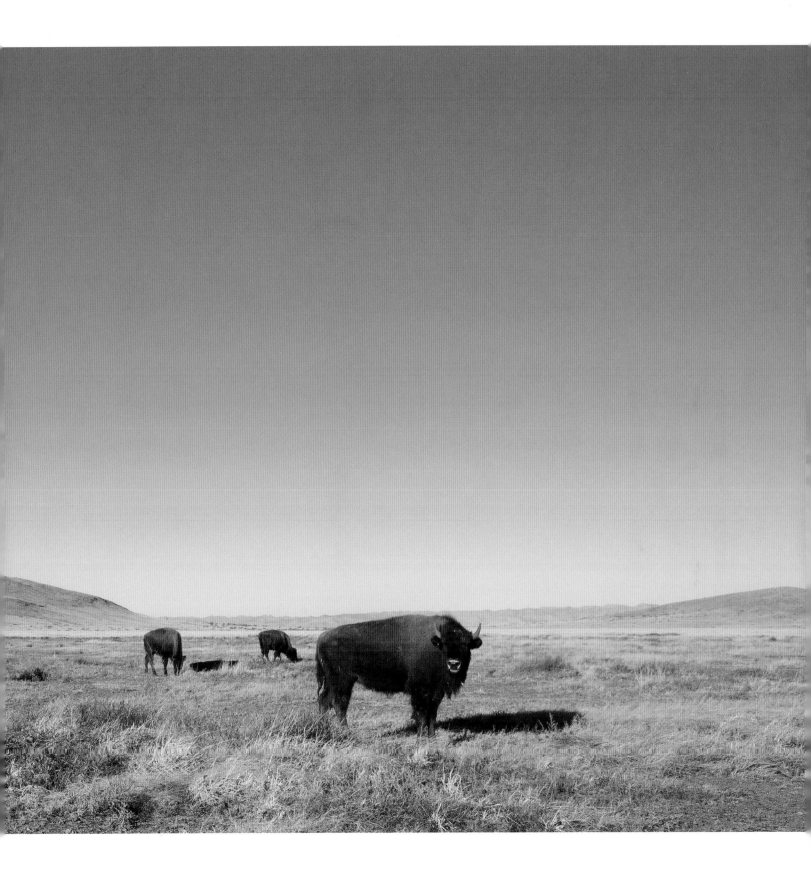

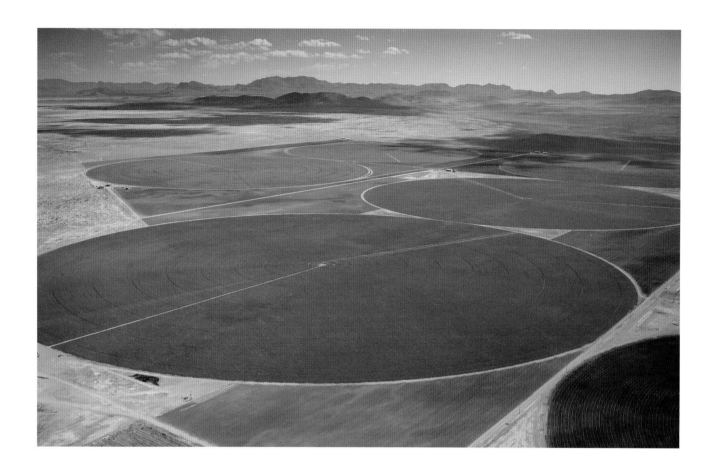

Agriculture has replaced most native grasslands in North America, and it continues to threaten the few remaining grassland remnants, like those in Chihuahua.

(At right) Advanced technology in irrigation has sped the transformation of grassland habitat into soybean and other cash crop agriculture.

(Following page) Intact grassland in Janos, Chihuahua.

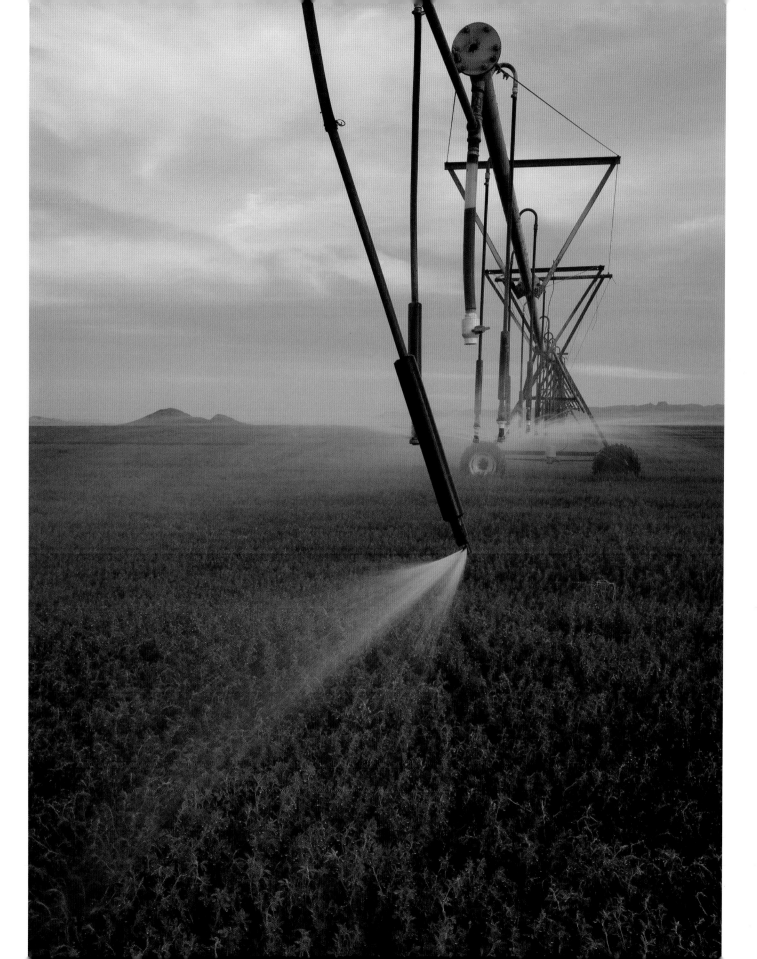

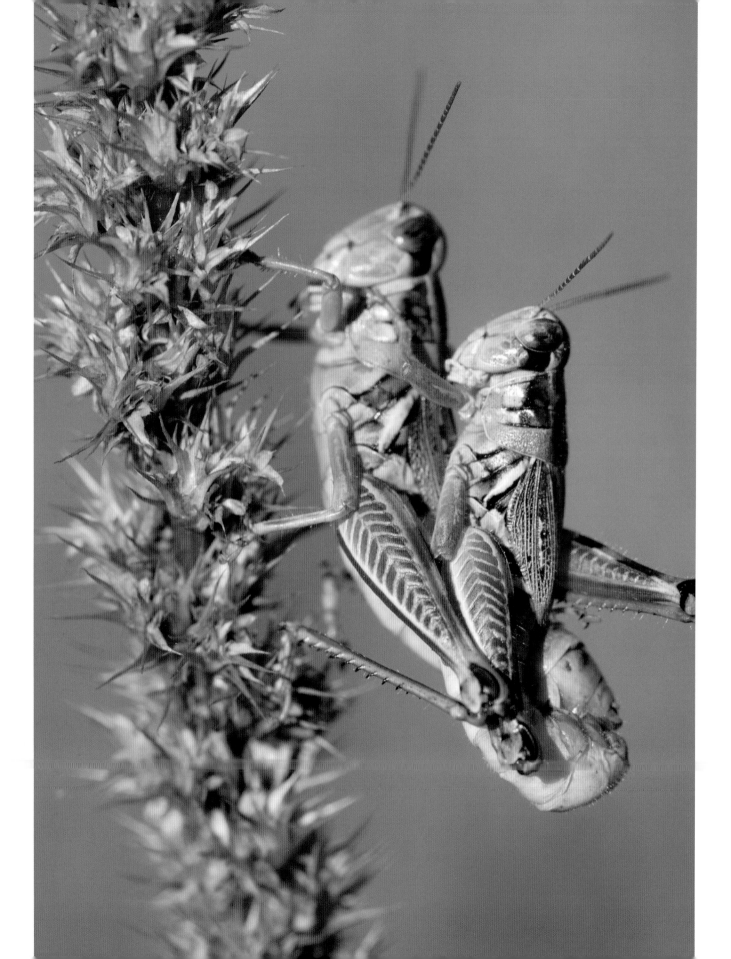

Grasshoppers constitute a diverse micro-community in grassland ecosystems.

Grasslands in Janos, Chihuahua.

Porcupine quills.

(At right) A porcupine in Janos, Chihuahua. This animal was part of a study on porcupines and grassland habitat.

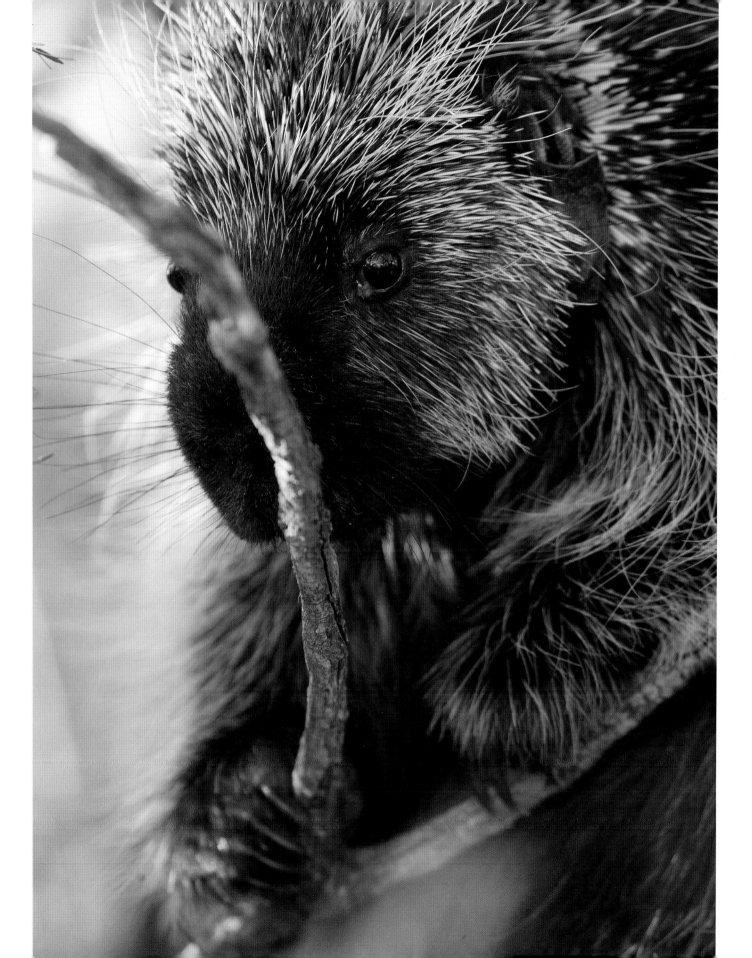

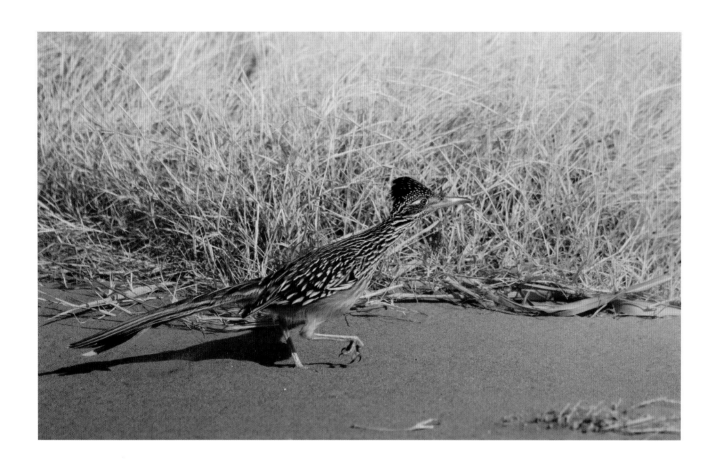

*Roadrunner in Big Bend
National Park in Texas.*

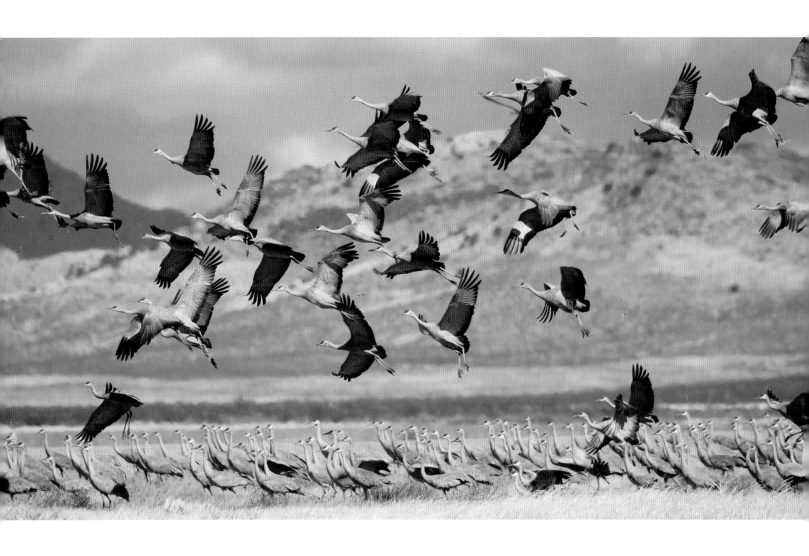

*Sandhill cranes in the
Chihuahuan grasslands.*

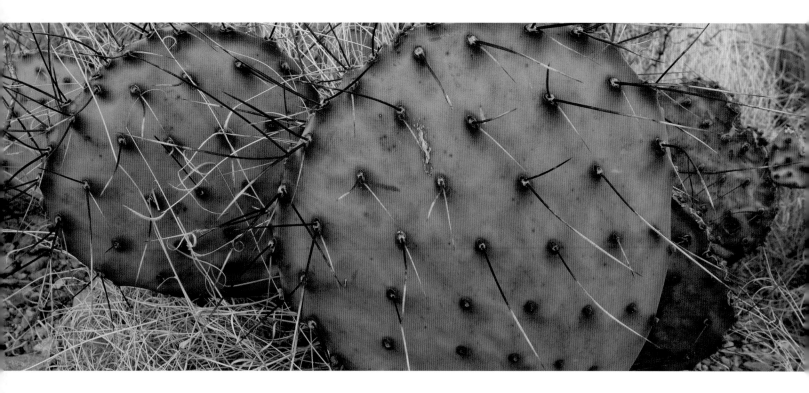

*Prickly pear cactus in Big
Bend National Park.* (At right) *Close-up on a sotol plant.*

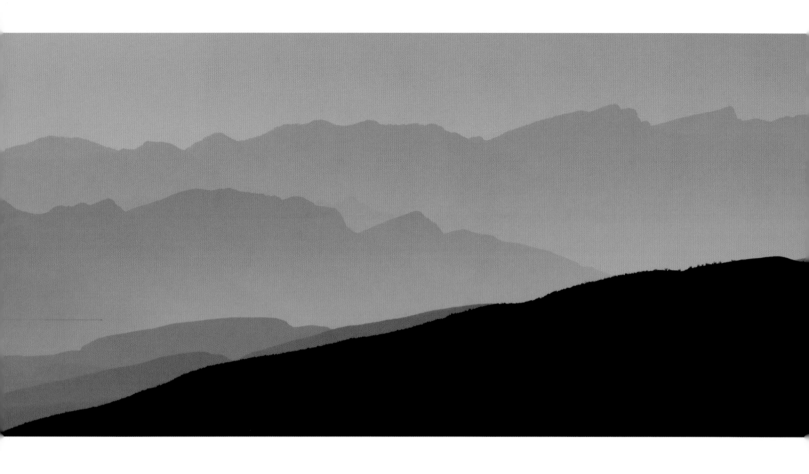

Reestablished migration
corridors between Mexico
and the United States have
allowed black bears to return
to the Chisos Mountains in
Big Bend National Park.

(At right) *Stream on its way to the Rio Grande.*

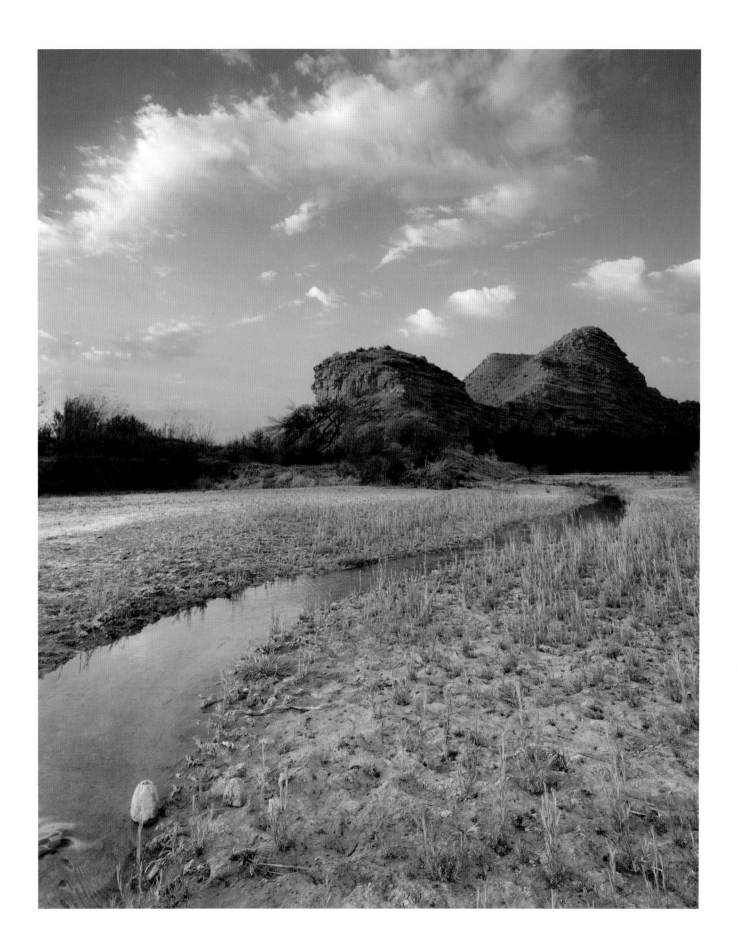

Animal tracks in the riverbed
of the Rio Grande.

RIO GRANDE

In the Lower Rio Grande Valley, late summer dew glistens on the quivering threads of a spider web draped upon the bough of a honey mesquite. On a nearby branch, a malachite butterfly dries the morning mist off its pale green wings while a buff-bellied hummingbird pauses momentarily to clean his shimmering iridescent feathers, then zooms away. And all the while, the cries of plain chachalacas, the melody of the altamira oriole, and the chatter of dozens of other bird voices fills the air. There is no morning quiet under the riparian canopy. A sudden bright burst of colors explodes from the shade of an ebony tree—a Cooper's hawk on the hunt has spooked a hooded oriole and long-billed thrasher. They find safety behind a veil of Spanish moss at river's edge, and the Rio runs past, ever hurrying to the Gulf. Such is a day in the life of the South Texas wildlands. All along the Lower Rio Grande Valley, this enchanted scene has repeated itself for 100,000 years.

This ribbon of native forest and scrub sits quite nearly at the midpoint between the tropics—which officially begin about 300 miles south—and the temperate zone, which starts about the same distance to the north. Sitting in the transition zone between these two distinct climates, the Lower Rio Grande Valley contains hundreds of species of plants and animals that do not exist elsewhere

in the United States or Mexico, and in some cases, the whole of the wild world. Like the rest of the borderlands, the Lower Rio Grande Valley sits at the confluence of several distinct natural communities. Here the Chihuahuan Desert meets the Gulf Coast, the Great Plains, and the tropics, at almost seven degrees latitude south of where the border begins in San Diego and Tijuana. This difference in latitude and a vastly different topography ensure that this borderlands region is defined by different rainfall and temperature patterns and is home to yet another unique community of wild species.

The Valley contains a collection of plants and animals so diverse, its classification can be confusing even to scientists. Trees can appear as shrubs in this transitional zone; it is a compromise habitat—offering just enough of the conditions of both the tropics and temperate regions to be hospitable to many species from both of the vastly different ecological zones. Species like the northerly American elm and the tropical Mexican olive can live in the Valley, but they grow relatively small here due to the undependable moisture and altered temperature extremes. Similarly, desert trees, like mesquite, grow much taller in the milder and wetter Valley than they do in the more arid regions further west and south.

And as it goes for flora, so it is for fauna. Ocelots stalk the thick brushlands of South Texas, one of only two places in the United States where these small cats still roam. About twice the size of the average house cat, with fur like a jaguar, this wild feline is at home in the tropics as well as in the warm subtropical habitats of the far southern United States and northern Mexico. Existing on rodents and rabbits and sometimes birds and lizards, ocelots travel areas thick with grasses or brush to keep out of sight.

Somewhere in its roamings, the ocelot may encounter another reclusive feline shadow in the thick vegetation of the Rio Grande Valley: the jaguarundi. This small dark cat possesses a stealth that makes it an extremely rare sight for human eyes; catching a

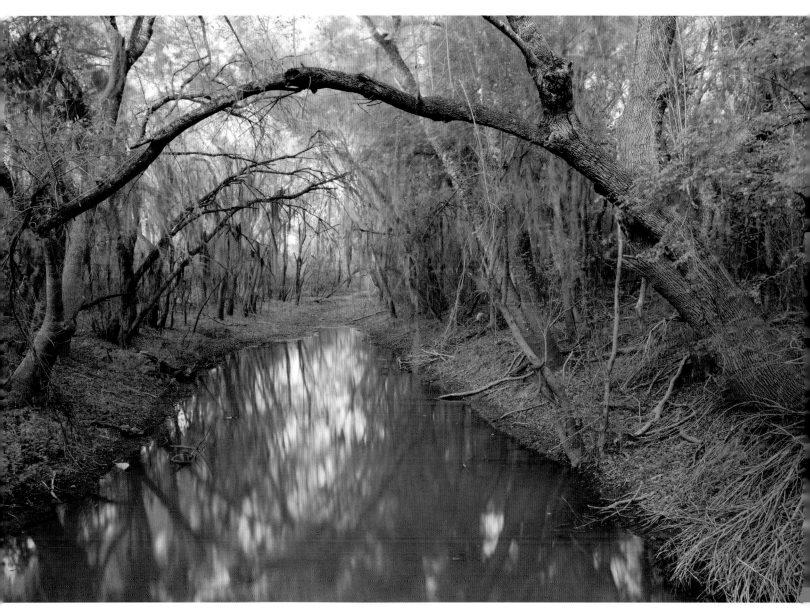

glimpse of this shy cat in the Valley would be akin to winning the wildlife-watching lottery.

Where the Rio Grande empties into the Gulf of Mexico at Boca Chica, endangered Kemp's Ridley, loggerhead, and green sea turtles dig nests in beaches, tucking their eggs away beneath a warm blan-

Side channel of the Rio Grande in the Santa Ana National Wildlife Refuge in McAllen.

A long-billed thrasher in the Lower Rio Grande Valley. The species is endemic to northeastern Mexico and South Texas.

ket of sand. Above them, shorebirds forage for invertebrates tossed onto the beach by the incessant waters of the Gulf. These dowitchers, plovers, and sandpipers are members of the fabled, megadiverse bird community that exists along the lower stretches of the Rio Grande. As Mecca draws the Muslim faithful, the Lower Rio Grande Valley draws congregations of birdwatchers. Of the roughly 900 bird species that can be seen in the United States, more than half of them spend time in the tiny sliver of native land remaining in the Valley. This incredible abundance of avian diversity—higher than any other location in the continental United States—is owed in part to its geographical position at the nexus of three different continental flyways, making the Valley a bird-loud amphitheater of winged communities. The travelers converge here in order to avoid the stress of flying over the Gulf to the east, or the desert to the west. Year-round residents, like the brilliant northern cardinal, can watch the travelers come and go, sharing a perch with a green jay, altamira oriole, plain chachalaca, or great kiskadee, all of whom can be found no farther north than South Texas. Other tropical species, like the ringed kingfisher and least grebe, join them, fishing the oxbow lakes carved by the meandering Rio Grande over millennia.

Thanks in no small part to the river, eleven distinctive biological communities are represented here, including riparian forest, wetlands, Gulf shoreline, grasslands, and mesquite brushlands. Over eons, the river deposited rich silt along its meandering banks and delta, giving rise to more than 1200 plant species, including Mexican ash, black willow, ebony trees, and sabal palms, and endemic species like the black lace and starr cacti. This lush borderlands location has grown world famous during the past few decades as people have come to recognize the rare beauty of the Valley, one of the most critical refuges for birds in the Western Hemisphere.

A green jay at the Audubon Sabal Palm Preserve.

In fact, winged creatures of all kinds gravitate to the South Texas region. Of North America's 500 butterfly species, 300 of them can be seen in the Rio Grande Valley, including many that appear nowhere else in the United States. Species like the malachite, Julia, and silver-banded hairstreak float the skies of South Texas, along with more than 100 species of dragonflies and damselflies.

All these birds and butterflies, tropical cats, and sea turtles would likely have vanished from this region decades ago if not for the efforts of the National Wildlife Refuge System and a network of conservation supporters in South Texas. This conservation effort began in the middle of the twentieth century and intensified in the late 1970s, in what could be described as a moment of panic for those who recognized the incalculable natural wealth of the region and the rate at which it was disappearing. The destruction of the Rio Grande Valley had been 200 years in the making, but the final decline was precipitously swift.

In the mid-eighteenth century, Spanish colonists arrived in the Valley to find vibrant natural communities and native peoples who had lived for many centuries as hunter-gatherers in the dense forests, brush, and grasslands of the Lower Rio Grande. The Spanish commenced, little by little, to displace the native peoples and clear the land for agriculture and herd animals. Before long, large mammals like black bears, jaguars, and other sensitive species disappeared, and the introduction of domesticated animals and the diversion of river water began to alter the dynamics of the landscape.

Historically, the Rio Grande was a river that ruled the land, periodically flooding its banks and changing course, creating oxbow lakes and wetlands, and leaving behind rich deposits of soils. The river's natural legacy supported varied habitats of tropical jungle lushness that became home to thousands of plant and animal species, including margay, Texas tortoise, and the northern Aplomado falcon. In its natural state, the Rio Grande, like the

Colorado River, was an instrumental force in the creation, destruction, and re-creation of the land. The Spanish dubbed it the angry river—Rio Bravo.

The river remained angry and the region remained sparsely populated and largely wild until the United States took control of the land north of the Rio Grande after the Mexican-American War. By the late nineteenth century, settlers and land developers began to trickle into the Valley from the eastern United States, with population intensifying upon the arrival of the railroad in the early 1900s. The new settlers and developers built channels, drained lakes, and burned forests. With the construction of Falcon Dam in the 1950s, and the Amistad Dam in 1969, the subjugation of the Rio was complete. The dams strangled the ecological functions of the river and quelled flooding that had previously hampered large-scale agricultural industry. The final blow came in the 1960s when the US government began to subsidize the burning and clearing of native vegetation.

With the government sanctioning and supporting the destruction of native habitats, those who valued the Valley's lush forests and colorful birdlife were able to do little—aside from witness the natural landscape's demise. Acre after acre of prickly pear, purple sage, and ebony were mowed down and burned, and the creatures—from ocelot to deer—that were once sheltered under the Valley's vegetation, were either killed or sent scurrying over the bare landscape in search of a place to survive. Arturo Longoria, a reporter for the *McAllen Monitor* whose family lived in the Valley for generations, described what he saw in the 1980s:

"In the wee morning hours, deer fleeing for their lives ran past me. And a group of perhaps twenty javelina wandered by looking confused and disoriented. When the first meager shades of tarnished yellow sunrise surfaced behind me, I looked on in horror at what had occurred during the night. It was as if a great monster had erased the landscape."

By the late 1980s, millions of acres of lush riparian forest and brushland had been scoured to bare dust. Species that were once fairly common in the Valley, like red-billed pigeons, Aplomado falcons, and tropical parulas became rare or disappeared altogether. Seasons of drought intensified the dust, and rains and wind eroded the bare ground. But federal crop subsidies kept farmers coming to the region, and the discovery of oil brought a new generation of developers. By the 1990s, housing development, oil, and agriculture had destroyed 96 percent of the native landscape. What nature created over eons and which had endured for millennia in balance with native people, had been erased in mere decades. Gone were the black lace and starr cactus; gone were the dense thickets that sheltered the ocelot and jaguarundi. Cactus, cat, and habitat are now in danger of extinction within the borders of the United States.

Development in the El Paso/ Juarez area has reduced the Rio Grande to a trickle in this stretch of the river.

All but 5 percent of the native habitat of the Lower Rio Grande Valley has been converted to agricultural fields and other human development.

Fortunately, as all this land clearing was happening, a group of visionary people prompted the US Fish and Wildlife Service to step up and start saving some of the brushlands and riparian forest before it, and all the wild creatures within it, were gone. Their work was cut out for them, literally cut into small pieces. Of the habitat left after industry was finished, what remained was a narrow ribbon of tattered remnants—and much of it consisted of small isolated tracts of fewer than seventy-five acres, scattered throughout the Valley. For wildlife, trying to survive on such a discombobulated smattering of habitat is like a person trying to clothe herself in confetti. Despite the challenge, the people dedicated to saving a piece of the Valley have worked for thirty years to stitch back

together the shredded cloth of valley habitat. And slowly, they have been succeeding.

By puzzling together scores of land holdings, comprising a total of 180,000 acres, the wildlife refuge has begun to create a corridor of habitat along 275 miles of the Rio Grande Valley. So critical is the conservation of this landscape to the natural heritage of the United States that the federal government has declared it crucial to maintain all existing riparian thorn forest, sabal palm habitats, and oxbow lakes in the region; additional acreage is to be restored for all the dependent species, like elf owl, gray hawk, and hook-billed kite.

In the process of mending the Lower Rio Grande Valley habitat, the Fish and Wildlife Service and private non-profits have not only endeavored to buy what is left of intact land as it becomes available, but also to purchase farmland and other disturbed land that lies between the native habitats. Those involved in conservation efforts have undertaken the arduous process of restoring the native flora to these lands so that species can travel between bits of refuge and preserve land. Local farmers have been engaged to plant native seedlings on refuge land, and to support wildlife communities within citrus groves. And because the movements of the now crippled Rio Grande were so important in maintaining the health of these ecosystems, conservation efforts have required refilling oxbow lakes and wetlands that the river can no longer reach. By mimicking the seasonal flooding of the Rio Grande, biologists simulate the wetland conditions that birds and other wildlife depend on.

Some injuries to the ecosystem cannot now be easily mended. The damming of the Rio and subsequent loss of frequent flooding has reduced the acreage of riparian forest, a habitat type essential to some birds, including rare species like clay-colored robins, gray hawks, and muscovy ducks. Without a restored river, these forests will continue to struggle and likely remain an active management project for valley conservation efforts.

Restoring such a diverse and complex ecosystem requires pains-

*A clay-colored robin in the
Lower Rio Grande Valley.*

taking attention to the natural rhythms of the region. The life-support system created on behalf of valley wildlife has been ongoing for the past three decades all along the length of the Lower Rio Grande Valley. On one restoration parcel, called the Monterrey Banco tract, refuge staff has worked for decades replanting native shrubs and trees and restoring the denuded ground into an island of habitat. Tragically, just when the refuge was beginning to function as a healthy ecosystem, and threatened species like indigo snakes and Texas tortoises were starting to again make their homes on Monterrey Banco, construction began on the border wall, and a torturous unraveling began.

A great kiskadee.

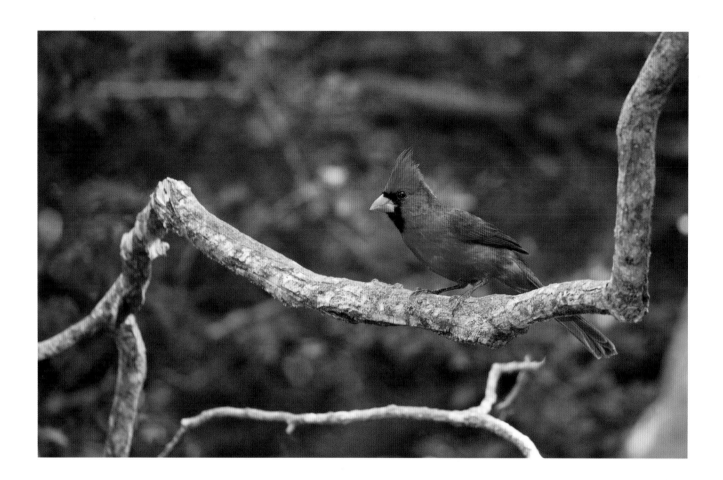

Northern cardinal.

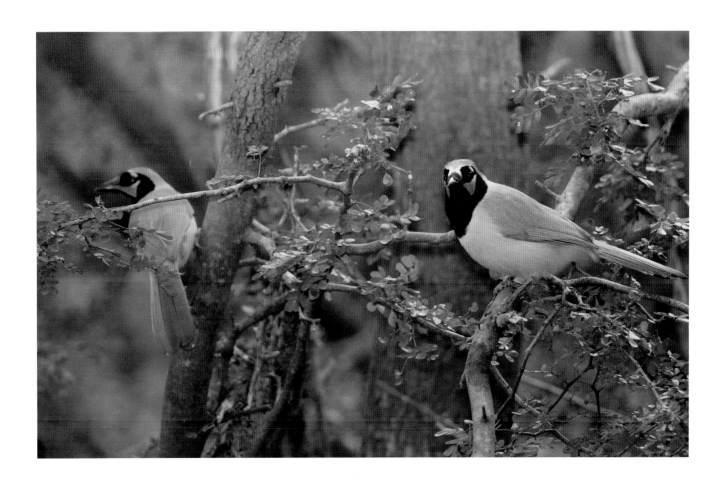

Green jays in the Audubon Sabal Palm Preserve in Brownsville, Texas.

*Wildflower in the Santa Ana
National Wildlife Refuge in
McAllen, Texas.*

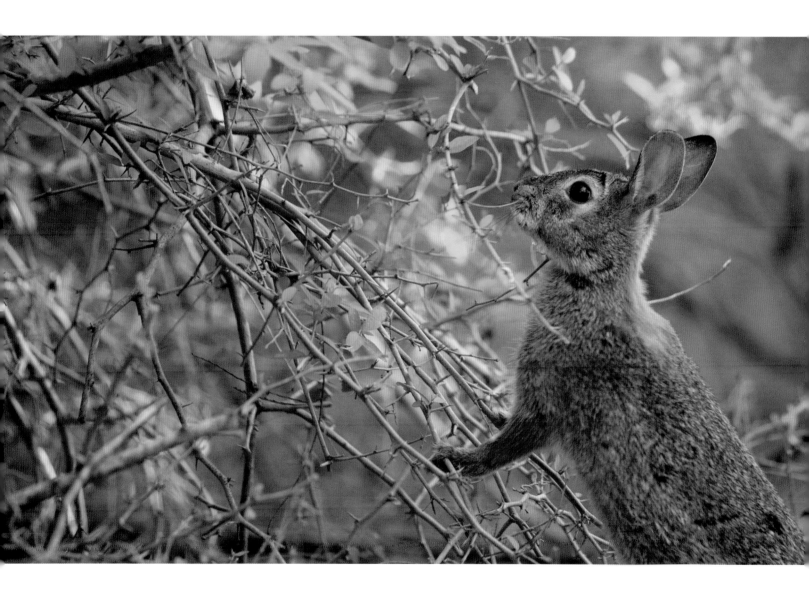

*Rabbit at the Quinta
Mazatlan preserve in
McAllen, Texas.*

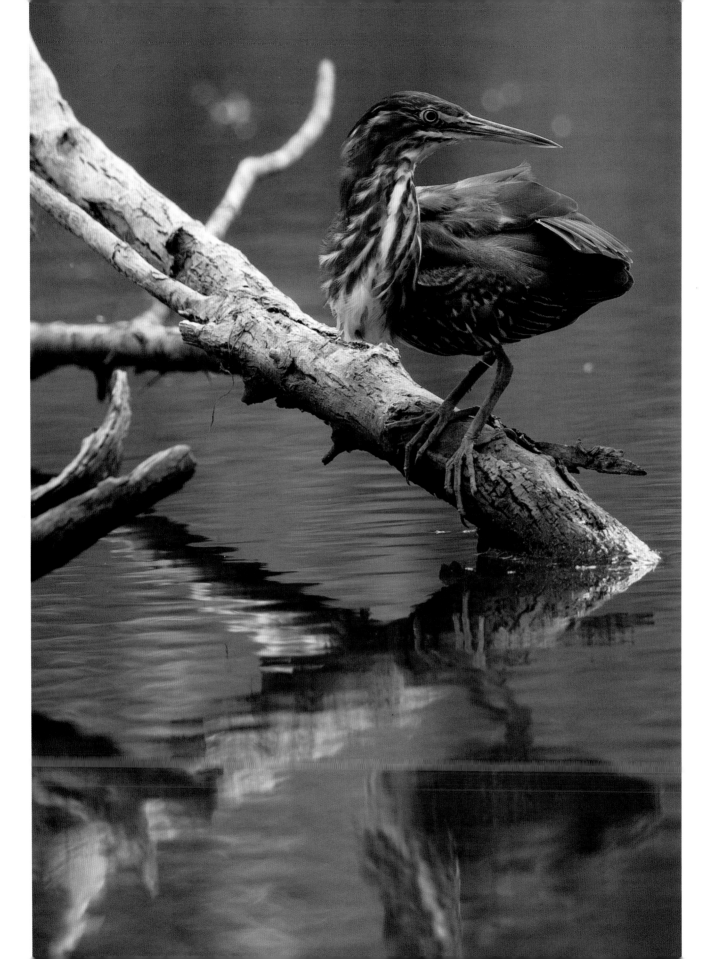

Whirligig beetles in
the Santa Ana National
Wildlife Refuge.

(At left) *Green heron at the Santa Ana National Wildlife Refuge.*

*Reeds in a Rio Grande
wetland pond.*

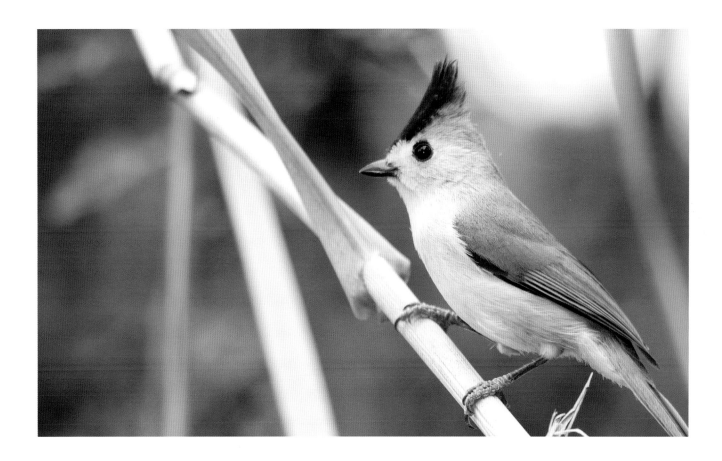

(Following page) *A ringed kingfisher perches on Spanish moss-covered limbs in the Santa Ana National Wildlife Refuge.*

The black-crested titmouse can only be seen in northeastern Mexico and Texas.

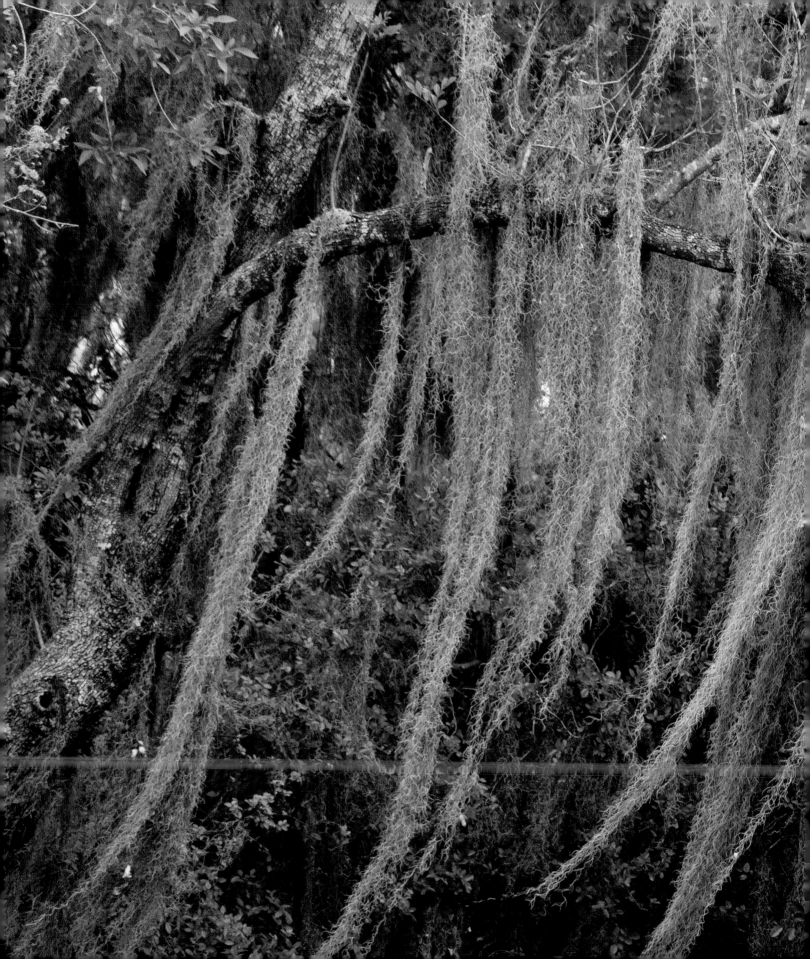

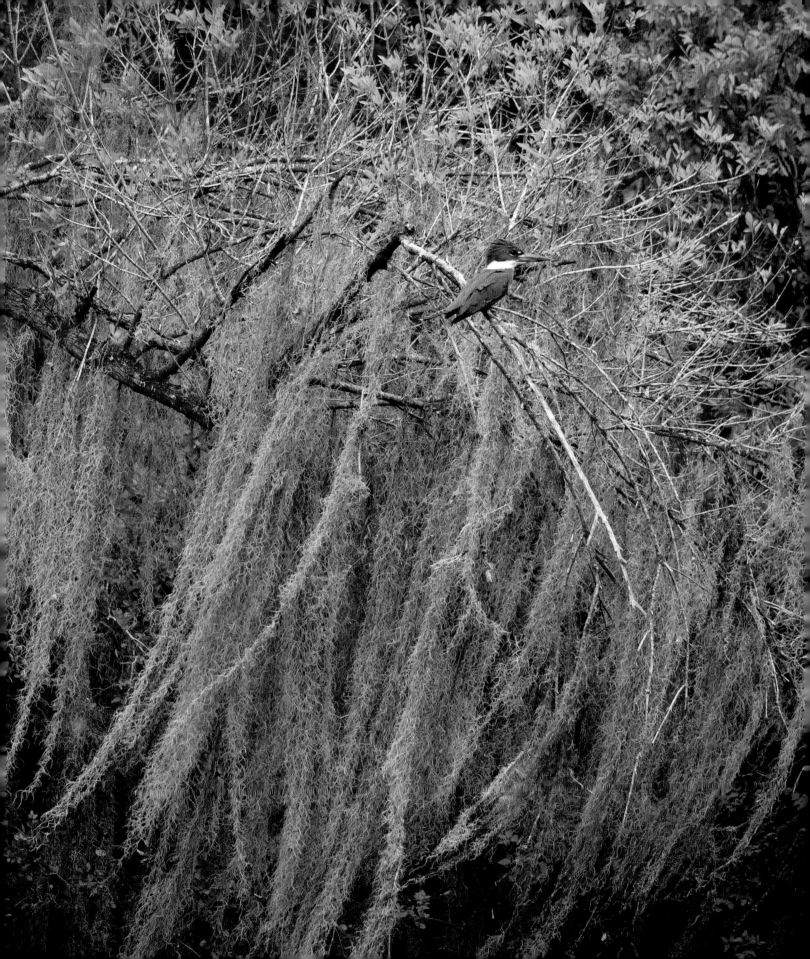

*Plain chachalaca are a
subtropical species that
cannot be seen further north
in the United States than
South Texas.*

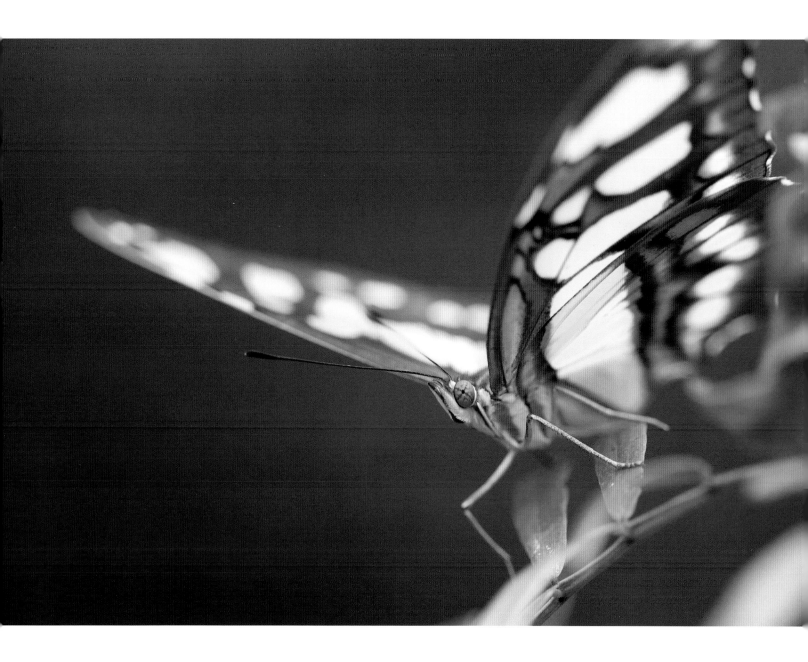

Malachite butterfly are one of more than 300 butterfly species that can be seen in the Lower Rio Grande Valley.

128

A tiny tree frog in a South Texas wildlife refuge.

*Spider web near the
Rio Grande.*

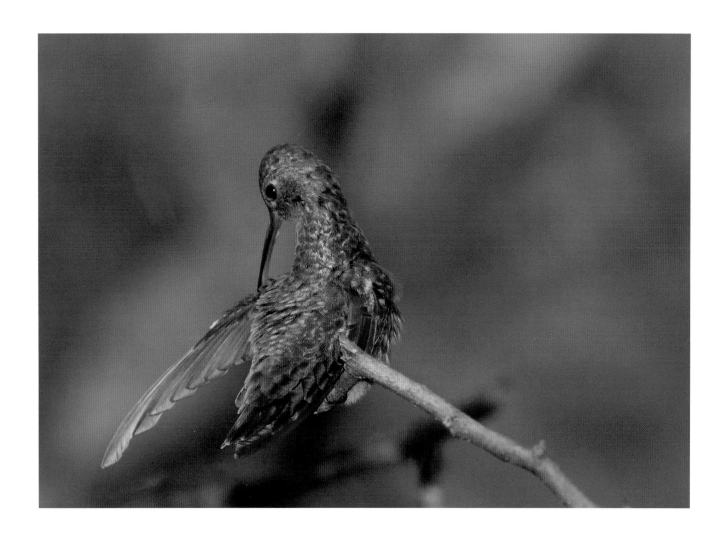

A buff-bellied hummingbird preening in the Sabal Palm Preserve in Brownsville, Texas.

An insect on a dew-laden plant in the Santa Ana National Wildlife Refuge.

Construction of border wall on the Lower Rio Grande Valley National Wildlife Refuge.

Wildlife Refuge staff Nancy Brown at a wall construction site.

THE WALL

In the Pinacate Biosphere reserve in northern Sonora, Mexico, a bighorn ram heads north. Water sources in the western Sonoran Desert are few, especially in the summer, but water persists in rare locations, including the one he's headed to a half-mile north in the Tinajas Altas Mountains in southwestern Arizona. On this trip the bighorn, one of Mexico's most endangered species, brings his lambs and mates because summer requires frequent trips to water, and the young ones have not yet learned the route. Luckily for him, the map he carries in his head of the location of water, etched deep in memory from many hundreds of trips over his lifetime, has no markings of international boundaries; the only laws he obeys are the life-and-death laws of nature.

Wild species like the desert bighorn that live in arid lands must make frequent use of scarce resources shared across the landscape. These creatures live on the very edge of existence, either by the nature of the land they inhabit, which is prone to drought and temperature extremes, or due to human disturbance, hunting, or habitat degradation.

The Sonoran pronghorn, a subspecies of pronghorn that has adapted to life in the Sonoran Desert, is a creature of two binational distinctions: it is the fastest land mammal in both the United States and Mexico, and it is also one of the most endangered. Habitat loss

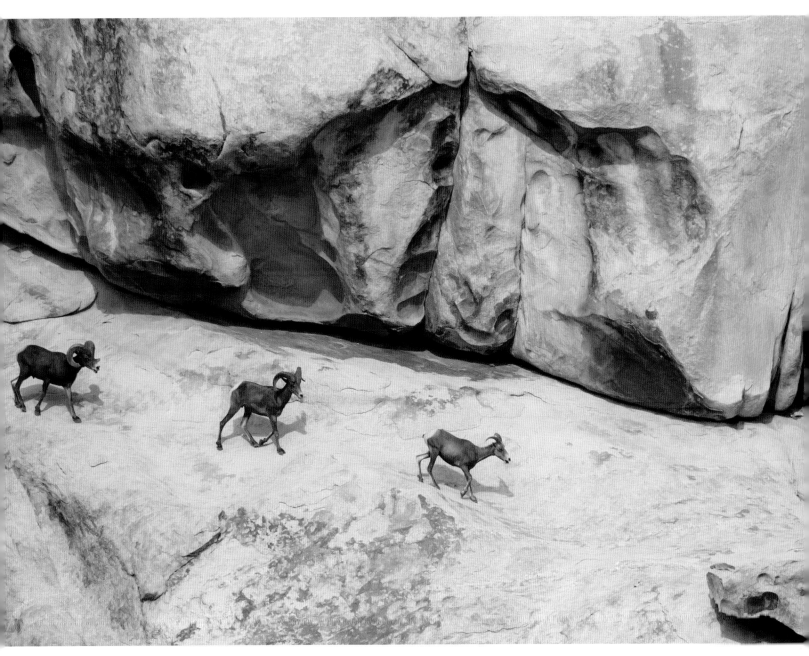

Bighorn sheep have become rare in the southwestern deserts and are nearly extinct in Mexico. The best hope for their continued survival is open travel corridors. These bighorn were photographed less than a mile from the border in southwestern Arizona.

and fragmentation from highways, livestock, agriculture, and military use of the land displaced pronghorn from much of their habitat and isolated them from others of their kind. Barely clinging to existence in the United States, the Sonoran pronghorn's greatest hopes for escaping extinction are increased connectivity to the slightly larger and more genetically diverse population in Mexico, and decreased disturbance from humans in its habitat in the States. Life for the pronghorn, bighorn, and many others hinges on two countries figuring out a way to cooperate on habitat protection and restoration of migration corridors. Instead, in 2007 the United States started building a wall that separates the bighorn from the Tinajas Altas water, and the pronghorn from its extended family living south of the border.

But the story of the border wall did not start there. US border policy began having disruptive and disturbing impacts on the wildlands of the border region in the 1990s, when the Clinton administration began a series of hard crackdowns on migrant workers coming through San Diego and El Paso. The crackdowns pushed desperate migrants looking for work—many of them farmers displaced by NAFTA—out into the deserts and other remote landscapes in the borderlands. In addition to the main target, immigrants, the policy also shifted drug trafficking routes.

The heightened focus on enforcement in San Diego did not ultimately stop or even slow migrant traffic through the southern border. In fact, due to the economic factors that have always governed migration, the number of undocumented Mexican migrants in the United States *increased* in the 1990s—jumping from about two million individuals to almost five million by the year 2000. Only now migrant traffic was coming through some of the most pristine wildlands in the country—including many lands protected by federal laws in the United States and Mexico. On federal protected lands in Arizona, arrests rose astronomically between 1997 and 2000, from 512 to more than 110,000. The National Park

Service estimated that 200,000 undocumented migrants entered Organ Pipe Cactus National Monument in 2001, compared to scattered minimal traffic in the early 1990s, prior to what the Clinton administration called, "Operation Gatekeeper."

The new approach clearly did not solve immigration issues, which only worsened as the Mexican economy continued to falter. But what this federal border crackdown in San Diego did do was create a whole array of unintended negative consequences.

The government's new enforcement policy flooded what had been quiet, mostly unpopulated lands with many thousands of people seeking passage north. Because of the increased difficulty of migrant travel, a whole criminal industry of guides, or "coyotes," emerged. The arrival of the drug and coyote industry in the borderlands was an immediate disaster. Off-road vehicles filled with people and drugs gouged new roads into fragile desert habitats. Where people traveled by foot (at times abandoned by coyotes and left to die) trails of trash, clothes, and other human waste were left. What had been a refuge for an irreplaceable community of unique plants and animals, precisely because of its isolation from human activity, was suddenly confronted with unprecedented numbers of people, vehicles, and trash. Rather than reconsider the policy, the federal government doubled-down, sending more people, more vehicles, and more chaos to the borderlands. As the government added Border Patrol agents, humvees, and helicopters, the druglords and coyotes—well funded by the demand in the United States for both drugs and cheap labor—responded in turn with more sophisticated strategies, and even more isolated pathways. Thus began a contest of escalating measures that has endured for more than fifteen years.

While this battle raged on, one of the continent's most endangered species, a creature whose only hope to survive on this Earth is peace and quiet and open country, silently plummeted toward oblivion. By the 1990s, the Sonoran pronghorn population hovered

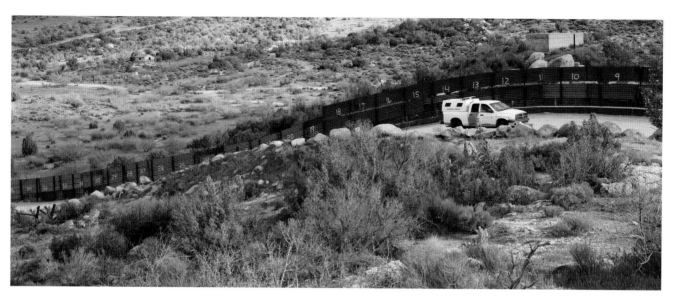

Border patrol and wall in southern California.

at about one hundred individuals within US borders—already a dangerously low level in terms of both raw numbers and the scant genetic bank that it represented. In 2002, the pronghorn's population had crashed, and only twenty-one individuals remained. The US Fish and Wildlife Service said the border crisis was likely a primary factor, creating frequent disturbance and stress on the pronghorn during a period of prolonged drought.

The pronghorn is just one of many examples of wild creatures and habitats being upended by the impacts of US border policy—from jaguar and bighorn, to desert fishes and saguaro cactus. Places like the San Pedro River corridor, a critical travel route and water source for a whole region's wild creatures, became an unofficial port of entry for migrant workers and drugs. Illegal roads polluted desert streams containing some of the last populations of imperiled desert fish. Endangered plants on public land that had been specifically designated to protect them were being trampled by migrant foot traffic. The cat-and-mouse game led Border Patrol to build more and better roads through remote wilderness, creating new dangers for wildlife as smugglers and Border Patrol alike used the roads for faster passage.

In time, the chaos of the conflict between Border Patrol and smugglers had escalated so far, that the land itself became a victim. The most minute and invisible creatures of this ecological region cannot even be seen and are unknown to most who travel here, yet they are at the base of the borderlands food chain. The bare ground in much of this landscape is alive, filled with a diverse biotic community of fungus, algae, and cyanobacteria that are eaten by slightly larger communities of mites, snails, and millipedes, and so on up the food chain. When intact, this base layer of biotic life holds the ground in place, but when it is disturbed, wind can whip the ground into dust clouds. Footprints and tire tracks may not heal for decades or even centuries.

Operation Gatekeeper and subsequent policy initiatives removed regulations guarding protected areas from off-road vehicle traffic, and the scars of Border Patrol vehicles began to slice through even the most isolated land in national wildlife refuges and parks. Between the Border Patrol and the smugglers, hundreds of miles of illegal roads were gouged into the land. Off-road activities became so pervasive in the Cabeza Prieta National Wildlife Refuge—once a remote wilderness of desert set aside for shy wildlife like the pronghorn and bighorn—that scars on the landscape could be seen from space.

In time, the air, the earth, and everything in between became impacted by the Clinton administration's decision to funnel undocumented migrants through isolated natural areas of the borderlands.

But it was about to get much, much worse.

The borderlands represent an immense area, and scattered piles of trash can easily be picked up. And in time, if a very long time, scars from illegal roads do heal. But there are some wounds that wildlife and wildlands cannot adapt to or heal over.

Following the fearful aftermath of the 9/11 terrorist attacks, the US Congress approved a series of laws that would undercut

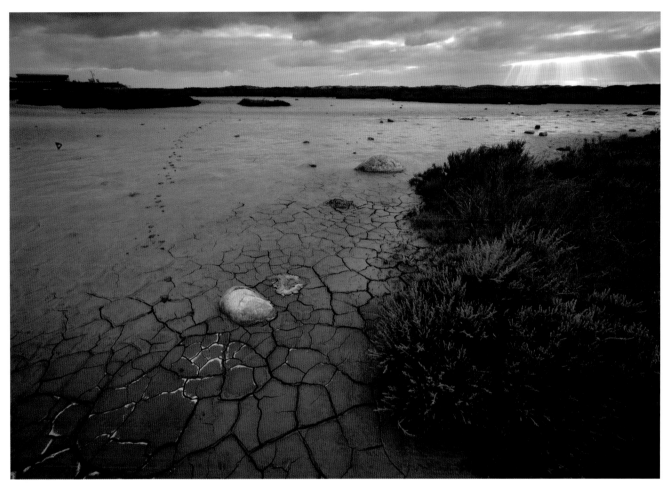

The Tijuana estuary is a recognized as a wetlands of critical global importance. Construction of the border wall and the waiving of environmental law have jeopardized the balance of this ecosystem by dumping excessive silt into the watershed.

the very foundations of environmental protection and ecosystem dynamics in the borderlands. In 2005, the Real ID Act gave the Secretary of the Department of Homeland Security (DHS) the authority to waive all laws—every democratically created law on the books—in order to expedite the building of a border wall in San Diego. The impetus was to speed construction by skirting environmental laws.

Then in 2006, Congress enacted the Secure Fence Act, requiring the construction of 700 miles of wall and other infrastructure along the United States' southern border. Secretary of DHS

Michael Chertoff took the opportunity to extend the authority given in the 2005 Real ID Act to waive all laws that would have governed the building of a US-Mexico border wall. The practical impact of Chertoff's actions was to remove all input that the public and conservation science community might have had, and to nullify some of our nation's most critical environmental safeguards like the Endangered Species Act, the Clean Air Act, and the National Environmental Policy Act.

To those unfamiliar with environmental law, the significance of Chertoff's dismissal may be hard to measure. The National Environmental Policy Act (NEPA) of 1970 was crafted as a response to several environmental disasters that occurred in the preceding decades, including the Santa Barbara oil spill in 1969. Many people believed these disasters could have been avoided if actions had been guided by environmental science and public input, so Congress created NEPA to ensure that federal agencies understood and considered all relevant environmental information before undertaking a project. The intent of the law was to avoid or minimize negative impacts, while at the same time keeping citizens informed and allowing opportunities for input.

Likewise, the Endangered Species Act, signed into law by President Richard Nixon in 1973, was meant to provide a safety net for the thousands of wild species made vulnerable by human activity. The law and a whole suite of environmental legislation in the early 1970s was the result of a consciousness that had been growing in the minds of the American people for almost a century, starting with the extinction of the passenger pigeon and the near extinction of the American bison, whooping crane, and scores of other wild species.

By disregarding NEPA, the Endangered Species Act, and dozens of other laws critical to the continued survival of wild species and their habitat, the Department of Homeland Security was able to speed construction of the border wall through hundreds of miles of

sensitive habitat, national parks, wildlife refuges, and wilderness—effectively cutting off animal migration paths and destroying thousands of acres of habitat all along the borderlands with new roads and construction scars. Chertoff's dismissal of law meant stripping the dozens of endangered species that live in the borderlands of their most basic protections, the protections that have in countless instances during the past forty years saved vulnerable species like the bald eagle and the California condor from certain extinction.

Following the passage of the Secure Fence Act, as Border Patrol began the process of building the wall, dozens of miles of roads were cut through the steep slopes of roadless wilderness southeast of San Diego, which unleashed mountainsides of silt and other debris on the watershed of a critical estuary in coastal California.

In 2007, as the Department of Homeland Security began building barriers in the San Pedro River corridor, Defenders of Wildlife and the Sierra Club sued to stop construction; they won a temporary restraining order in federal district court. But Secretary Chertoff invoked his legal waiver authority and dismissed all the laws that the judge had cited in the case, and the government continued building the wall to the banks of the San Pedro, right through the riparian corridor protected by the Bureau of Land Management and the grasslands and foothills of the Coronado National Monument.

In the Arizona desert, on protected public land stretching from Yuma to Nogales, the government erected a steel wall impenetrable to terrestrial creatures right in the heart of Sonoran pronghorn habitat. The lack of funding or a mandate for scientific study has made documentation of the impacts of this wall woefully incomplete, but simple observation has shown that they are severe. In the Organ Pipe Cactus National Monument, Sonoran toads have been observed and photographed jumping repeatedly against the border wall until they either died of dehydration or were taken by predators. Similar behaviors have been documented in the whip snake. Biologists have observed bobcats killing other bobcats over shrink-

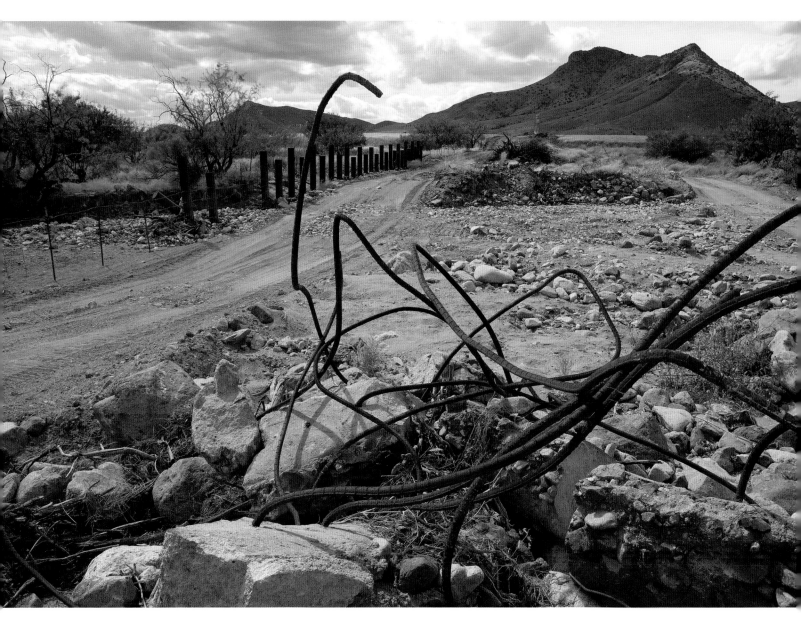

*Construction of wall on the
Coronado National Memorial
in Arizona began in 2008.*

ing territory resulting from wall construction. This same land fragmentation has caused other bobcats to be killed on highways as they sought out usable habitat in the Valley.

The impacts on species like bighorn sheep, pronghorn, mountain lions, fox, deer, and other four-legged animals is simple to surmise: creatures already struggling to survive on a landscape fragmented with roads, ranches, fences, and housing development will be further obstructed from food, water, mates, and habitats by a wall that in most places is between fifteen to eighteen feet high. I myself have seen wildlife pacing along the wall, including javelina and cottontail rabbits. Others have photographed similar behavior by mule deer, snakes, lizards, and toads.

Surprisingly to some, the border wall may also constrain the movements of low-flying birds, bees, and butterflies. Scientific studies have shown that species like the endangered cactus ferruginous pygmy owl rarely fly at elevations higher than twelve feet. In addition, they and many other flying species are reluctant to fly across land that has been cleared of vegetation, as is the case all along the border where barriers have been constructed.

A Sonoran desert toad, dead at the border wall in Arizona. © Carianne Funicelli Campbell

A coachwhip snake at the wall in Arizona. © Carianne Funicelli Campbell

In South Texas, where habitat itself is endangered, the problems with a border wall are compounded. So little of the brushlands and riparian forests remain (and in such small pieces) that further fragmentation will pose a dire reality for both wild communities and the people who have been trying to save them.

For the ocelot, trying to navigate between scattered pockets of habitat is essential, but in many places eighteen feet of concrete now slice through corridors that offered some hope of access to viable habitat. Additionally, this population is so small that it relies on connectivity with cats from south of the border where pockets of habitat provide for a healthier population of ocelots. Access to these cats for mating and genetic diversity constitutes an essential element in ocelot recovery in the United States. A border wall will curtail their movement and healthy reproduction, and could ultimately seal their fate.

The natural and essential process of animal migration, a key component of wildlife survival and evolution, now hangs in the balance. All over the continent and in the borderlands, fragmentation of habitat poses one of the greatest challenges to the survival and restoration of wild species. And though there has been little study

of the impact of politically motivated walls on wildlife movement, one study conducted on a red deer species in Germany suggests the impacts of land barriers may be felt by species for generations, even after the barrier is removed. Scientists put radio collars on deer near the border of Germany and the Czech Republic, the former site of the Iron Curtain fence that blocked Eastern Europe from the Western world. Much to the researcher's surprise, even though the study animals had never encountered the actual physical barrier, the collars showed that the deer would approach the former fence site, but they would not cross it. The scientists speculated that the deer had inherited behaviors and an understanding of the landscape that remained ingrained and restricted their movement twenty years after the Berlin wall fell and the barriers were removed.

What will happen with a US-Mexico wall, a much more extensive and potentially much more long-lived barrier? This wall, if it is finished along the entire 1952-mile border (as is proposed by some members of Congress) will be a barrier that passes through an entire continent, and it could not have come at a worse time.

As droughts in the Southwest become more common due to global warming, the wall's harm to borderlands species will grow, and not just to animals. Studies of the hoarded belongings of pack rats, who may inhabit dens thousands of generations old, show that saguaros have moved north during the past 10,000 years, as have creosote, mesquite, ironwood, and other plants, as the climate grew warmer and drier. Normal climate cycles of the Earth are slow and gradual, giving plants and animals time to adapt, but the current rapid buildup of greenhouse gasses may speed this process, possibly drastically reducing the time available to flora and fauna for migration and adaptation.

For saguaros and other cacti, migration depends on the movement of seed distributors like the javelina. Thus, if a javelina can't migrate to viable climates due to a wall, neither can the cactus that it carries. What will happen to the statuesque saguaro, icon of

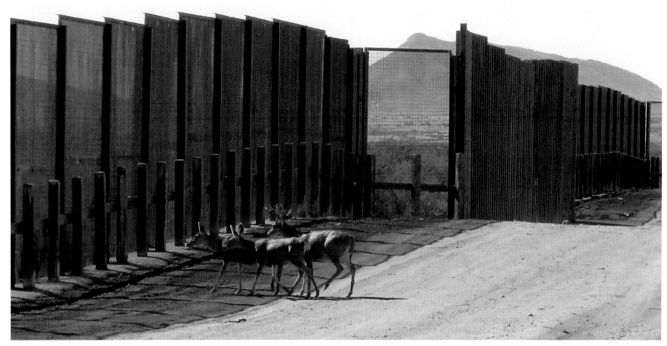

Mule deer at the border wall in Arizona. Anonymous

the Southwest, if, within the rapidly changing current climate, it is blocked from moving northward? What will happen to the jaguar, ocelot, and javelina, the bighorn sheep and the Sonoran pronghorn, the bobcat and pocket mouse?

This land is always in flux. The current plant makeup in the Sonoran Desert has been stable for less than 10,000 years, and changes are likely on the horizon. A barrier like a mountain can create a desert. But what is the impact of the sudden arrival of a great wall within a desert that is experiencing rapid warming and prolonged drought conditions? Though we look at nature in pieces, a landscape is really a whole being, with individual components working together, each playing its part. A wall through an ecosystem can act as a tourniquet, severing, slicing, and constricting vital dynamics. We know that the wall may cause serious, lasting harm to the biodiversity of the region, but, by dismissing the value of environmental law and science, the legal waiver ensured that

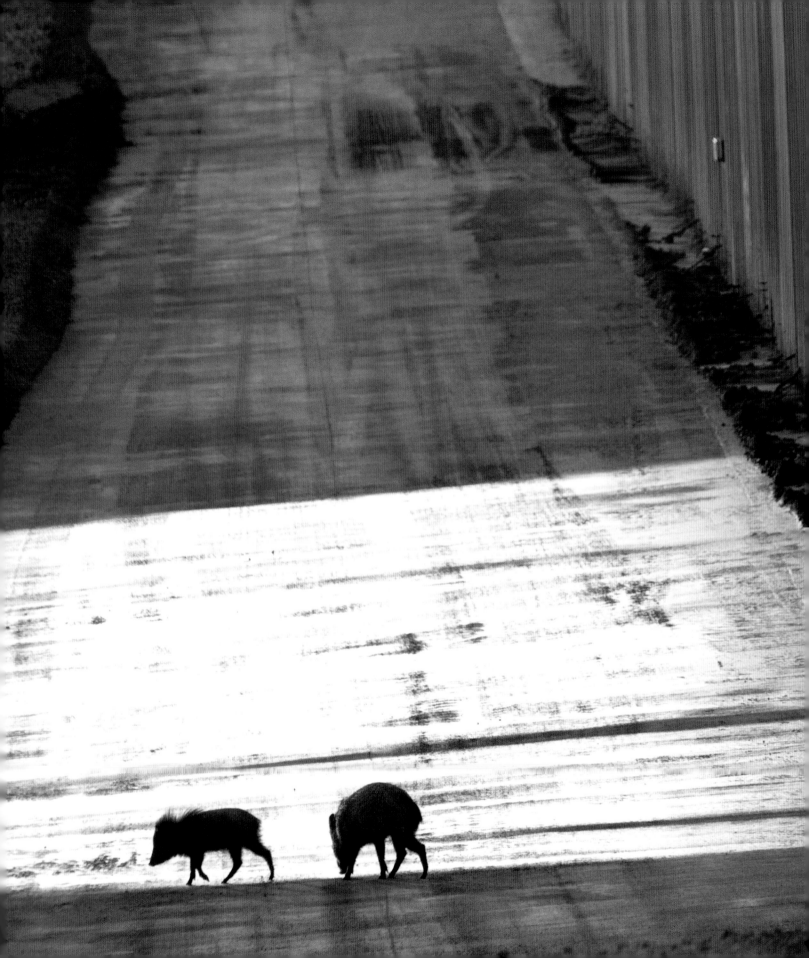

After traveling the US-Mexico border wall for 100 yards, looking for a place to cross, these javelina turned away. This stretch of wall in Arizona bisects the San Pedro River corridor, one of the last free flowing rivers in the state and a haven for wildlife traveling north and south.

precautionary studies would not be done. Consequently, we are now left guessing and scrambling to mend the wall's impact on the future of wild creatures and habitats, exactly the situation environmental laws were crafted to avoid.

Unfortunately, we do not know the specifics of the long-term implications of the wall on borderlands ecosystems, but we know enough about ecosystem dynamics to make a guess. Once undercut, an ecosystem's natural tapestry begins to fray. Threads of borderlands cloth have already begun to unravel. Sonoran toads and whip snakes are stranded at the wall, javelinas pace along its length looking for passage, and hillsides are eroding at the base of the wall, sending silt into the watershed. And this is just the beginning. The first threads to be completely severed on the north side of the wall will likely be those already thinned by habitat loss and hunting—the jaguar, ocelot, and jaguarundi, three of North America's six cat species, all of which are critically endangered. South of the cut, as global warming advances and droughts intensify, more of the ecological fiber will weaken. Without the ability to migrate north, creatures who cannot adapt to changing conditions will perish. Javelina, critical to ecosystems as prey species and seed distributors, will be denied passage to more appropriate climates. They and the plants they carry will likely face localized extinctions. And the birds, rabbits, and other creatures that rely on those plants for food will be left searching.

With history as a guide, the prognosis for an ecological community enduring multiple environmental stresses is grim. About 10,000 years ago, facing the simultaneous pressures of a changing climate and human hunters, two-thirds of North America's large mammal species went extinct. This massive extinction event occurred when significant changes in the land and climate stressed wild communities to the breaking point. We never know what the breaking point will be, or whether it is happening all the time, but for certain, with borderlands communities already facing climate

change and human development, a massive barrier through the entire continent could be the straw that breaks the jaguar's back.

The wall now covers only about one-third the length of the border, undercutting the ecological integrity of the borderlands, but not fully severing it. What becomes of the natural communities of the borderlands depends on what happens next. Do we work to mitigate the damage that has already been done by the wall and by harmful borderlands policy? Or do we spend billions more building the wall along the entire length of the border, a wall that not even the people building it believe is going to stop people from crossing. Some members of Congress are demanding more wall; in fact, some vocal members of the Republican Party propose building two parallel walls, several dozen feet apart, along the entire border. They also want to reduce even the minimal amount of input that wildlife scientists have in borderlands policy. One 2011 proposal, HR 1505, introduced by Rep. Rob Bishop of Utah, would allow the Department of Homeland Security to waive all environmental laws within one hundred miles of any border of the United States, in effect nullifying environmental protections for entire states and dozens of national parks, wildlife refuges, and wilderness areas. Another proposal, from Arizona senators John McCain and Jon Kyl, would castrate the Departments of Agriculture and the Interior within 150 miles of the southern border—giving DHS ultimate authority in this vast region. Whether or not these laws are passed, they represent a prevailing mindset in Congress that continually threatens the fragile web of life that exists in the borderlands.

From the greatest to the least of the natural inhabitants of the borderlands, from mule deer and Mexican gray wolf to monkey spring pupfish and fairy shrimp, all move quietly along the very precipice of survival. All have been here since long before the time of the current political boundaries and predicament, and all are now tied to its fate.

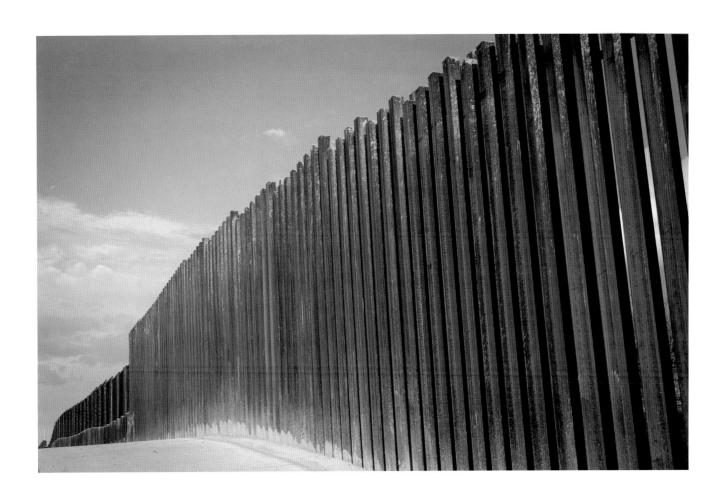

Border wall near the San Pedro River.

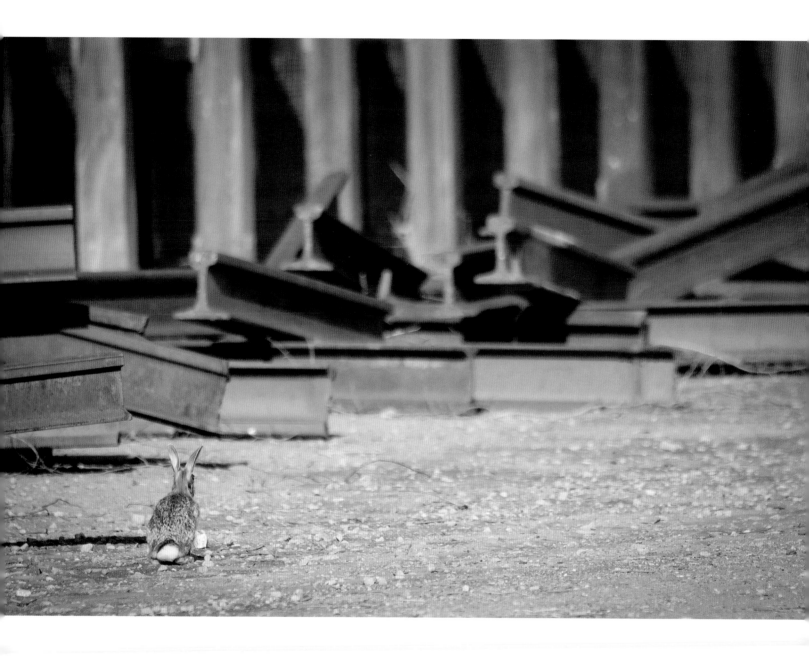

Desert cottontail at the border wall during construction in southern Arizona.

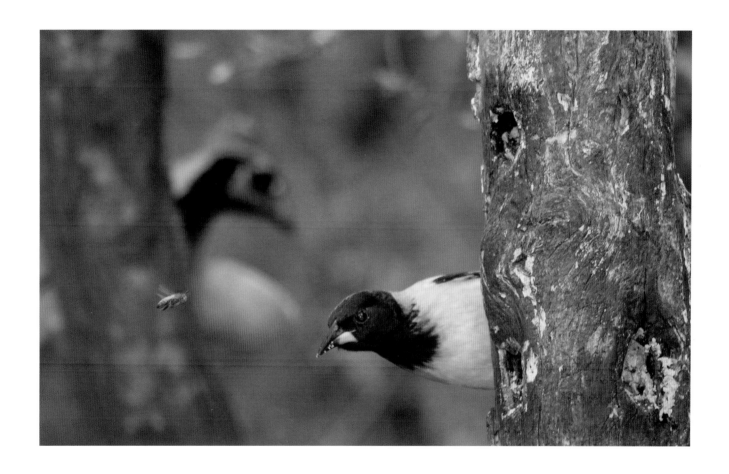

The wildlife refuge system
and private organizations
have spent millions of
dollars stitching together
native habitat for wildlife.
Habitat fragmentation
and destruction from wall
construction has begun to
unravel their decades
of effort.

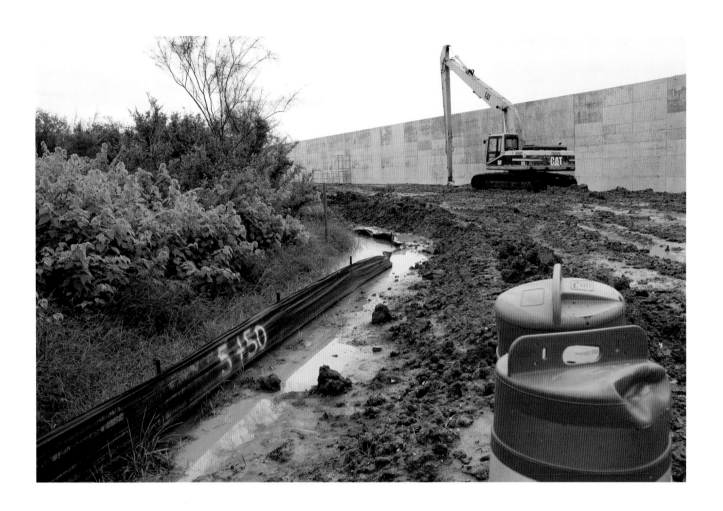

*Border wall construction in
the Lower Rio Grande Valley
National Wildlife Refuge
destroyed and fragmented
critical habitat for wildlife.*

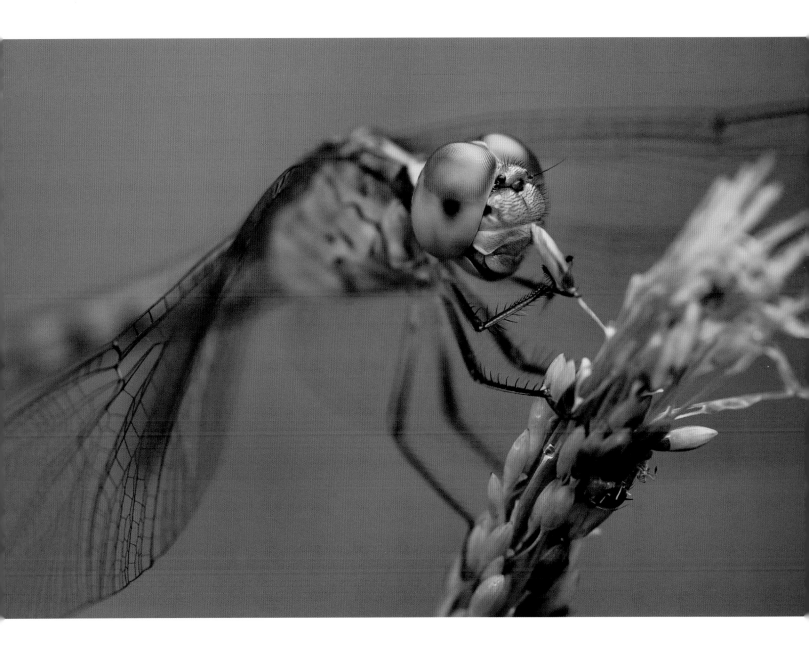

The Lower Rio Grande Valley is home to hundreds of species of dragonflies, in addition to a high diversity of birds and butterflies, all dependent on the last remaining 5 percent of native habitat left in the Valley.

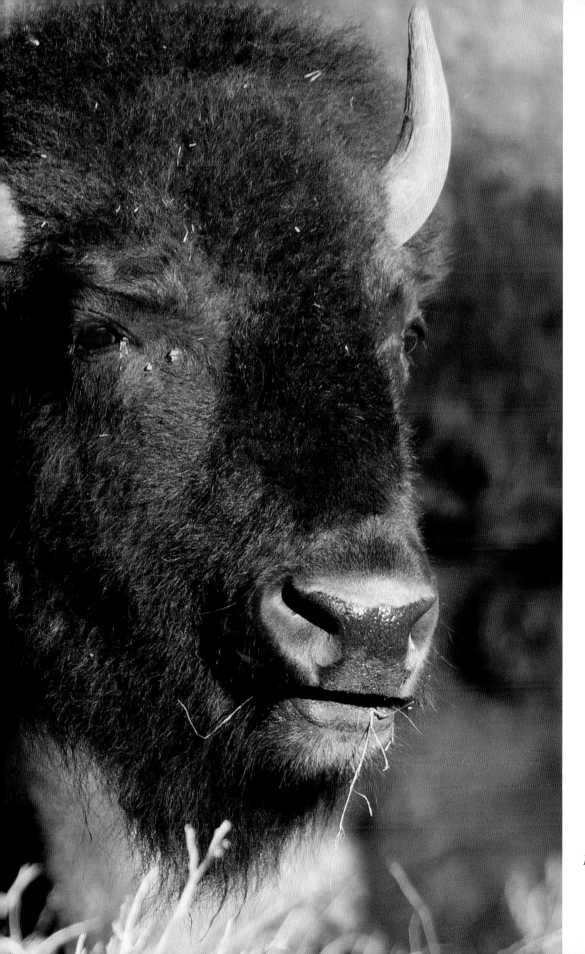

Bison in Janos, Chihuahua.

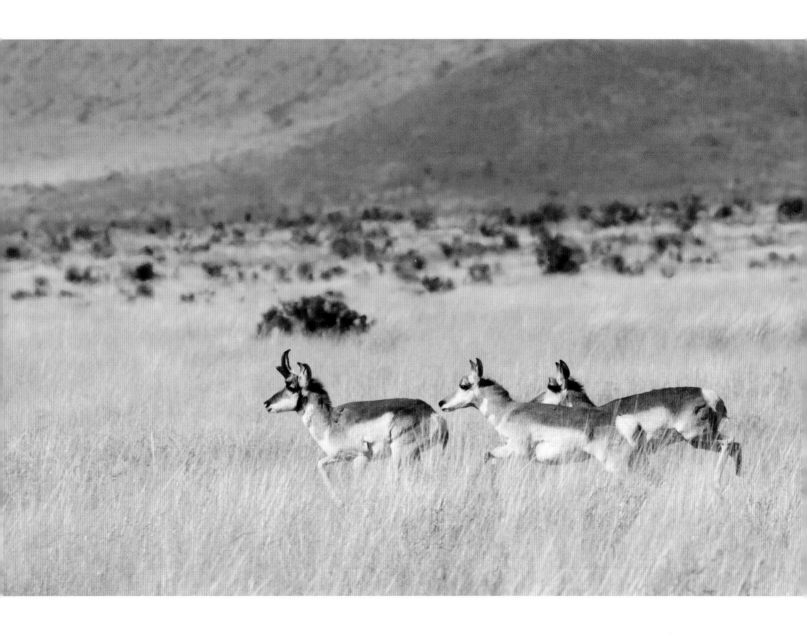

(At left) *The border fence in 2008 where the Janos-Hidalgo bison herd crossed between food and water resources daily.*

Pronghorn running in the Chihuahuan grasslands in Texas.

Vehicle barriers like this one constructed in 2009 between New Mexico and Chihuahua present no real challenge to humans, but it will make passage by most large mammals impossible, including the Janos-Hidalgo bison herd.

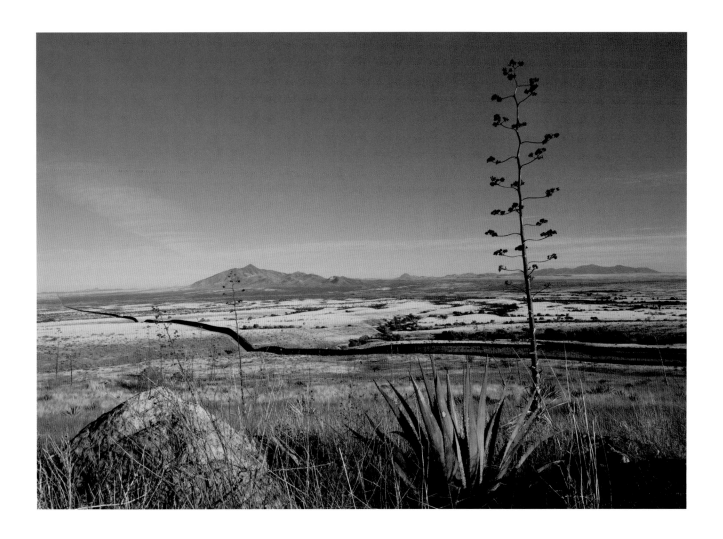

The border wall now
bisects the grasslands of the
Coronado National Memorial
and San Pedro River corridor.

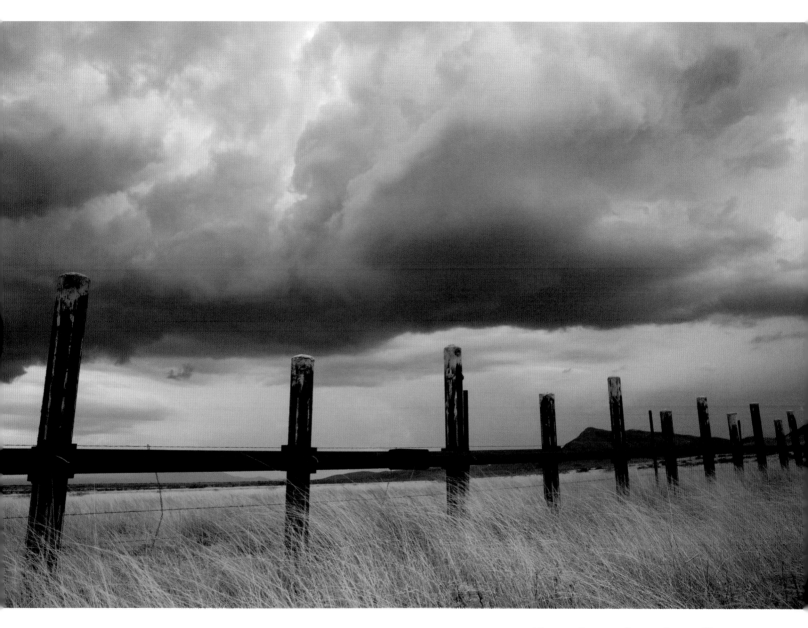

Alternatives to damaging wall or vehicle barrier are available, like this vehicle barrier that used to stand in the Coronado National Memorial. This barrier was replaced by solid wall in 2008.

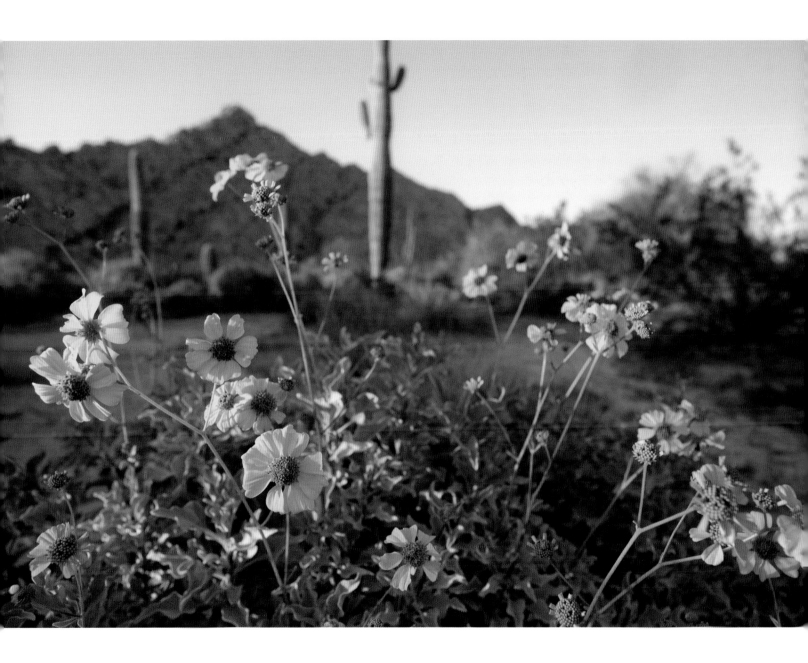

(At left)) *The Sonoran pronghorn struggles to survive on a fragmented landscape. The Cabeza Prieta Wildlife Refuge supports pronghorn and other species with supplemental water.*

The Cabeza Prieta National Wildlife Refuge.

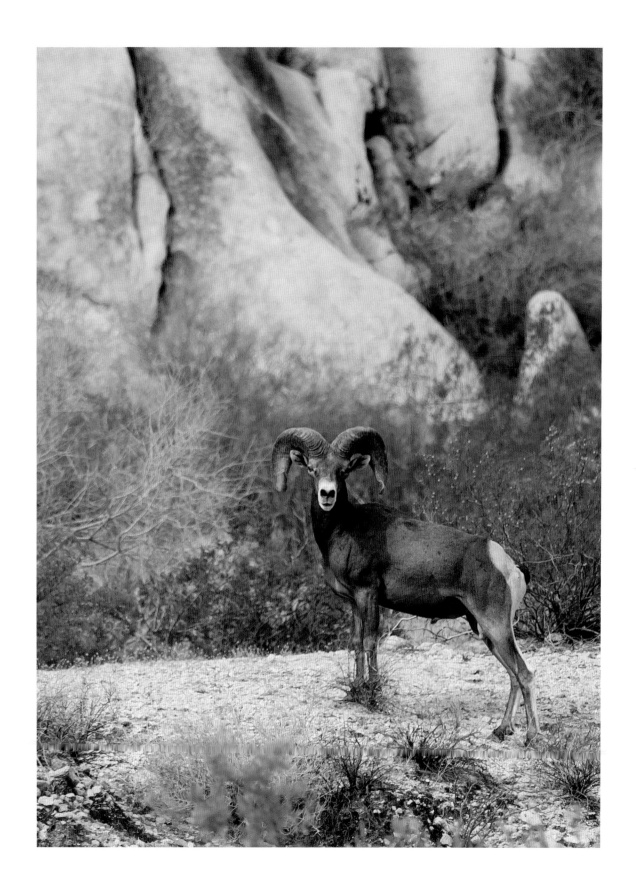

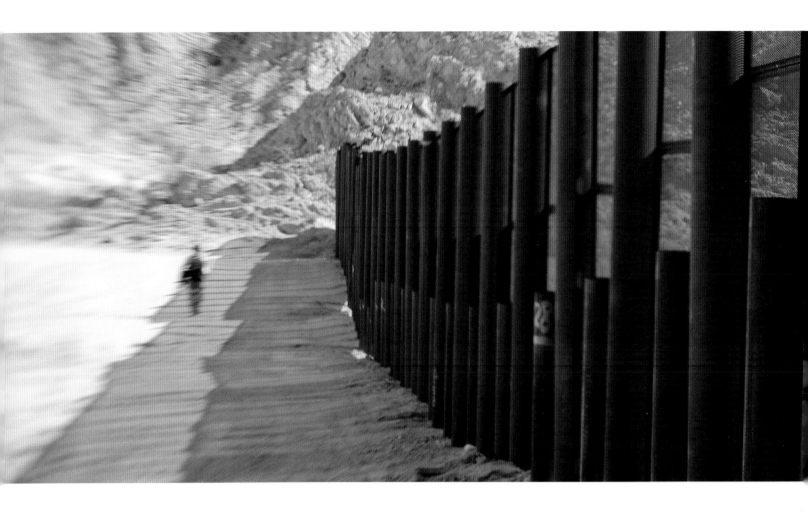

(At left) *Bighorn sheep are one of Mexico's most endangered species. Connectivity with the larger population of desert bighorn in the United States is critical to the sheep's recovery in Mexico.*

The border wall now divides habitat and water resources in Mexico and the United States for bighorn sheep, pronghorn, and many other species.

PEOPLE OF
THE BORDERLANDS

Noel Benavides walks a trail through a brushy forest of mesquite and ebony on a steamy September day in South Texas. An entourage of dragonflies colors the low brush where he passes. Where the trail ends, a clearing in the forest reveals the Rio Grande ambling to the southeast. Across it, within conversational distance, is Mexico. Noel, twirling a blade of grass in his hand, gazes out on the water and the far bank. His silence hovers, suspended somewhere within the thick summer air between two nations, anchored with sad apprehension, because, as for so many borderlands residents, what lies across this river represents something quite different to Noel than it does to most people in the United States.

For Noel and his wife Cecilia, this is the place where grandchildren play during family reunions, where decades ago their children and nieces and nephews made up games along the river banks, where Cecilia's parents and grandparents and great grandparents counted the passing of years and planned the future of the Ramirez family.

Noel and Cecilia and their family have been tied to this land—150 acres at the edge of the Rio Grande—since it was deeded to Cecilia's ancestors almost 250 years ago. The deed was signed not by the governor of Texas, but by the King of Spain. Since then, through ten generations, their family has been intermittently sub-

jects of the Spanish Crown, the Republic of Mexico, and the United States of America. But the land has always been for family, and the river at its edge has always been a waterway to more family on the other side.

This family plot has weathered political storms that have blown in and out of the region, upending the concept of nationality on more than one occasion. From the Texas Rebellion, to the Mexican-American War, to the US Civil War and the Mexican Revolution, political disputes have long embattled this location. And today is no exception. Noel points north to the levy almost two miles away, where the US government plans to build a border wall, essentially taking all of the land between the levy and the spot on which he stands, by eminent domain. Construction of the wall—eighteen feet of concrete meant to stop immigrants from entering the country without permission—will turn Noel's family land into a no-man's-land between the actual US-Mexico border at the Rio Grande and the effective border two miles north at the wall. All access to the river will be cut off.

For the US government this spot holds little meaning other

Noel Benavides and his wife Cecilia own land on the Rio Grande that has been in their family for 250 years. The Department of Homeland Security is taking a portion of his family land to build the border wall.

than as an enduring reminder of its failure to craft a workable relationship with Mexico. For Noel, it is a family treasure. Though he has fought a long battle against the seizure, before long he will lose, and the government will take his land.

Many in this valley are in a similar predicament, including Eloisa Tamez whose ancestors were deeded their land around the same time as Cecilia's. Descended from Lipan Apache and Basque settlers, Eloisa dates her family's presence on this land along the river to 1767. When she received a letter from the US Department of Homeland Security stating that she must sign over a portion of her family land so that the government could build a wall through it, she refused. When the government proceeded to take the land by eminent domain, Eloisa sued. She lost, and trucks showed up on her land within forty-eight hours of the lost battle, building a wall that now cuts Eloisa off from the riverfront half of her ancestral land.

Noel, Cecilia, and Eloisa in many ways typify the unique brand of US citizen that can be found here along the banks of the river. The oldest Texas families claim a connection to this land that predates the United States' existence as a nation. Their ancestors had been raising cattle or farming in the Rio Grande Valley for a hundred years before the ancestors of most US residents even entertained the idea of leaving their homes an ocean away. These families hold a memory of the land and its history that is essential to the story of this country. Like the green jay, whose bright tropical colors bring a piece of a far-away place to the United States, the deep human roots in the borderlands hold a piece of a far-away time. It is the kind of connection to the land that ignites questions of ownership, not the kind of ownership expressed on legal paper or by armies defending national borders, but a philosophical ownership of the land by those who have inhabited it longest, and who carry the most deeply rooted memories of its past. In the borderlands, even the oldest of human ties to this land persist in traces—a shard of pottery, the eroded ruins of an adobe home, sea-

shells in packrat dens. Within the vitriol that currently surrounds the issue of immigration and border enforcement, we tend to forget: many people lived and died on this land long before it belonged to the United States, and some of their descendents are still there weathering the foibles of federal policy.

History and Prehistory

In 1686, Spanish explorer Alonso de León found trails carved through the thick forest of brush that enveloped the Rio Grande and surrounding delta valley. It was through these trails that native people of the broader South Texas region, who are sometimes collectively referred to as *Coahuiltecans,* traveled, hunted, and traded with surrounding tribes. The brush, forest, river, and grasslands were the Coahuiltecans' source of food, building materials, and medicines, and had been so for a very long time. It is believed that some of the tribes who were living on the land when the Spanish arrived were descendents of much older Paleolithic-era peoples who arrived in the region more than 13,000 years ago.

At about the same time Paleolithic tribes moved into South Texas, small bands of hunter-gatherers also moved into the western reaches of the borderlands. These cultures moved with big game like mammoths and bison that were then numerous all over North America. Scientists speculate that excessive hunting compounded with the pressure of a changing climate may have led to the extinction of mammoths, giant ground sloths, tapirs, and many others. During this time period, two-thirds of the large mammals in North America went extinct. Paleolithic people therefore had to transition their reliance away from large mammals and rely more on plants and smaller wildlife. Around 7500 BCE, a further transition occurred when borderlands people began to settle into semi-stationary civilizations. They built temporary, seasonal shel-

ters and began planting crops like corn, beans, and squash, and they developed more sophisticated means of preparing and storing food, which led to the emergence, almost 2000 years ago, of a modern culture in the Sonoran Desert—a people we know as the Hohokam. The Hohokam created irrigation systems to feed permanent settlements, built spiritual and recreational facilities, created methods for charting the summer solstice and vernal equinox, and established extensive trade routes that took them south into Mesoamerica and west to the Gulf of Mexico. Traces of this innovative culture disappear from the archeological record in the fifteenth century, with few clues as to why. But for a society to survive so long in an arid land they must have learned to live in balance with the seasons of the desert—a mindset that remains a part of the culture of the Tohono O'odham, a contemporary borderlands community believed to be descendents of the Hohokam.

Throughout their genesis and evolution as a culture, the Tohono O'odham dwelled in the careful balance between scarcity and comfort that the desert demands. The Sonoran Desert figures deeply in their folklore and spiritual beliefs, so much so that the tribe's word for "people" and "saguaro" are the same word: *o'odham.*

The Tohono O'odham are one of several native tribes in the borderlands whose culture survived the arrival of Europeans. Conquistadors and explorers from Spain arrived in the borderlands in the 1500s, looking for gold and other riches, and later they staked out territory for the Catholic Church and Spain. These first Europeans, often with the guidance of native peoples, used the pathways and resources learned by native North Americans over millennia. They traveled the brush trails of South Texas and the foot trails of the Sonoran Desert, including a major borderlands route that the Spanish called "El Camino del Diablo." Over the centuries, this historic path, a rugged trail through searing desert, has been traveled by waves of diverse peoples, from the Hohokam to the Mexican and Central American migrants of today.

In the Lower Rio Grande Valley, Spanish settlers in what is now northern Mexico began to move northward in the 1750s to claim land within declared Spanish territory, which at that time spread more than 1000 miles to the northwest. Upon their arrival in the Valley, several thousand settlers and soldiers began to stake out land for farms and ranches—thereby beginning the displacement of hunter-gatherer societies who would soon find the natural habitat, and therefore their way of life, gone.

These early settlements were codified in the mid-1700s when Spain sent a delegation of representatives to legally apportion the Lower Rio Grande Valley through land grants that would encourage further agricultural development of the region. In order to ensure water was available for land production and livestock, the plots were all given river frontage. In this arid land, settlers who planned to run ranches (and most did) would need access to the river.

And so began a new era for the Lower Rio Grande Valley, an era whose deep roots in history survives in some form to this day, with the bond between land and river tied to family names like Garcia, Hinojosa, Tamez, Benavides, and Ramirez. Following this early Spanish settlement period, population in the borderlands did not see a rapid rise for almost a century, until the decades following the Mexican-American War.

Just as the arrival of the Spanish had impacted both the natural and human character of the borderlands, the Mexican-American War ushered in another dogleg in history, one that brought about a more profound and long-lived transformation.

In the early 1800s, expansionists in the United States developed the notion of "manifest destiny," the idea that providence demanded that the Anglo race control the land between the Atlantic and Pacific oceans. Though the sentiment had been developing for decades, the term "manifest destiny" was first used in 1845 by John O'Sullivan, a journalist writing for the *Democratic Review*.

O'Sullivan's article, entitled "Annexation," was in support of the United States' annexation of the Republic of Texas. O'Sullivan's thinking reflected that of the Democratic Party of the time: that the United States was fated to possess the entire continent "which Providence has given us for the development of the great experiment of liberty." An 1872 painting by John Gast entitled "American Progress," depicted the concept of manifest destiny as a white goddess, floating above the prairie in advance of white settlers, carrying a book and trailing a telegraph wire as she moved across the land. Before her, a shadowy land of native peoples and wild creatures flees, and where she has passed all is light.

This romanticized, and by now grotesque, notion of the progress of white civilization was not held by all even at the time. A US representative from Ohio, Joshua Giddings, a member of the Whig Party, opposed the policy of manifest destiny and the war on Mexico, calling it "aggressive, unholy, and unjust." Fellow Whig Abraham Lincoln also opposed the war, as did the abolitionist community and Henry David Thoreau, who went to prison for refusing to pay taxes that supported the war on Mexico. But the overwhelming power was then in the hands of expansionists like President James Polk, and right or wrong, the history of the West, of South Texas, of the Sonoran Desert, and of the borderlands was written in the aggressive prose of manifest destiny.

To be a continental power, Polk's administration believed the United States had to control California and possess secure travel routes to the Pacific through a southern transcontinental railroad. In 1821, opportunity arose for the United States when Mexico gained its independence from Spain. At that point, Mexico's northern territories extended north to present day Utah, Colorado, and California and east to Texas. But population in these northern territories remained sparse, with major population centers in Santa Fe, San Francisco, and San Antonio largely cut off from each other by great distances and hostile relationships with native peoples.

The painting American Progress *by John Gast (1872).*

There was little communication or travel between these outposts. Further complicating the efficacy of a central government, travel from Mexico's northern territories to its seat of power in Mexico City could take six months.

In the wake of its split from Spain, Mexico had not had the time to form itself as a nation when Texas rebelled and declared itself an independent republic in 1836—a republic Mexico did not recognize as legitimate. When the United States annexed Texas in 1845, it claimed the southern boundary line asserted by Texas, the Rio Grande, rather than the Nueces River further north, which according to Mexico had been the terminus of the Texas territory.

Agitating for war, Polk sent troops to the Rio Grande to claim it for the United States, an act that effectively began the Mexican-American War. The speed with which the United States took over Mexico's northern territories was aided by Mexico's concurrent conflicts with the Apaches, Comanches, Utes, and Navajos. It was

in some ways a free-for-all battle for the soul of the West, with Native Americans trying to retain what remained of their ancestral lands, and the United States and Mexico fighting for dominance over the Pacific coast.

By the end of 1847, US troops occupied most of Mexico's major cities, forcing the nation to sign the Treaty of Guadalupe Hidalgo on February 2, 1848, under which the United States took control of all of Mexico's northern territory. Many in Mexico opposed the treaty, and for some Mexican people the outcome of that page of history remains a bitter memory of US aggression.

For the United States, the outcome of the war allowed the nation to emerge as a world power by the dawn of the twentieth century. Following the war, continuing boundary disputes led to the Gadsden Purchase of 1853, in which the United States bought the territory of southern Arizona and a small portion of New Mexico for a sum of $10 million. This purchase in effect set the modern boundary line between the United States and Mexico and set in motion scattered waves of Anglo settlers seeking out the new territories.

As their numbers increased, Anglo settlers spread out over the South Texas Valley. These new arrivals, alongside the Spanish and Mexican people that had ranched and farmed the land for a century, began to establish the culture that to some extent survives in the eastern borderlands today. Farther west, settlers and fortune seekers made their way through the wilds of the Sonoran Desert, many traveling the Camino del Diablo and finding fortune in gold mines of California, and many others leaving their bones and worldly desires among the rocks and sand of the desert.

The landscape of the borderlands was, by the turn of the twentieth century, changing rapidly, with large silver and copper mining operations creating Arizona boomtowns like Douglas, Bisbee, and Tombstone. All along the borderlands, entrepreneurial industries were taking shape, from large-scale farming and ranching, to saloons, and a new brand of "public servant." The archetypal

outlaw/lawman, western rogue was coalescing around characters like Judge Roy Bean in South Texas and the Earp Brothers in the Arizona borderlands.

The late 1800s and early twentieth century also saw the rise of transboundary smuggling operations. Variances in international law created a market for guns smuggled by US citizens into Mexico, where gun laws were much more restrictive; and during Prohibition, Mexicans smuggled alcohol into the States. As the decades rolled on and alcohol was legalized, Mexican smugglers turned to other illegal drugs like marijuana and cocaine. Kept in ammunition and arms by the US gun industry—and cash by American consumers—the Mexican illegal drug business has become a multi-billion dollar industry. The market forces that created smuggling operations and labor dynamics have changed little over the past century, but with the population of the borderlands greatly increased, and the economic disparities between nations greatly exaggerated, the stakes have risen—as have the costs to borderlands people.

In the early twentieth century, the demographic makeup of the borderlands developed into a dynamic mix of longtime Mexican residents, whose families were spread on both sides of the new border; new Anglo settlers and other immigrants; and native peoples who had held on to some of their ancestral lands after several centuries of fighting European occupation. The apex of the American Indian struggle in the borderlands came with the surrender of Apache warrior Geronimo in 1886 in the Peloncillo Mountains, thirty miles northeast of Douglas, Arizona.

As the US government established military dominance of the newly acquired territory, agriculture and mining industries began to expand. In borderlands mines and smelters, Mexicans provided much of the back-breaking labor, and US companies supplied the capital and management. Even at this time, wages for people of Hispanic descent were often lower than those for Anglo workers, but racial inequalities had not yet simmered into institutional hos-

tility. In the late 1800s, ethnic hostilities were more often aimed at Chinese laborers, while labor from Mexico was encouraged. But as time progressed, and workers of Mexican descent grew tired of inequitable pay scales, racism began to taint relations between some Anglo citizens and those who traced their roots back to Mexico or Spain. By 1900, less than a half-century after the United States took control of the borderlands from Mexico, there were restaurants in Texas that posted signs reading: "No Mexicans Allowed." Some towns had segregated barber shops and corporal punishment for speaking Spanish at school. Edcouch, Texas, drew a line down the center of town and declared it illegal for people of Hispanic descent to cross the line—unless the person was working as a servant for an Anglo resident.

Still, even as one segment of the population acted with hostility toward Hispanic people, the region's growing industry needed labor. Some towns that encouraged racist segregation simultaneously solicited Mexican workers. And despite the offenses, migrants were so eager to work seasonally in the United States that some would walk twenty-four hours straight for days to reach US farms, ranches, and factories. Their perseverance, toughness, and ability to do hard work at low wages without complaint made business owners eager to hire them.

Segregation and racism in the borderlands has quieted considerably over the years as the various ethnic groups have built a common culture. But, on a national scale, the tension endures. Examples of this tension arise periodically with enough force to make national news out of seemingly local borderlands affairs. In 1999, with a unanimous vote, the city council of El Cenizo, Texas, approved a policy to conduct town meetings in Spanish. Within weeks, the news had spread across the country. Fewer than 8000 residents live in El Cenizo, right on the banks of the Rio Grande, and most of them are native Spanish speakers. The town decided that conducting official business in English was fostering a lack

of civic participation by residents, so it changed the official town language to Spanish. Some US media and pundits expressed shock over the town's policy, and town residents were shocked in return that anyone would care about a policy that made nothing but good sense to them. The appropriateness of a Spanish language town in the United States can be debated one way or another, but underlying the debate sits a basic disconnect between the human character of the borderlands, and what the rest of the country perceives, or desires it to be.

For many borderlands residents, cultural and familial ties create a natural kinship with Mexico. The shift in nationality that followed the Mexican-American War did not greatly alter population demographics in the borderlands. Anglo people moved in, but still, large majorities of borderlands towns remain of Hispanic descent.

In Laredo, Texas, 90 percent of households use Spanish as their principal language. According to the US Census Bureau, the counties of the deep South Texas borderlands are all overwhelmingly Hispanic—between 86 and 97 percent. Some of those residents are recent migrants, but many have family ties to the region that predate the existence of the United States.

The borderlands in general constitute one of the poorest regions in the United States. Much like rural Appalachia, entrenched poverty has long shadowed the region. Historically, rather than count on assistance from the federal governments in Mexico or the United States, many border towns have turned to their closest neighbor across the international divide, cultivating a borderlands interdependence that benefits communities on both sides of the line. When the Phelps Dodge smelter shut down in 1987, Douglas, Arizona, would likely have withered further without its sister city Agua Prieta, Sonora. Today with high unemployment and two-thirds of its residents living below the poverty line, Douglas continues to rely on cross-border traffic from the much more populous Agua Prieta. On any given day, many of the cars in the parking lots

Kids playing on the north bank of the Rio Grande in Eagle Pass, Texas, across the river from Piedras Negras, Coahuila.

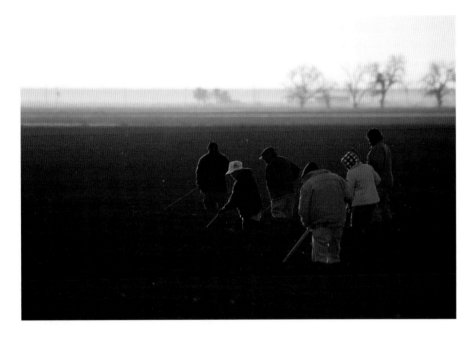

Agricultural laborers in southern California.

at Douglas restaurants and stores are likely to bear Mexican plates, and currency-changing kiosks are as common as gas stations.

A similar interdependence exists for sister cities like Lukeville, Arizona and Sonoyta, Sonora; and Calexico, California and Mexicali, Sonora. A portion of Mexicali's 600,000 residents travel frequently to Calexico's stores, which cater to Spanish speakers, accept pesos, and carry Mexican cuisine alongside American. All along the California border, towns like San Luis and Calexico are staging grounds for pre-dawn crossings of documented and undocumented migrant laborers, who rise well before the sun to cross the border and board white busses bound for California's Imperial Valley farms.

People and Policy in Conflict

In Texas, along the upper stretches of the borderlands portion of the Rio Grande, residents on both sides of the border live an exis-

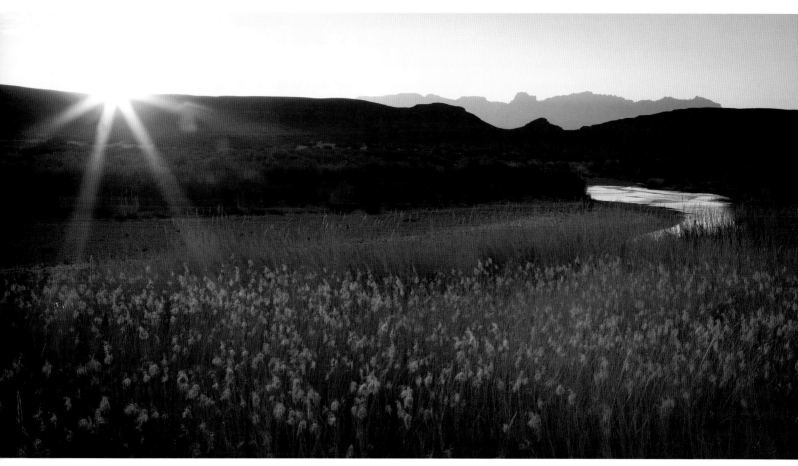

Rio Grande in Big Bend National Park, with sun setting over Chihuahua, Mexico.

tence far removed from the rest of the United States and Mexico. Candelaria, possibly one of the most remote towns in the United States, had been for many decades joined with San Antonio del Bravo, Mexico, by a footbridge and a shared borderlands culture. The footbridge here, a narrow pathway suspended over the Rio Grande, connected these towns not so much as an international passage between foreign countries, but as a well-trodden pathway between neighboring rural towns. Many of San Antonio del Bravo's residents have family ties across the river, and many sent their children across the footbridge for school or to see a doctor in Candelaria. This bridge, which for generations connected citizens

to holiday meals and card games, funerals and weddings, was torn down by Border Patrol in 2008.

The Candelaria footbridge was one of a precious handful of informal crossings between the United States and Mexico that had maintained a largely lost feeling of connection between national neighbors. These were places where the strife and political fury that often bears down on international borders seemed far away and irrelevant next to the bond of human beings sharing a bowl of salsa or a couple of beers. Historically, visitors to Big Bend National Park in Texas were able to experience this informal connection to Mexico by taking a rowboat across the Rio Grande to Boquillas and the other small rural border towns across the river from the park. But this connection was lost in 2002, when Border Patrol shut down the rowboat crossing in an attempt to tighten border security. The crossing at Boquillas in Big Bend may reopen, but with the climate created by borderlands policy, it will not likely return to the place it once was: a place for neighbors rather than citizens, people rather than legal and illegal entities, tied not to a nation but to a moment in time in an unforgettable wilderness in the Sierra Madre.

A similar loss has been experienced all across the borderlands as residents try to maintain family and cultural ties across an increasingly imposing borderline. These ties, to Mexico, native culture, and the past, characterize most border towns, where everywhere reminders of the region's rich history abound in Spanish missionary style architecture, roadside shrines, Mexican cuisine, native art, and a Western mentality. Perhaps more than anywhere else in the United States, this region represents a true melding of cultures. But all along the border, communities have found themselves increasingly divided by government's inability to craft workable border policy.

Throughout the history of the borderlands, the day-to-day lives of residents have been impacted by the fallout of international pol-

icy. In the early part of the twentieth century, Mexicans fleeing the violence of the Mexican Revolution sought safety and new lives in the United States. Shortly afterward, with the onset of the Great Depression, the US government created its earliest restrictions on immigration from Mexico, and even took the extreme measure of deporting tens of thousands of Mexican Americans, many of whom were natural born citizens. This measure by the Herbert Hoover presidential administration was turned on its head in 1942 by a series of agreements and laws, referred to as the "bracero program," in which the United States reversed its restrictive immigration policy and actively solicited Mexican laborers to work the agricultural fields and railroads in the United States.

When the bracero program ended in 1964, the legal framework for most migrant labor ended, but the demand for laborers did not. Mexican workers continued to follow the demand, and as immigration policy was tightened, political pressure began to mount for a solution.

In the 1990s, faced with challenges from the political right wing on immigration policy, President Bill Clinton took the path of political expedience. Pressured by election-year rhetoric from politicians like California gubernatorial candidate Pete Wilson, the Clinton administration launched a policy of supply-side enforcement that, despite its practical impotence and exorbitant cost, endures to this day. Rather than deal with the demand for immigrant labor, which was the indisputable first cause of the situation, Clinton followed all those who had failed before him. He chose to crack down on the supply of workers drawn by the great demand. From a human perspective, Clinton's policy, launched as "Operation Gatekeeper" in 1994, has divided and eroded borderlands communities in ways few people outside this region understand. In essence, Operation Gatekeeper flooded San Diego with Border Patrol agents and border barriers, thereby directing undocumented traffic through remote areas of the border. In addition to

all the problems this created for wild creatures and habitats, the policy inundated border communities with desperate people and an army of government agents.

In the process of directing migrant traffic to rough, dangerous terrain, the federal government also spawned a new criminal enterprise for guides (referred to as "coyotes") smuggling human beings across the international line. Now almost as lucrative as drug smuggling, the coyote business has escalated the situation by thwarting the government's attempts at enforcement.

By encouraging and dispersing criminal enterprise throughout the borderlands, the government heaped big-city challenges on small border towns. While the new violent element in these towns does not match the hype in the media—El Paso, San Diego, and other border towns remain some of the safest communities in the nation—the policy of sending illegal activity into remote places has altered the borderlands environment. Most of the impact has been felt on the Mexican side of the border where wars frequently erupt between rival gangs battling for dominance over smuggling routes and markets. And with the extreme wealth afforded by the drug trade, cartels have acquired an armory of guns from suppliers in the United States, which they use to terrorize border towns like Juarez and Reynosa. Within Mexico, thousands of people, most of whom were innocent bystanders, have been killed by warring drug gangs.

This violence has implications that ricochet throughout the nation, from the terror and grief unleashed on Mexican citizens, to the loss of tourism dollars from wary international travelers, right down to the work of conservation. One of the locations I have visited frequently in the state of Chihuahua, a biosphere reserve near a small town called Janos, had been the site of innovative research and community outreach to protect a unique grassland ecosystem. This work has been significantly curtailed due to drug violence that shifted to the region when the US government applied pressure in the Juarez/El Paso sector. In January 2011, eleven people

were executed in this rural community, some of them on hilltops and ranches where I had recently photographed. The team of scientists that had been working to raise awareness of the tremendous ecological resources in Janos have sought safer places to work—though few places are entirely safe in Mexico while the war between the US government and drug cartels moves as a dark, amorphous shadow over the nation.

As the power of organized criminals has risen in Mexico, it has been met with increasingly violent reactions by Border Patrol agents—some of whom were hired in haste as the government rushed to cover a much more expansive territory. In a series of reports following the implementation of Operation Gatekeeper, Human Rights Watch and Amnesty International detailed abuses by Border Patrol agents. Abuses included the use of excessive force, rape, and murder. Some agents were screened so poorly that they were hired despite previous arrests for border smuggling—an enterprise some continued after being hired by the US government.

Such abuses of power were occurring regularly. But the blame did not rest at the feet of Border Patrol or the Immigration and Naturalization Service (INS). Most agents serving along the border were and are dedicated soldiers in an ill-conceived war. Over the past two decades, failed immigration policy set an impossible task upon the shoulders of the INS—to hold back the flow of goods and people even as they were actively solicited and generously compensated by US consumers and industry. It was as if one arm of the United States was holding up a hand to stop traffic, while the other hand was gripping a wad of cash and beckoning Mexico's poor.

As Border Patrol continued to fight and lose at the border, the situation escalated further. In some locations the government sent military forces, bringing a new set of problems to bear. In 1997, Marines patrolling the border near Redford, Texas, shot and killed an American boy herding his family's goats. Even after this tragic event, the government marched onward on its treadmill of escalation.

In 2006, the US Congress mandated the construction of 700 miles of wall and other barriers on the border with Mexico, giving the Department of Homeland Security unchecked authority over how and where to build, how to obtain land from private citizens, and which laws the department might like to ignore. The project was largely complete by the end of 2010, but it did not stop traffic coming across the border illegally. Migrants and smugglers used ladders, ropes, and tunnels to clear the multi-billion dollar hurdle, or they traveled alternate routes, creating further problems for local residents. What the wall did do was erect concrete and steel between borderlands communities that had coexisted as neighbors, friends, and family for centuries. And it continued the decades-old policy of supply-side enforcement—a lack of attention to root causes of the demand for labor and drugs that has been undercutting the very foundations of borderlands communities.

For the Tohono O'odham, the wavering ability of the United States to craft workable immigration policy has eroded the social and governmental fabric of tribal lands. Over the centuries, the O'odham have seen their ancestral lands defined and divided by the United States and Mexico. With the Gadsden Purchase, Mexico sold half of the O'odham native land to the United States. Initially the tribe was not greatly impacted, because they were not even told the sale had taken place. But ultimately, the deal resulted in a severing of tribal lands between two different nations. On the approximately 4800 square miles of tribal land retained by the Tohono O'odham, the tribe had managed for more than a century to maintain an essentially undivided community, where a fluid, dotted international line was easily traveled by tribal members. Some Tohono O'odham living south of the US-Mexico line traveled north of the border every day for work, for visits with family, or to see a doctor at the tribe's main health clinic. Informal paths like the San Miguel Gate were both meeting places and informal travel routes without Border Patrol presence. But in the 1990s,

when Operation Gatekeeper began to impact remote stretches of the border, everything changed. Since then, the seventy-four miles of international border slicing through the heart of the Tohono O'odham homeland has become a hard line between the tribe's people in the south and health centers in the north; and between Tohono O'odham in the north and yearly religious ceremonies in the south.

Because most tribal members were born on the reservation—a sovereign land administered by the tribal government—they did not have or need official identification for either Mexico or the United States. But as border enforcement began to shut down the tribe's traditional travel routes, members of the tribe became suddenly illegal on their own lands. Those living in Mexico now have problems gaining access to hospitals just a dozen miles away across the US border, and those residing in the United States fear crossing the international line because they do not have the documentation to return. Border Patrol agents now regularly patrol tribal lands. Tribe members, many of whom have no proof of their tribal status, are often arrested, harassed, or detained.

In addition to dividing approximately 25,000 Tohono O'odham people from their family and jobs, border policy has impacted some of the most basic religious practices of the tribe. The Tohono O'odham's creation story centers around a cave in the Baboquivari Mountains on the tribal lands in Arizona. Here people of the tribe have come for many generations to offer prayers and ask guidance of one of the tribe's spiritual guides, I'itoi, the spirit of goodness, who is believed to dwell in Baboquivari. This sacred place is now essentially off limits to many Tohono O'odham living south of the US-Mexico border.

The challenges put upon sovereign native lands are echoed across borderlands communities and cultures, from San Diego and Tijuana, where the border crackdown began, to Brownsville and Matamoros.

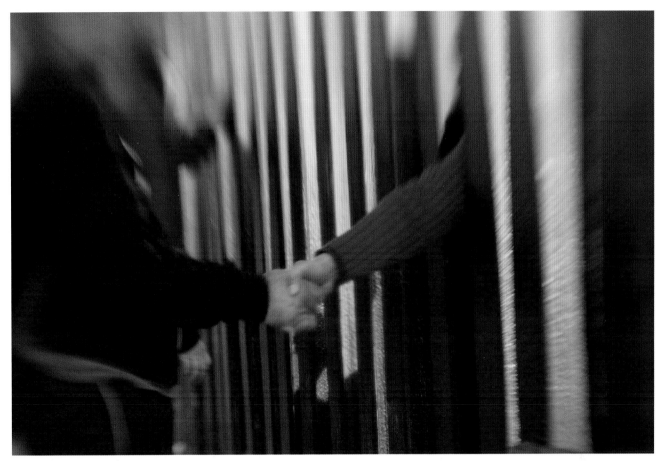

Friends greeting each other through the wall at Friendship Park in San Diego/Tijuana.

At the western edge of the US-Mexico border sits a white obelisk on a hilltop overlooking the endless open horizon of the Pacific Ocean. Just over a century and a half ago, the United States and Mexico erected the monument to mark the terminus of the border. On this same spot, in the early 1970s, then Governor Ronald Reagan and President Richard Nixon designated Friendship Park as a symbol of the shared relationship between Mexico and the United States. Political symbolism tends to be a slippery, transient, and at times vacuous notion, but for the people who have visited Friendship Park for the past forty years, that friendship is

more than a feel-good political moment. When the park was dedicated, First Lady Pat Nixon was on hand, and she presided over not just a cutting of the ceremonial ribbon, but also a cutting of the barbed wire fence that at the time demarcated the border. She wanted to shake hands with America's neighbor to the south, and reportedly said, "I hate to see a fence anywhere." Since that time, countless US and Mexican citizens have come to this spot at the meeting grounds of two nations to celebrate a birthday or share news of a death in the family or a new job. This line is literally drawn between families, and since the Clinton administration's shift in border policy in the 1990s, the hardness and height of that line has grown. Today, Pat Nixon's secret service detail would need a blowtorch and a couple of hours to cut a hole through several layers of border wall at San Diego's Friendship Park.

Friendship Park sits at the heart of a borderlands debate about what a wall here means for borderlands communities. In addition to the cultural impacts of borderlands policy and infrastructure, reverberations of the policy have impacted the already fragile economies of the region. Border towns in the United States and Mexico depend on ports of entry that bring shoppers and facilitate the easy passage of goods. The United States economy at large is also critically tied to the effectiveness of our ports of entry because the nation's two largest export markets are Mexico and Canada—markets worth $360 billion in 2008. With the extreme expense of building a border wall, repairing damage from daily breaches, and hiring thousands of new Border Patrol agents to cover the vast remote expanses of the border, money and policy have drained the effectiveness of our ports of entry along the Mexican border. Funding that could have gone toward modernizing, hiring inspectors, and alleviating the hours-long lines at ports, instead went toward policing the wilderness.

Additionally, the onset of previously rare drug cartel violence on the Mexican side of the border and Border Patrol presence on

the US side has upended societies that did not formerly have to deal with the social and economic costs of these enterprises. While border communities in the United States remain some of the safest places in the nation to live or visit, media coverage of border activity distorts the reality. By sensationalizing violence, the media has undercut the tourism industry that plays a foundational role in some borderlands economies. Eco-tourism, which had been one of the growing fiscal bright spots in the borderlands, has been broadsided, both by the reputation the region has gotten in the media, and more directly by the presence and impact of the wall.

In some areas of South Texas, wildlife-related activities, including bird watching, photography, cycling, and canoeing, are more financially lucrative than agricultural production. Eco-tourism is one of the fastest growing economic drivers here, growing at a rate of 10–30 percent annually, compared to about 4 percent annual growth for tourism in general. South Texas, with a natural environment unique to the continent, has an opportunity to vitalize a long-struggling economy with nature-related businesses. Currently, eco-tourism brings about $170 million to the region annually, largely because the South Texas region is considered one of the top bird watching destinations in North America. Birds and other wildlife in the Santa Ana National Wildlife Refuge draw 100,000 visitors each year, bringing more than $30 million and many jobs to the local economy.

In a region where poverty is pervasive, this type of sustainable industry could be a critical shot in the arm. At the same time, it would encourage protection of rare ecological assets. But the border wall in South Texas is being built on the Rio Grande levee, which lies in some locations several miles north of the international line at the river. Most of the Valley's scant remaining natural habitat, most of the nature preserves, and most of the wildlife exist within this thin belt that, where the wall has been completed, now lies in a no-man's-land between the levee border wall and the Rio Grande.

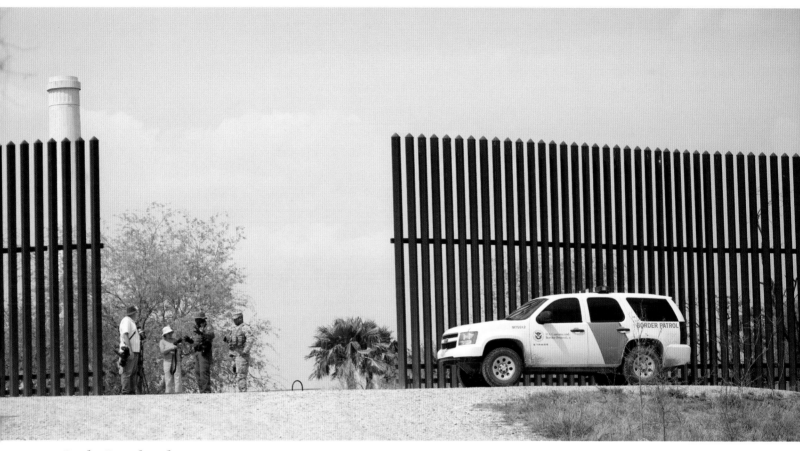

Border Patrol at the entrance to the World Birding Center in Hidalgo.

If the wall is extended throughout the Valley, these lands of critical environmental and economic importance will be lost to South Texas behind up to thirty feet of concrete and steel.

Conservation lands, like the Southmost Preserve run by the Nature Conservancy and the Audubon Sabal Palm Preserve in Brownsville, have already been crippled in their attempts to both protect wild creatures and inject some vitality into the local economy. The Sabal Palm Preserve, after a decrease in visitation due to the wall and related issues, had to shutter its doors to the public for more than a year—a likely loss of millions of dollars for the South Texas economy. And, in addition to the direct impact of the wall, the region's nature preserves suffer the daily impact of the activi-

ties of Border Patrol. I have seen tourists turned away for days at a time by Border Patrol, citing "ongoing activities" on private preserve lands. On a trip in 2011 to the World Birding Center site in Hidalgo, Texas, I was turned away by Border Patrol at the preserve entrance twice. On the third visit, during which I was accompanied by sixteen people for a tour I was leading to the Valley's birding sites, Border Patrol agents partially blocked the entrance and one told me, "You can enter, but you may get caught in crossfire."

"Can you warn us if you are going to start shooting?" I asked him.

"No, not really."

The members of my tour said they would take the risk. After the tour I talked to the manager of the preserve who told me that Border Patrol was not allowed to close the preserve to the public. I wondered if they are allowed to engage in a firefight with birdwatchers in the middle.

Similar situations exist all along the border, from the national parks and wildlife refuges in the western Sonoran Desert to the San Pedro Valley and Ramsey Canyon in Arizona, where bird watchers are known to generate nearly $30 million in revenues annually. Wall construction, the militarization of the border, and negative media attention have adversely impacted the allure of these places for tourists. In addition to the immediate implications of borderlands policy for the eco-tourism industry, the degradation of borderlands environments will have long-range implications for the region's ability to support sustainable, nature-based economies.

Federal policy also offends another of the borderland's most reliable tourist customers. Mexicans constitute three quarters of Arizona's international tourists, representing millions of tourism dollars. With smart border, law enforcement, and fiscal policy, a state like Arizona, containing some of the nation's most iconic natural wonders, could enjoy a stable, sustainable eco-tourism economy like few other states. And the same holds true for Texas, which also relies on tourism and trade with Mexico. But the wall,

Eco-tourism brings hundreds of millions of dollars to borderlands communities.

federal policy, and more recently state policy offensive to people of Latino descent, will further undercut the state's economy. Arizona's fiscal picture relies heavily on tourists, and reductions in tourism dollars are accompanied by serious economic consequences for the state and the 170,000 of its residents that work in the tourist industry. According to the Arizona office of tourism, more than one million fewer visitors came to the state in 2008 than had come the year before. And the economic implications of antagonistic immigration policy reach even further. In May 2011, the *Arizona Daily Star* published a story detailing some of the broad economic losses resulting from the state's rigid anti-immigrant policies. According to the story, Arizona resorts and hotels have lost lucrative contracts for conferences, the University of Arizona has lost top-tier professors and students, and business recruitment and thus revenue has slowed due to the anti-immigrant controversy that has received international media coverage.

The Paupers' Graveyard

All of the lamentable and avoidable consequences of the past two decades of border policy are compounded by a singular, shameful tragedy at the center of it all. When Operation Gatekeeper was set in motion, the Clinton administration stated its intention to reroute migrants into remote, isolated, rugged regions where Border Patrol would have a clear advantage. The administration believed that the passage would become so onerous, and the likelihood of getting caught so great, that people would give up trying. They were half right. The government did gain the upper hand as migrants attempted to cross one of the hottest, driest places on Earth. But the upper hand included not only increased ease in catching migrants made sick by the terrain, but also increased need to gather up the bodies that piled up on the scorching sands, floated down the Rio Grande and Colorado River canals, and froze to death in the mountains outside San Diego.

In the end, the Clinton administration's expectation that migrants would give up trying to come to the United States failed to account for the most basic tenets of economics and the most elemental motivations of the human psyche. Rather than a decrease in undocumented immigrants entering the country, pressed by extreme poverty in Mexico and tremendous opportunity in the United States, the 1990s saw a marked increase. Many of those people came on legal visas and overstayed them. But those that came without visas through the southern border were now walking dozens of miles in the open desert, with summer temperatures in the triple digits, and braving flooded rivers and rugged mountain passages, all for the opportunity to do jobs most US citizens would not be willing to do for less than a livable wage.

Tragically unprepared for the remote terrain, migrants often set out carrying little water or food and wearing too little protective clothing, with no clear knowledge of the safest direction to

travel. In the Texas stretches of the borderlands, people crossed the Rio Grande by stripping naked and swimming, or floating with the meager assistance of inflated plastic bags. Even in winter, when the air temperature can be 40 degrees Fahrenheit and water temperature in the 50s, workers plunged into the river.

In his book *Hard Line,* Ken Ellingwood detailed many ill-fated migrant oddessies. In the Sonoran Desert, migrants walking for days without shelter or water began to succumb regularly to dehydration and heat stroke. In California, in order to stay out of sight migrants would try to swim Colorado River canals, which appear placid on the surface but are almost impossible to swim. As their desperation increased, lost migrants began to turn up regularly in these waters, in desert washes, at the base of mountains, and at the edges of highways.

As the difficulty of the passage became clear to migrants, rather than stop trying to come, they turned more frequently to coyotes to help them make it through alive—and many did. But many thousands died trying, and tragedy became routine. One day it would be a group of seven migrants found burned beyond recognition under the desiccating sun in the Imperial Valley. The next, it would be eight people found drowned in the storm drainage system beneath Douglas, Arizona. It is hard for most US citizens to imagine the sort of desperation that would drive people to risk their lives for a job. What sort of a mindset sends a woman into the desert with a young baby, who, once her mother has succumbed to dehydration and death, is taken as an orphan from her arms?

For the most part, US citizens are born to privilege, even in the poorest of areas—the privilege of public schools and social safety nets. It takes some study, some attention, and some genuine human empathy to understand the circumstance that leads people into one of the harshest climates on Earth. For Julio César Gallegos, little will ever be known of the joys and sorrows of his life leading up to the moment his body was found in the California

Memorial for a lost migrant at the edge of the Salton Sea in southern California.

desert in 1998. But we do know why he was out walking in the Imperial Valley. Julio and the other migrants he traveled with had all removed most of their clothes as the intense August heat brought panic and desperation. They had very few belongings, and there was no water or food anywhere near where their bodies were found. The one possession Julio kept, clutched in his dying hand, was a photo of his two-year-old son.

Migrants entered these places, not on a whim or with some spontaneous desire for a change of scenery. They went because they love their children, spouses, and parents, and they live in a land without privilege, and, more importantly, without hope. Faced with no prospects in Mexico, or Guatemala, or Honduras, with children to feed and hopefully send to school, and the near certainty of work in the United States, migration becomes more an inevitability than a choice. And with US federal policy having shut down legal and urban paths to employment, venturing into a remote, unknown, and potentially deadly land is just another sacrifice that must be made.

It is not a difficult choice to understand for anyone familiar with the economic realities faced by Central American and Mexican people. In 1999, while speaking to Iowa voters during his campaign for the presidency, George W. Bush explained it like this:

"Family values do not stop at the Rio Grande River. There are moms and dads [who] have children in Mexico. And they're hungry. . . . And they're going to come to try to find work. If they pay $5 in one place and $50 in another place, and they've got mouths to feed, they're going to come. It's a powerful instinct. It's called being a mom and being a dad."

This statement, from a president who failed to bring about much-needed immigration policy reform due to backlash within his own party, sums up why the policy of supply-side enforcement can never work on its own. Operation Gatekeeper did not decrease poor migrants' need to come to the United States, it only increased

the danger of their crossing and instilled an elevated sense of desperation.

As urban crossing became more and more difficult over the years, finding identities for the escalating number of bodies became increasingly difficult. As Ellingwood reported, badly disfigured bodies would arrive at a county coroner's office with no identification and be catalogued with a single name, John Doe, and a number. John Doe 01–177 came into the Imperial County coroner's office as a collection of bones and scraps of clothing, and a single belonging—a bus ticket to Mexicali. With nothing to help identify him, the coroner sent John Doe 01–177 to the paupers' cemetery in Holtville, California, where the graves of the poor and unknown sit in a muddy field behind the manicured Terrace Park Cemetery. Out in that bare field, signs warn visitors that cave-ins are common, and many of the gravesites are sunken into the earth. Graves are marked with crumbling bricks, some with small painted crosses bearing a single phrase, "no olvidados"—not forgotten. Somewhere among the crosses and stones, lies John Doe 01–177 in a plain wooden box beside hundreds of other John and Jane Does, the faceless dead of the borderlands' nightmare.

Many residents of the borderlands know these faceless people, even if they've never met them. They are a part of the cultural identity here just as much as the rounded domes of Spanish Christendom. Some borderlands residents have personally seen what becomes of a migrant lost in the desert at the heartbreaking end. Dan Millis, while out in the desert leaving water and food for migrants in February 2008, found Josseline.

At age fourteen, Josseline Quinteros had been caring for her little brother for several years in El Salvador before their mom, who was working in Los Angeles, was able to save enough money to send for them. After weeks of difficult travel over thousands of miles, Josseline and her brother made it to the United States, in the mountains just northwest of Nogales, Arizona. But before long,

The paupers' graveyard in Holtville, California, the final resting place for many unidentified migrants lost in the desert.

due to lack of water or simply exhaustion, Josseline fell sick. The coyote who was leading their group said they had to keep moving, and Josseline commanded her brother to continue on and reach their mother safely. That night, the temperature dropped below freezing and hovered there for days.

A few days later, Dan, a volunteer for the migrant support organization No More Deaths, was hiking a remote wash, dropping water, food, blankets, and clothing along remote migrant trails. As

he rounded a curve in the wash, he saw a pair of shoes and, suspecting a person was still nearby, he called out, "Hola, hola! Tenemos agua y comida!" But Dan cut his greeting short when he saw on the ground the immobile body of a girl in pink sweatpants.

"I had never found someone dead in the desert before," Dan wrote later. "So ugly, frustrating, tragic. I just looked at my feet and said 'Goddammit.' I'm still mad."

He contacted the police and the network of people who work to support migrants in southern Arizona. He didn't have to wait long for answers. When Josseline's brother arrived in Los Angeles without her, their mother called the Salvadoran consulate and photos of her were distributed in southern Arizona. The photos had reached Dan's connections in Tucson—he had found the missing girl, but several days too late.

Josseline was the youngest of the 183 people whose bodies were found in the Arizona desert that year. They joined the more than 5000 that have died in the borderlands since the beginning of Operation Gatekeeper in the mid-1990s. For Dan, the experience changed his life. He learned what he could about Josseline, and now he splits his time between working for No More Deaths and the Sierra Club, hoping to raise awareness about the impacts US border policy is having on people and the environment.

Every year on February 20, the anniversary of the day he found her, Dan does something special to commemorate Josseline's life and death. On the first anniversary of her death, he gathered with friends at El Tiradito shrine in downtown Tucson, to acknowledge what would have been Josseline's quinceañera, a coming of age ceremony celebrated during a girl's fifteenth year. A shrine at the location where Dan found Josseline has been created; people have left offerings for her over the years, and there is a pretty white wooden cross bearing a poem written by her mother. It reads, translated from Spanish:

"When you feel the road has turned hard, don't give yourself

*Shrine created for Josseline
Quinteros after her
disappearance and death
in 2008.*

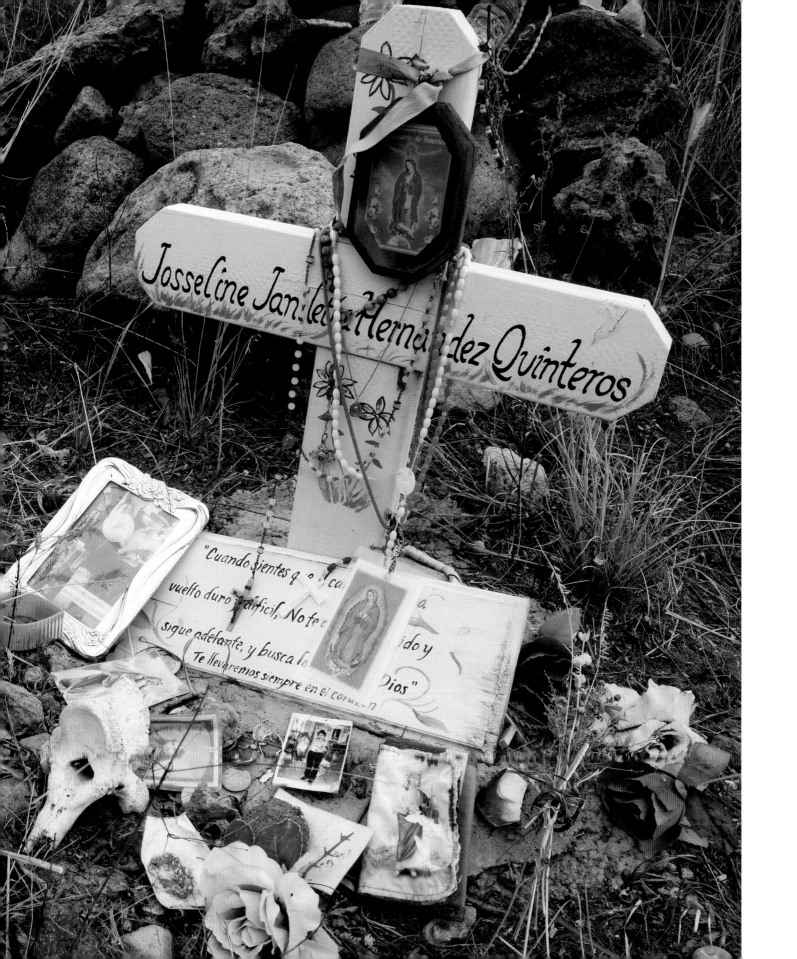

up as lost. Continue forward and seek God's help. We'll carry you always in our hearts."

There is much about Josseline's life that will remain forever occluded, but like many migrant women and girls, she faced dangers all along the odyssey that brought her to her final resting place in the Arizona mountains. A 2010 report by Amnesty International estimated that six out of ten migrant women traveling from Central America and Mexico to the United States are sexually assaulted at some point along their journey—by bandits, gangs, Mexican federal police, or, in some cases, the US Border Patrol. Women are the most vulnerable of the wayfaring peoples desperately searching for a better life.

I myself have met migrants who were on the edge of this abyss, as have many who spend time in the borderlands. On a photo trip, driving through the Sycamore Canyon area of southern Arizona, a friend and I spotted two people dressed all in black standing on the side of the road. It was August, and temperatures that day exceeded 105 degrees. We slowed our vehicle to approach a woman in her late fifties and a young man; both were flushed red and appeared exhausted. The woman spoke in rapid Spanish, with desperation in her eyes. A coyote had taken them past the border a few miles south of where they stood and told them there was a town within easy walking distance.

"The closest town is at least fifteen miles away," I told them, watching despair darken their faces. I told them we had seen a Border Patrol encampment a few miles back, and had seen many Border Patrol trucks since. The woman pleaded with us to take them to the encampment.

On the ride, we gave them water and food. They had not eaten in two days, and the only water they'd had came out of puddles from recent rains. The woman, on the verge of tears, was not much younger than my mom, who I couldn't imagine trekking for days through that rugged country without food or water. Having faced

hardships in our lives, and knowing what my mom was willing to sacrifice for our family, I knew this woman would have a story behind why she came. Before I could ask her about it, a Border Patrol truck approached. We hailed them and started to explain the situation when one of the agents cut us off sharply.

"You just committed a felony. I should arrest you right now." He looked us over carefully, as if assessing whether to throw us in the back of his truck with the woman and young man. Instead he said roughly, "You're lucky I don't feel like dealing with you right now," then turned his back and climbed back into his truck.

This border—and the laws and social climate surrounding it recently—suggest our allegiance to a country's legal code should be stronger than our connection to another human being. No More Deaths brings water out to sections of the desert heavily traveled by migrants, hoping to spare some of them suffering and torturous death. But Dan and some of the people he works with have been charged with breaking the law for leaving water in the desert—as if a ticket or even jail time could waver the resolve of a person who had encountered a child lying dead in the desert.

The current clash between governmental law and human ethics is not a new one.

We've been here before, not long ago.

In the early 1980s, violence, war, and repression in El Salvador led to a mass exodus from that country. The migration of people from El Salvador happened amid a series of well-publicized killings, including the assassination of Archbishop Óscar Romero in 1980 and the rape and murder of four nuns. As the refugees arrived in the United States, the stated federal policy was to send most of them back to El Salvador. In 1982, a group of religious leaders in the United States gathered in Tucson, Arizona, and declared the Southside Presbyterian Church a sanctuary for refugees. Many other churches followed the example, as did universities, and the entire state of New Mexico. This network of support for ref-

ugees helped many thousands enter the country and obtain passage to safe havens. They were, of course, breaking the law of the land; in 1986 eight leaders of the sanctuary movement were convicted, most of them Catholic clergy. The convicted were thwarting national laws to follow laws of ethics and morality, just like those who have followed in their footsteps during the mass migration from poverty in Mexico during the 1990s and first decade of the twenty-first century. In 2000, human rights activists created Humane Borders, based on the idea that "regardless of anything else, these are human beings."

One of Humane Borders' early supporters, John Hunter, is the brother of US Representative Duncan Hunter, one of the most vocal supporters of a border wall and strict enforcement along the border. This family divide illustrates the essential and profound conflict we face when trying to dictate the movements of any species, be it human or otherwise. Author Craig Childs, in his book *The Secret Knowledge of Water*, likened the movement of migrants across borders to the passing of seeds carried by the wind or "green vine snakes following prey along the stream." We are, in fact, a species that grew up with the same natural laws as the jaguar or bighorn sheep; we are all wayfarers within nature, on our way to whatever offers us survival.

While we tend to separate human beings out from nature, and, indeed, I have done so in this book, we are still subject to many of the same dynamics and pressures that nature has always presented us with. Scientific studies have shown that climatic cycles prompted the same movement of humans that they did for animals. When climate was inhospitable for a few years, animals would start to move, and so then would the hunter-gatherer cultures that depended on them. Similar forces of migration continue to bear on human survival, though they are tied not as much to the seasons of the Earth as to the seasons of human geopolitical realities. Financial realities, the currency on which we currently

base human survival, are even less constant than climate, and they impact the movements of people just as shifting weather patterns spur the movement of wild creatures. When the economic climate of a region shifts radically, people will move, out of necessity. If a man can make only $2 per hour in Mexico but $8 per hour in the United States, and he has a family to feed and clothe, he will brave whatever obstacle to reach the opportunity for a better life.

So ironclad is this rule of movement when climates are changing that it cannot be thwarted by walls or laws or international boundaries. We can stop animals from moving, and we can consequently precipitate their demise. But we cannot stop humans from moving, at least, not by any means we as human beings in modern society would be ethically willing to employ. During the tenure of the Berlin Wall, the imposition of the barrier was imposed by lethal means—crossing meant risking death, and yet, an estimated 5000 people successfully crossed it during the almost thirty years it existed. For those who risked the passage, what they stood to lose by *not* crossing the barrier was worth more than what they might lose attempting to cross it. Many did lose their lives. The first was a woman, Ida Siekmann, who jumped out of her apartment window on the third floor at the very edge of the wall. Siekmann cleared the wall, and landed in West Germany, but she hit the ground before firefighters could open a sheet to catch her. Many others trapped in East Germany followed Siekmann's lead; ultimately, about 200 people died trying to reach West Germany across the Berlin Wall.

On the US-Mexico border, more than 5000 people have died attempting passage to a different type of freedom. Of the bodies found, about one-third have never been identified.

Many millions who have attempted this crossing have made it to the United States, highlighting the futile nature of trying to put a cage around human migrations. Even if we station guards every hundred feet along the border, with orders to shoot to kill,

people will find a way around it—whether through the 4000-mile Canadian border or by way of the Pacific or Atlantic coasts—and many will die trying. But as long as the economic climate stays the same, the pressure for migration will continue, and people will not stop trying to migrate—just as animals will not stop trying to move as the intensity of heat and drought increases due to global warming. The only difference is, even with a wall blocking their way, many humans will succeed. Wildlife will not.

As people are continually funneled into the desert, the future of wild creatures will continue to be pitted against the survival of the most vulnerable humans. Several years ago, with migrant deaths on the rise, Humane Borders asked the Cabeza Prieta National Wildlife Refuge for permission to place water tanks on the refuge for migrants. The request was denied by wildlife refuge officials, who cited the extreme danger the entire species of pronghorn was facing due to the waves of human traffic that Operation Gatekeeper had funneled into the desert.

This is the impossible predicament US border policy has established. Pronghorn are barely hanging on as a species, and they are highly sensitive to human disturbance of any kind. In addition, all the wildlife of this particularly dry section of the Sonoran Desert depend on scant waterholes—waterholes that are also now used by migrants trying to survive the desert passage. Competition from migrants, if they are lucky enough to find the scarce water resources here, could mean the difference between survival and extinction for imperiled wild creatures.

And so in the final analysis, US policy has pitted the two most powerless and voiceless communities on the continent against each other. For decades, people have risen up to urge ethical solutions to immigration and environmental issues, but for most people in the United States these issues fade from memory quickly because they seem so very far away from everyday life. In 2009, the National Museum of American History in Washington, DC, hosted a photo-

graphic exhibit on the bracero guest worker program. The exhibit documented the extreme circumstances that brought workers from Mexico during the middle of the twentieth century, and the harsh working conditions that many of them faced after they arrived.

After the exhibit, viewers, including me, very likely had gained a new perspective on the lives of migrant workers, then and now. But when we left the exhibit, we went to the museum café for some hot cocoa, not to the Sonoran Desert in the middle of summer with no food or water; not to the farm fields of the Imperial Valley to pick lettuce for twelve hours a day; and not into the coursing waters of an irrigation canal where our bodies would be discovered weeks later in the agricultural runoff from the salad bowl of a nation.

No, we all went to dinner in the city, or to the museum gift shop, or to a warm home or hotel room nearby. Perhaps some stopped at the grocery store and picked up a head of lettuce in a produce section containing every imaginable variety of fruit and vegetable, most of it carefully picked by the hands of a migrant.

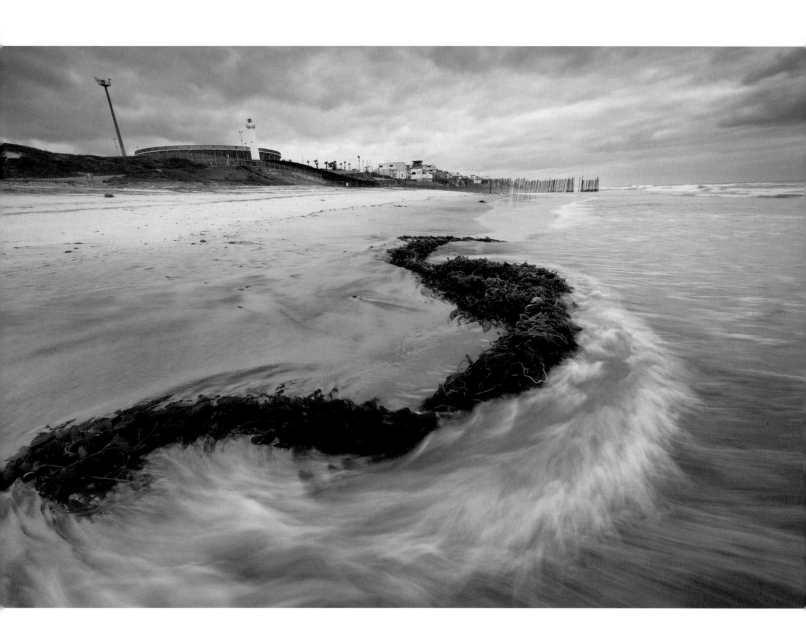

*Pacific Ocean and the border
wall.*

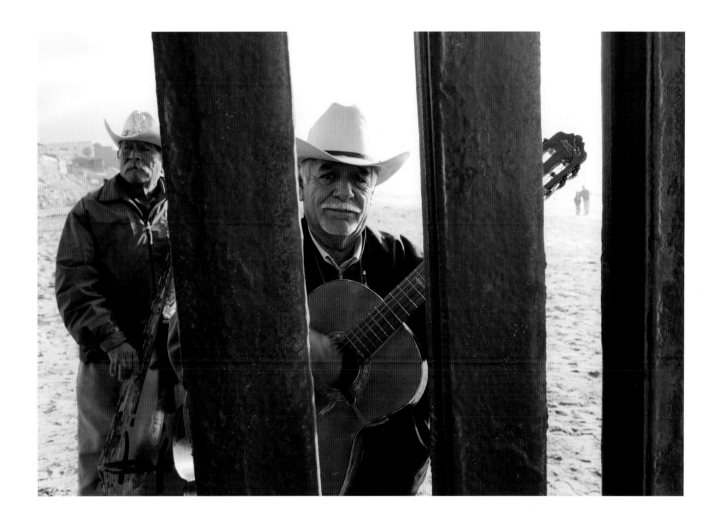

*Musicians playing on the
beach in Tijuana, seen
through the border wall.*

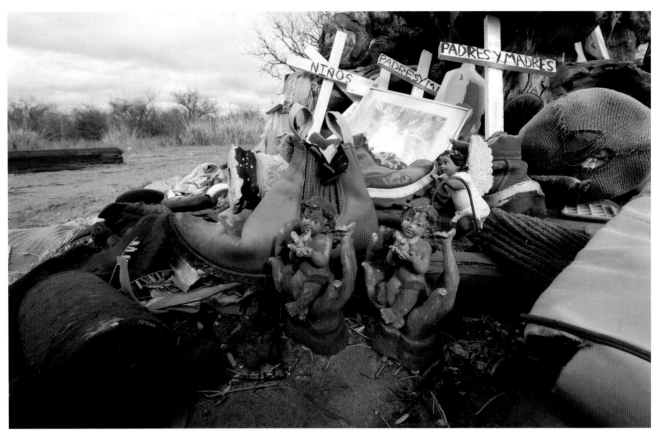

Belongings of migrants left in the wilderness and collected by volunteers with No More Deaths in Arizona.

(At right) *Agricultural fields in southern California.*

(Following page) *Border wall in the Algodones Dunes.*

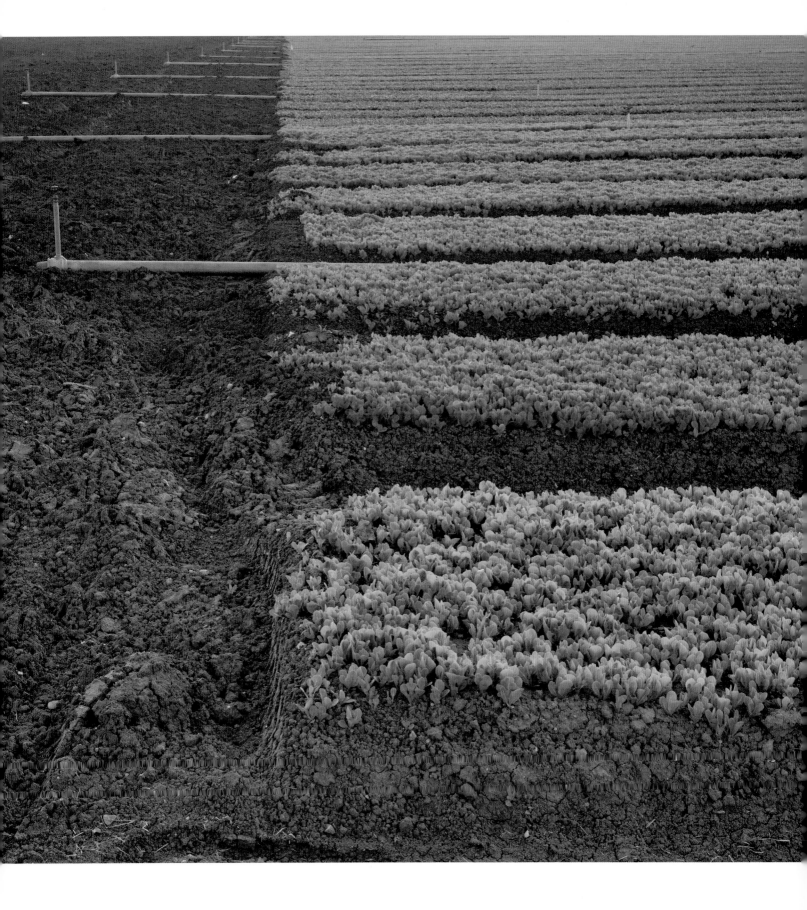

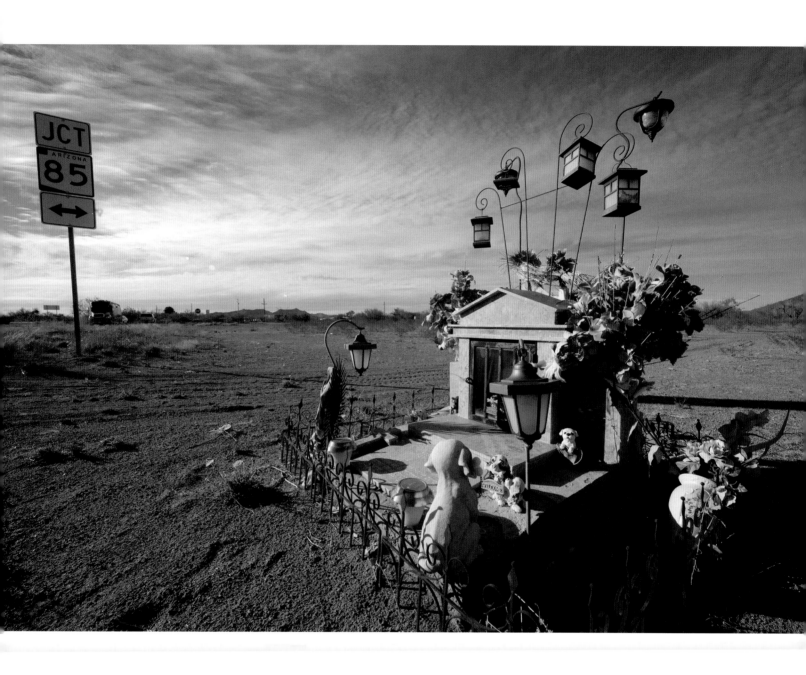

Roadside shrine in Arizona.

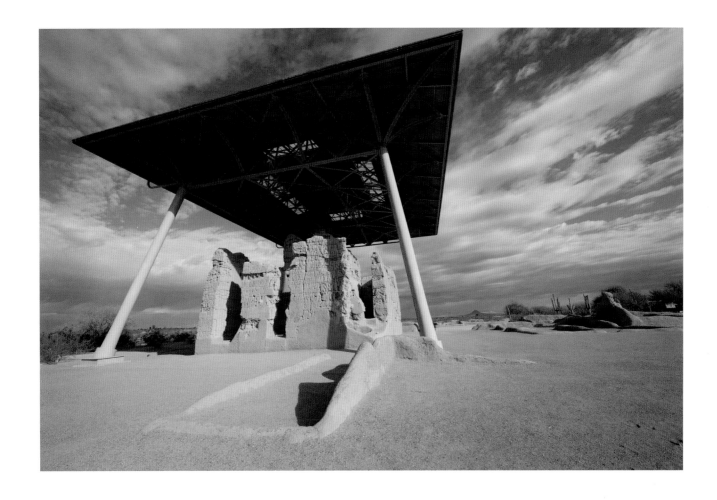

(Following page) *Border residents at the wall.*

Casa Grande National Monument houses remnants of the Hohokam culture, one of the earliest advanced civilizations of the borderlands.

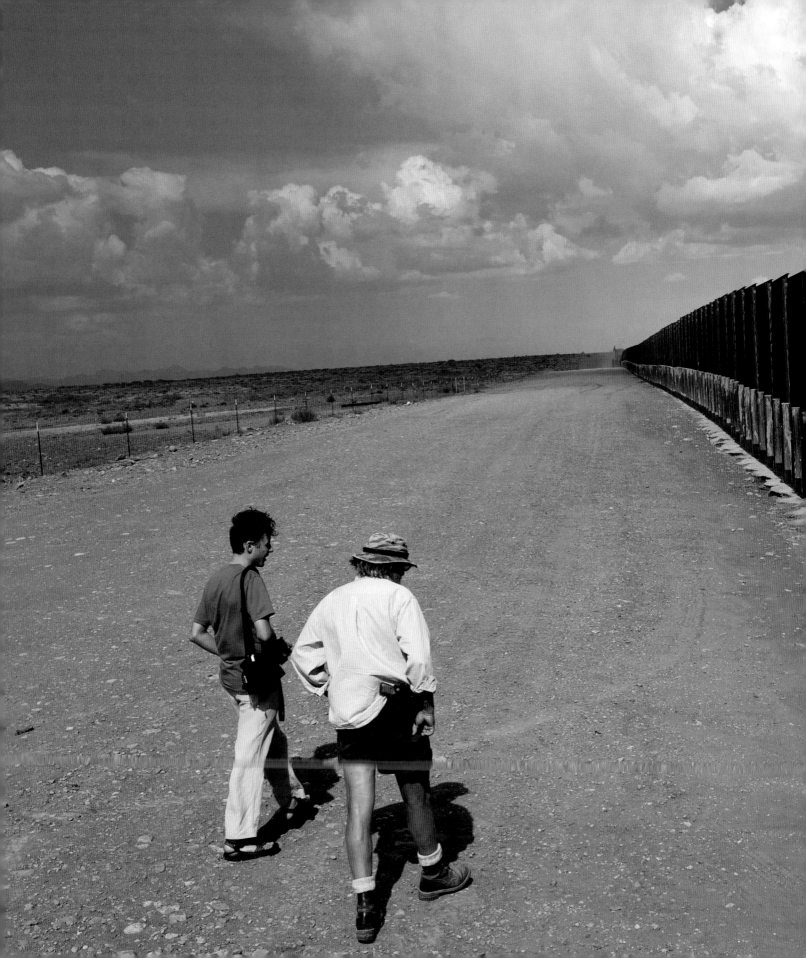

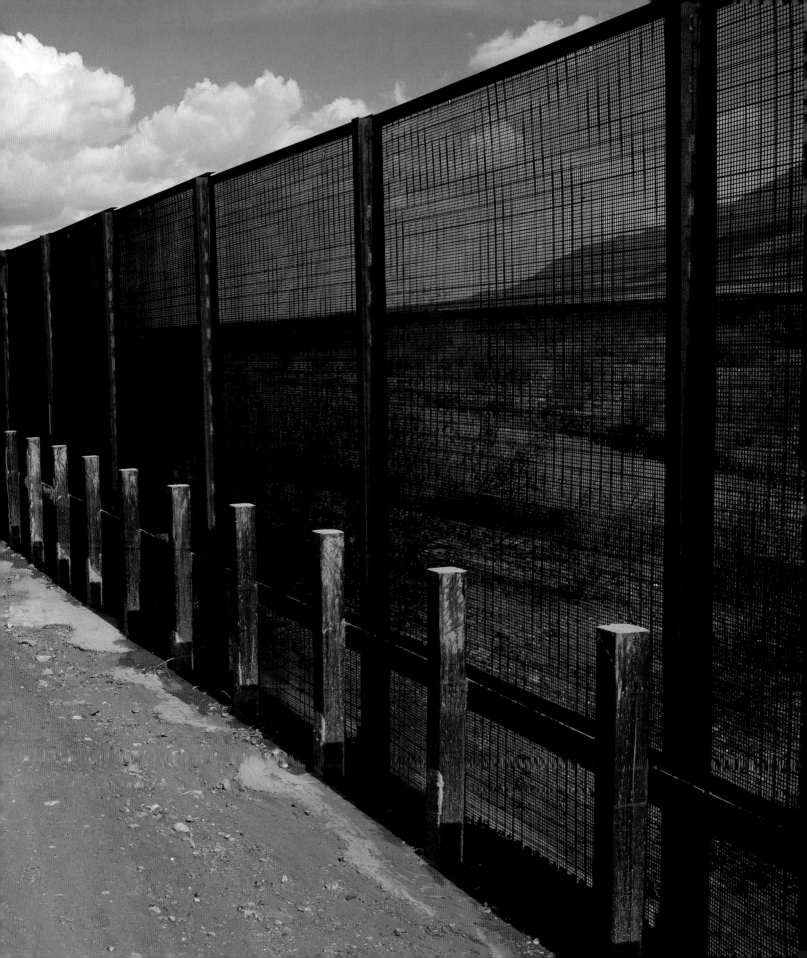

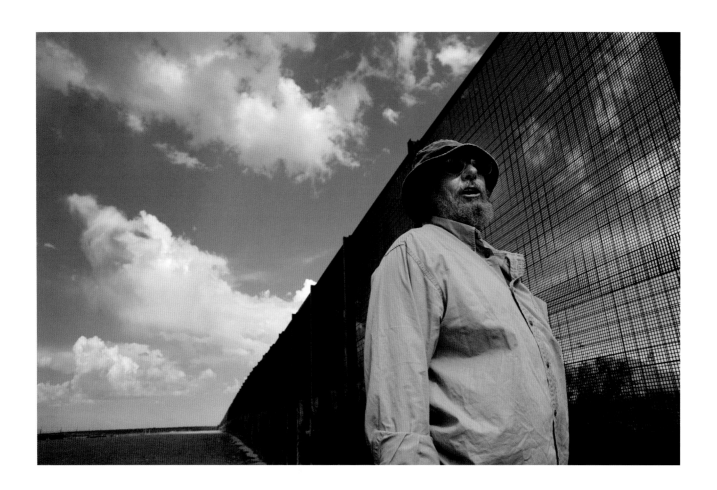

Border resident Bill Odle.

*Rev. John Fanestil presides
over a communion ceremony
through the border wall at
Friendship Park.*

Mexican man looking across
the border barrier into
Arizona.

*Mexican biologist Eduardo
Ponce looking for porcupines
for his doctoral research
project.*

Wildlife researcher Ed Stowe at the construction of a border wall segment that will go through his study site at Coronado National Memorial.

(At right) *Prairie dog skull found in a pack rat midden in Janos, Chihuahua, by wildlife scientist Rurik List.*

Borderlands conservationist
and landowner Valer Austin
on her property in Mexico.

Rio Grande Valley residents Martin Hagne and Betty Perez out on the river for a birdwatching tour.

(At left) *A visitor to the Lower Rio Grande Valley canoes a quiet stretch of water near the World Birding Center site in Roma.*

Longtime resident of South Texas, Max Pons manages the Southmost Preserve, a property owned by the Nature Conservancy in Brownsville, Texas.

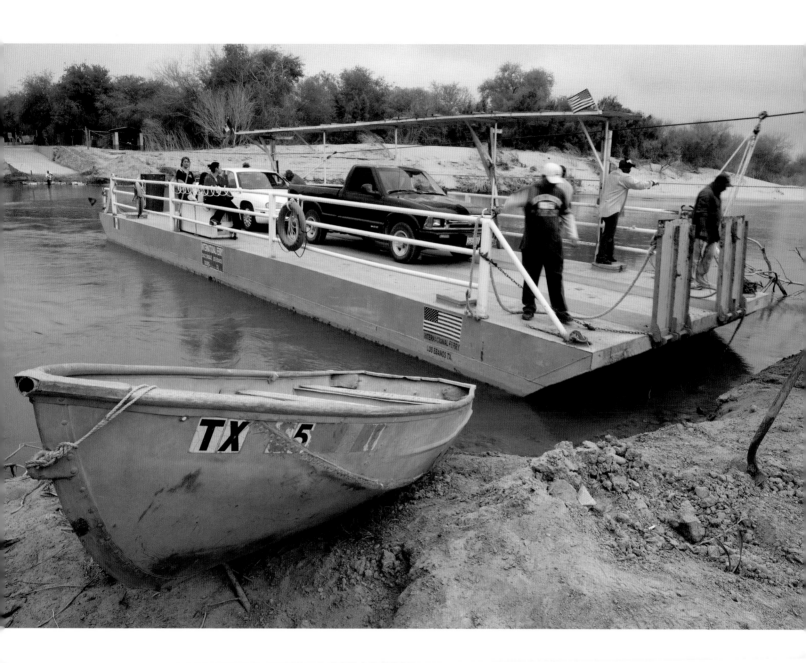

A hand-drawn ferry across the Rio Grande, one of the few remaining informal crossings on the border.

(At right) Property owners working to restore a deforested landscape along the Rio Grande.

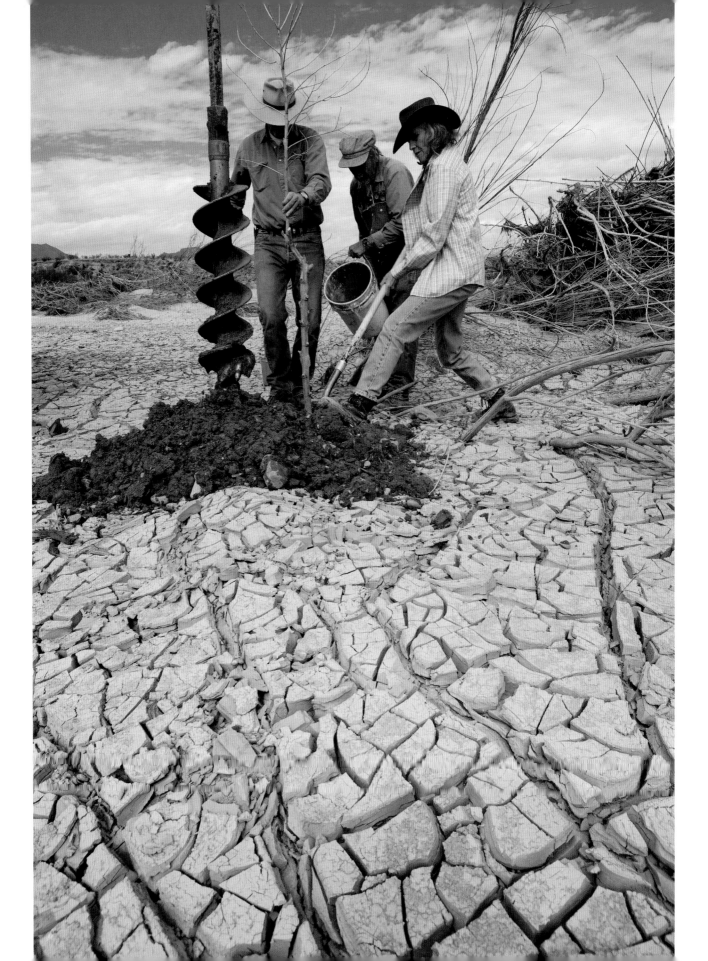

*International bridge
between Eagle Pass,
Texas, and Piedras Negras,
Coahuila, sister cities in the
borderlands.*

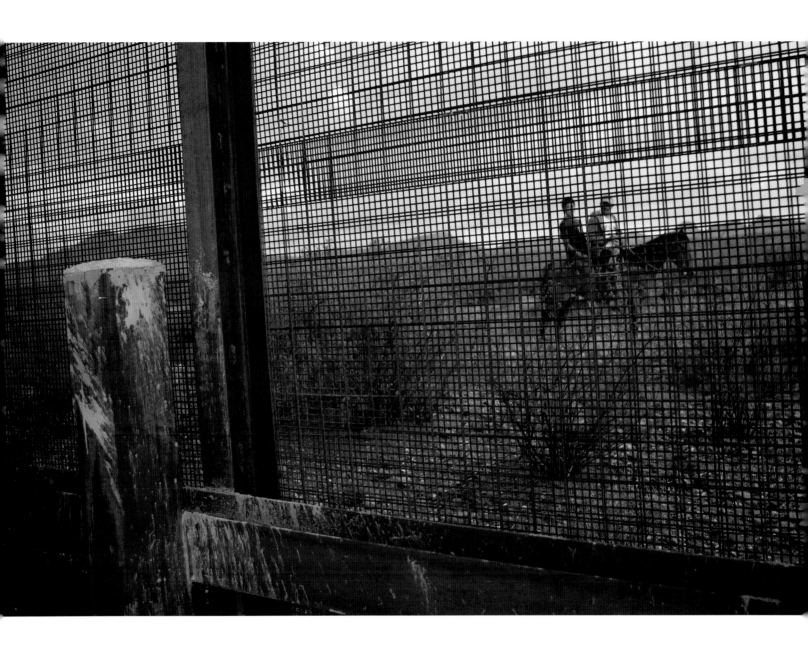

Mexican citizens seen through the border wall in southeastern Arizona.

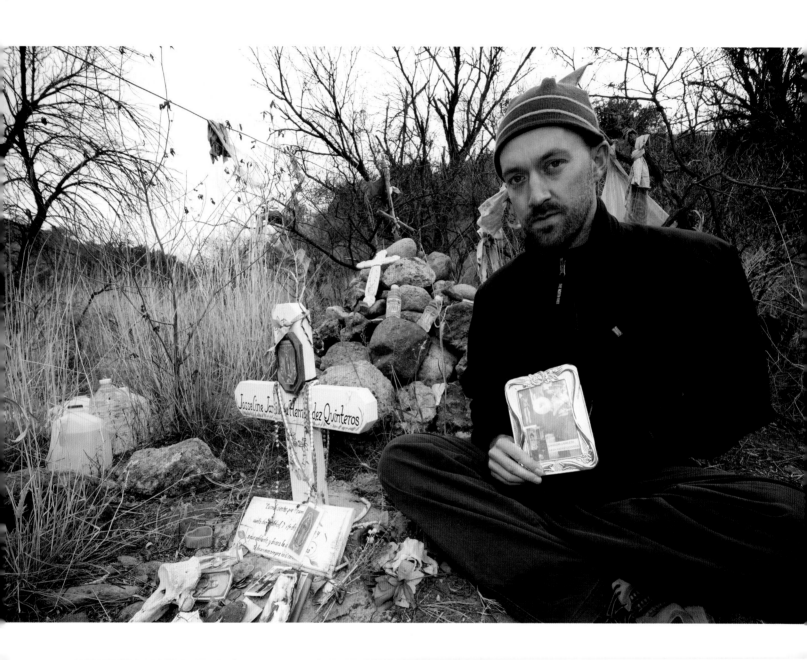

*Dan Millis at the memorial
he and others made for
Josseline Quinteros.*

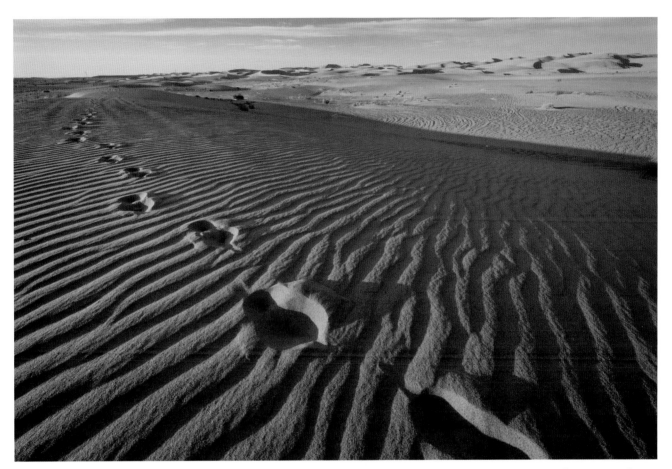

Footprints in the Imperial Sand Dunes in southern California.

(Following page) *A paupers' cemetery in southern California houses many graves of unidentified migrants lost in the desert.*

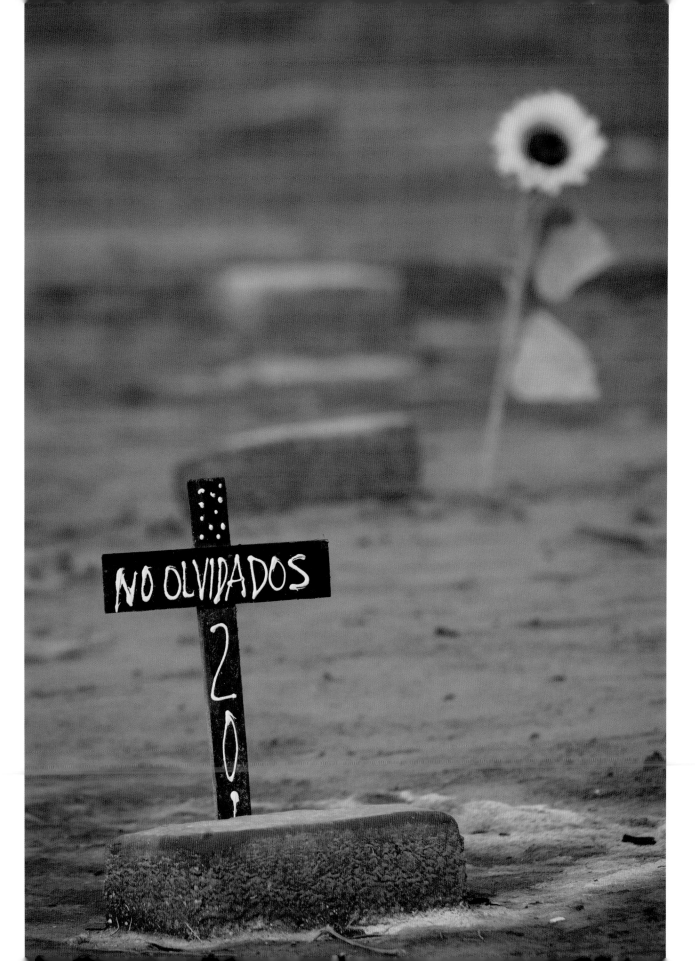

SHINING CITY ON A HILL

In his farewell address to the nation in 1989, President Ronald Reagan mused, as he had many times before in his political life, about a shining city on a hill. He spoke of the United States as a "tall, proud city built on rocks stronger than oceans, windswept, God-blessed and teeming with people of all kinds living in harmony and peace." His idyllic America was a beacon of freedom and opportunity for the world, with doors wide open "to anyone with the will and heart to get here."

Reagan's "city on a hill" was not a notion of his own making, but an elaborated reference to previous leaders who had similarly expressed the promise of the United States. The "city on a hill" had been invoked by John F. Kennedy, and long before that, by Puritan John Winthrop, who had envisioned a model society, "watched by the world." But originally, Reagan's words were written in the Gospel of the Christian Bible, as part of Jesus' Sermon on the Mount: "You are the light of the world. A city that sits on a hill cannot be hidden."

Though referencing the Bible, Reagan's notion of the city was not in its essence a religious commentary, at least not the Christian religion. The preeminent prophet of profit, capitalism, and the infallibility of the free market, Reagan was picturing what he believed to be the achievable American ideal, a place of mini-

mal government restriction and interference that he thought constituted the essence of an economically thriving, free society. And, as a shining city on a hill, America would attract and welcome all those who saw her from a distance. Throughout his political life, Reagan's approach to immigration was, simply stated, "Yes!"

Despite the idyllic prose of his musings, Reagan's support of immigration and immigrants was a practical one. He recognized that much of the low-skill, grueling labor that formed the foundation of the nation's food industry was done by immigrants. He knew that throughout America's history, immigrants had made and kept the nation competitive (people like Andrew Carnegie, Levi Strauss, and Albert Einstein who advanced science, industry, and the arts). And he knew that one of the greatest strengths of the nation, one pointed to by scores of economists, was its ability to constantly attract people from other countries for all levels of employment.

Reagan was so convinced that immigrants made the country stronger that he advocated for an open border policy with Mexico to increase trade and the availability of labor. He also signed into law a piece of legislation that many Republicans today pointedly ignore when they are extolling the virtues of their patron saint of modern conservatism. In 1986, Reagan signed the Immigration Control and Reform Act, which granted amnesty to three million immigrants working in the United States without visas. That piece of legislation led to a few years of reduced undocumented immigration, but the bill could never be a true success, in part because the provision that Reagan professed to be its keystone—sanctions against employers who hired undocumented workers—was blocked by resistance from within his own party. A vocal group of Republicans called it intrusive government interference in business. (Ironically, this same vocal faction now argues for a wall that will strangle market forces on the border.)

Of course, the entrenched absurdity of immigration policy did

not begin under Reagan; it began with the very notion of building a "shining city on a hill." Where there is opportunity, people will come. It is a basic law of nature, much older than human history. As wild creatures have always migrated to find food and territory, humans have always moved to find a better way of life and firmer footing on the quest for survival. This is our nature. If a society holds itself up as a beacon for those in search of opportunity, it will both benefit from their arrival, and by necessity, need to deal with the associated complications.

The United States began to experience this tension from its earliest days, but in the nineteenth century, as trade with other nations spread word of opportunity, people began to arrive at every border and coastline. New arrivals faced hostility from the previous generations of immigrants who made up the population of the young United States. Sometimes anti-immigrant sentiment came in the form of violent discrimination, including lynchings of immigrants from all ethnic backgrounds. But the first major federal action against immigrants in the nineteenth century came with the passage of the Page Act of 1875, followed by the Chinese Exclusion Act in 1882; together, they banned all Chinese immigration.

Many Chinese immigrants had been drawn to the United States in the mid-1800s to seek fortune in the California gold rush and later, to work as laborers on the Central Pacific railroad. By the 1860s, Chinese people comprised the largest immigrant group in California, and politicians and the news media began to blame Chinese immigrants for a range of societal problems, from white unemployment and low wages to eroding morality. The Chinese became one of the nation's first scapegoats.

The first decade of the twentieth century saw the highest levels of immigration in US history, bringing unprecedented numbers of people from Europe. From Jews fleeing anti-Semitism in Russia to Irish people seeking an escape from poverty, hundreds of thousands came. The following decade, World War I and the Mexican

Revolution sent another wave of refugees and immigrants to the United States.

The influx of new people and cultures brought new ideas and new challenges, including alternate political philosophies, some of which turned violent. It was during this period that one of the first terrorist cells developed in the United States, when anarchist revolutionary Luigi Galleani orchestrated a series of bombings in US cities. Weary from the war, reeling from terrorist attacks, and experiencing a continued flow of immigrants from around the world, the United States began to turn inward. After assessing the numbers in the 1920 census, the United States enacted a series of laws that for the first time imposed immigration restrictions on almost all populations entering the country. Though this legislation also established the Border Patrol to protect the northern and southern US boundaries, significant legal restrictions on Mexicans entering the United States still did not exist. Most Mexican people just walked across the border to visit friends and family, or paid a nickel for a visa, and headed to work. But things were about to change quite drastically. With the crash of the stock market and the beginning of the Great Depression, attitudes toward immigrants shifted. In the 1930s, the US government tightened visa requirements at the Mexico border and forcibly deported—or harassed into leaving—tens of thousands of Mexican Americans, many of whom were US citizens who owned property or had lived in the country all their lives.

But the policy shifted again during World War II when, suffering a severe labor shortage, the US government made a 180-degree turnabout and began negotiating agreements with the Mexican government to bring laborers to the United States. The "bracero program," as it became known, began as a way to legally hire Mexican migrants during the war, but it was extended for almost two decades because the agricultural industry claimed continuing labor shortages. In negotiations that created the program, Mexico

gained assurance for the wages, healthcare, and working conditions of the braceros. But because these conditions cost employers money, some companies began hiring migrants outside of the program, knowing that if workers entered the country illegally, they would be unlikely to complain about abuses.

Industry solicitation of undocumented workers brought hundreds of thousands of Mexican workers into the country outside of bracero authorization and quotas, and this ultimately undermined the program. In response, in 1954, Dwight D. Eisenhower's administration launched the racially charged "Operation Wetback," an initiative of the Immigration and Naturalization Service (INS) that sent agents into border states demanding proof of resident status from people who "looked Mexican." More than 100,000 people (including some citizens of the United States) were deported, and many more left out of fear. Tens of thousands were forced onto busses or ships and taken far south, to the central coast of Mexico or its interior, regardless of where they had come from. On one sea voyage, seven frightened deportees jumped overboard and drowned.

Following the deportation initiative, the INS declared the border had been secured, but in fact, illegal crossings rose in the 1960s when the bracero program was ended. The crackdown had done nothing to address the underlying economic issues that had brought the braceros in the first place—at the request of the American government—and this sad chapter of history was just the beginning of a political and economic problem that has persisted and worsened since then.

In 1965, Congress passed an immigration bill that did away with the national-origin quotas that had governed the racial and ethnic makeup of the United States, but until Reagan's Immigration Act in 1986, there had not been an attempt to control economic factors that brought people to the United States, namely, poverty in other countries and the demand for low-wage labor within the United States. In the Immigration Reform and Control Act, the

federal government acknowledged the role that US industry played in bringing laborers to the country illegally. Still, the Immigration Act's sanctions against businesses hiring undocumented workers were never really enforced. To do so would have meant rigorous policing of industry and the establishment of an identification system more fool-proof than the easily-forged social security card.

Reagan's own party objected to the employer sanctions, undercutting the one provision of the legislation that the president considered the foundation of any success it might have. On the heels of Reagan's immigration reform attempts, the 1990s saw one of the greatest challenges to immigration policy yet. Economics had always been the main driver of immigration, both on the demand side and the supply side. And great economic upheaval in Mexico, coupled with political tensions in the United States, made the 90s a decade that stretched the immigration situation to the breaking point.

NAFTA

Since its revolution in the early twentieth century, Mexico's government had struggled with corruption and economic stability, but there had been a longstanding commitment to providing safety nets for Mexico's poor, in particular, within the nation's agricultural system. But things began to change in the late 1980s, when the United States, Mexico, and Canada began discussing policies that would eventually become the North American Free Trade Agreement (NAFTA). Mexico's President Carlos Salinas was determined to modernize Mexico's economy to put it on a more level economic playing field with the United States. He wanted to reduce emigration and get people working in cities and factories, rather than on subsistence farms in rural areas. At the time, many in Mexico believed Salinas's approach would help the country, but

they had failed to anticipate the relevance of factors outside the theoretical economic models. Peter Canby detailed the fall out from this oversight in a 2010 article in *The Nation*. According to Canby, Mexico's belief that farmers displaced by NAFTA would go to work in urban factories did not account for the connection rural farmers had to their land. Also unrecognized was the ability of American agricultural conglomerates to manipulate markets with the help of US subsidies.

When Mexico dropped its tariff protections, US corporations began flooding the Mexican market with cheap corn supported by US government subsidies. Starting in the late 1990s, the US Congress began a series of legislative actions that further buoyed American corn exporters by doubling subsidies. And, at the same time that the US government was adding subsidies for its corn growers, Salinas was dismantling Mexico's farm protections, some of which had been in place since the revolution. Price supports, infrastructure assistance, and subsidies were removed for millions of farmers, making it impossible for them to compete with US conglomerates. By 2008, the price paid to Mexican corn farmers had dropped by half from pre-NAFTA levels. At the same time, the Salinas government removed essential protections within Mexico's communal land system, so that for the first time, farmers were at risk of losing their land.

With farming nestled so deep within the country's heritage, cuisine, and economics, Mexico couldn't really afford to have its agricultural economy destabilized. By some estimates, twenty-two million people, a quarter of the country's population, worked in jobs with some direct or indirect connection to the agriculture industry. Many of the rural corn farmers, dispossessed of their livelihood and even their way of life, began a mass migration north to the United States. A 2004 Carnegie Endowment study found that NAFTA put one million Mexican workers into the labor market each year, but produced jobs for only about 500,000 people—at the

same time, the number of immigrants entering the United States from Mexico happened to be about 500,000 people per year.

Concurrently, US corn corporations that had helped pull the rug out from underneath small-scale Mexican farmers began buying up Mexican corn companies, whose value had dropped due to the destabilization of the corn market. Once in control of large Mexican corn operations, US companies began to raise prices on corn. Because corn is such a foundational staple of the Mexican diet, the government had long protected its citizens by placing caps on the price of tortillas. But in 1998, pressured by the US government, Mexico removed those caps, and the price of tortillas doubled.

As a result of all this upheaval, many farmers lost their land, and with the farm economy reeling and prices for staples like tortillas being determined by US conglomerates, many Mexicans couldn't afford to buy basic foods. The escalation of prices for corn and corn-derived food, which makes up an average of 70 percent of the caloric intake for Mexican people, is estimated to have resulted in malnutrition for one Mexican child in five. Meanwhile, between 1993 and 2002, profits tripled for US agricultural giant Archer Daniels Midland.

Corn, which now sits at the foundation of diets and economies around the world, was developed by ancient agrarian civilizations in southern Mexico. Many of the farmers who live in Oaxaca and neighboring states in the southern part of the country still practice the brand of artisan farming responsible for the first cultivation of corn some 9000 years ago. But NAFTA and related government policies upended the rich culture of corn in Mexico. Many of the corn producers who stayed on their farms faced abject poverty. The Mexican government estimates that in the rural southern part of the country, 70 percent of the population is now often unable to secure even the minimum daily food requirements.

Subsequent to the destabilization of the corn economy, US fac-

tories that had been moved to Mexico in the 1980s to take advantage of cheap labor began to relocate to China, where corporations could pay workers a fraction of the Mexican wages. Many of the factory jobs, which President Salinas had hoped would absorb the displaced Mexican farmers, were leaving the country.

Joblessness, loss of homes and farms, and increasing rates of poverty and malnourishment sent unprecedented numbers of Mexican nationals to the United States. Undocumented immigration more than doubled in the 1990s, from about 2 million people to 4.8 million by the year 2000, according to the US Immigration and Naturalization Service.

Operation Gatekeeper

About a year after NAFTA went into effect and the impacts were beginning to be felt in Mexico, a public debate about immigration that had been simmering in the United States came to a boil. With a lack of serious employer regulation from Reagan's 1986 immigration law, and facing the same market pressure that sent factories to Mexico and then China, US industry continued to solicit low-wage laborers from Mexico. Because immigration laws allowed relatively few laborers to work in the country legally, millions were entering without work permits or visas, or coming in on legal tourist visas, and overstaying them. Of those that came without legal permission, many entered through San Diego and El Paso, the major urban centers of the southern border.

In early 1994, a member of the California state legislature introduced Proposition 187, a state referendum on providing public services to people in the country without legal resident status. The proposition required publicly funded schools and hospitals to deny services to anyone who could not produce citizenship or residency papers. Struggling in his reelection bid, then-governor of California

Republican Pete Wilson threw his support behind the ballot refer-endum. As 1994 progressed, Wilson's poll numbers showed that he was gaining traction on the anti-immigrant message. And with the Democrats facing a tough challenge that same year for control of the US Congress, President Clinton took a page from the playbook of anti-immigrant stalwart Rep. Duncan Hunter. On the eve of the 1994 mid-term elections, Clinton unveiled Operation Gatekeeper, a policy that has beleaguered the borderlands for almost two decades.

Operation Gatekeeper increased the number of Border Patrol agents in San Diego, heightened prosecution of smugglers, and authorized steel border fences and other infrastructure on the San Diego/Tijuana border. Between 1994 and 1998, the INS added almost 3000 Border Patrol agents to its ranks. The operation was designed on the premise of "prevention through deterrence," a policy that had been repeatedly debunked on the border since the declaration of a secure border following the 1950s' Draconian "Operation Wetback." But the administration forged ahead, claim-ing that migrants would stop coming or would be forced into remote borderlands territory where they could be easily apprehended.

Operation Gatekeeper didn't really work on a political level (Republicans swept the mid-term congressional elections in 1994) and it was ultimately counterproductive on a practical level. Arrests in the San Diego sector did decline significantly in the mid- to late-1990s, but people continued to cross, digging tunnels under the wall or using ladders, ropes, and other inexpensive devices to get over it. In spite of this, as of 2011, the San Diego sector con-tinues to pour excessive funds into border enforcement; there are multiple layers of wall and constant helicopter and ground pres-ence at the border.

Significantly, the decline in arrests in San Diego was more than offset by an enormous increase of migrant traffic along the rest of the border. In Calexico, California, fewer than 30,000 undocu-

mented migrants were arrested in all of 1994, but by 1998, the figure had grown to 30,000 *per month,* more than the entire population of the town. In Arizona, roughly 10,000 migrants were arrested per month prior to Operation Gatekeeper. By 2006, that figure had risen to 70,000 per month.

The Border Patrol expected to seal San Diego and then plug holes along the border as they popped up. There were two failings in this strategy. First, the border is one huge, 2000-mile hole. But more importantly, it is not a black hole, but a series of communities and natural lands that all of a sudden had to bear the economic and social burden of waves of migrant and smuggling traffic that had been going through urban centers—locations that were much better equipped to handle it.

The stress that this massive shift in border traffic put on borderlands communities elicited a range of responses. Many border residents sympathized with migrants and blamed the government for creating a policy that overwhelmed their small towns with big-city problems. It was as if the government had decided to reroute the millions of drivers on Interstate 95 and the Washington Beltway to Yellowstone National Park and rural Wyoming.

A much smaller number of borderlands residents were so aggravated by the sudden increase in migrant travelers that they began forming vigilante groups to guard the border. Some of these militia groups went so far as to round up migrants and detain them forcibly. Along with the re-emergence of private militia groups, Operation Gatekeeper also sparked California-style anti-immigrant campaigns, some of which were organized by the Californians who had created Proposition 187. They declared Douglas the new San Diego and organized rallies that drew public figures like Pat Buchanan and Barbara Coe, who was a major organizer for California's anti-immigrant law. The Ku Klux Klan even showed up at a rally in tiny Sierra Vista, Arizona.

Operation Gatekeeper created myriad problems and solved

none. In 1997, the General Accounting Office (GAO) reported that undocumented immigration in the United States had increased by an average of 275,000 people per year in the years between 1992 and 1996, despite the increase in annual spending on Border Patrol from $374 million in 1994 to $631 million in 1997. The GAO also noted that the Immigration and Naturalization Service had no plans for measuring the effectiveness of Operation Gatekeeper, despite the ever-escalating expenditures. Billions of dollars had been invested in the policy, but the INS had no evidence to suggest it was working—or ever would work.

Ultimately, the border was no tighter, and, as displaced farmers in Mexico continued to seek an escape from grinding poverty and homelessness, undocumented border crossings increased. The GAO estimated that in 1994, 68 percent of undocumented migrant apprehensions border-wide had taken place in San Diego and El Paso. By 1997, that figure had dropped to 33 percent, leaving two-thirds of migrants to cross through national parks and small towns like Calexico, Laredo, and Douglas, creating an array of negative impacts for these towns and natural areas—and a grisly death toll for desperate migrants. Prior to Operation Gatekeeper, migrant deaths along the border were exceedingly rare, but within a few years of the policy taking effect, bodies began to turn up by the dozens in the rivers, canals, and desert regions of the borderlands. Within less than a decade of the crackdown in San Diego, hundreds of migrants per year were dying along the border; the known death toll exceeded 5000 by 2010.

As the danger of crossing the border became apparent to migrants (many of whom had been day, seasonal, or temporary workers), they began increasingly to set up more permanent residence in the United States. In the decades preceding Operation Gatekeeper, the average time migrant workers spent in the United States was about two years, but since the tightening of the border it has gradually increased to ten years. As immigration scholar

The border wall has been breached thousands of times. In Arizona alone the cost of repairs on the wall is nearly $10 million per year.

Edward Alden noted in his book *The Closing of the American Border*, the intent of Operation Gatekeeper may have been to deter entrance to the country, but instead, it discouraged migrants from going back home. And, rather than be separated from their families in Mexico for so long, migrants became true immigrants, bringing their families with them and starting new lives.

Increasing dangers of migration also carved out a lucrative economic niche for human smugglers. Within years of the implementation of Operation Gatekeeper, demand for coyotes raised the per person rate for crossing the border from a couple hundred dollars to more than $1000 per person. The potential for profit was immense,

almost as much as smuggling drugs, and, like the illicit drug industry, smuggling people soon drew the attention of organized crime. In fact, much of the political and economic climate of the 1990s fueled the expansion of organized crime in Mexico. As trade policy undercut legal economic enterprise in Mexico and exacerbated poverty, much of the industry that replaced it was illegal, driven by demand coming from the United States for marijuana, cocaine, and cheap labor.

In his essay, "The War Next Door," author Charles Bowden, speaking of the symbiotic relationship between poverty and organized crime described it like this, "Almost certainly, the drug industry and illegal migration are the two most successful anti-poverty initiatives in the history of the world."

Between the people and drug smuggling industries, and the amount of money migrant workers send home to Mexico, much of Mexico's economy has become concentrated on the border. Mexicans living abroad sent $24 billion home to family in 2007, most of it coming from workers living in the United States. With few opportunities at home, Mexico's poor have an enormous incentive to reach work in America. Consequently, smugglers can now charge between $2000 and $6000 per person for passage to the United States. The coyote industry is believed to earn close to $10 billion each year. Mexico's illegal drug industry earns somewhere between $30 to $50 billion per year, making it the second largest source of foreign currency in Mexico, right behind the oil industry.

With a steady supply of funding from US consumers, and an endless supply of guns from US arms dealers, the Mexican organized crime sector has become a force strong enough to challenge the Mexican government. At its essence, the War on Drugs is really a civil war, a war of US citizens against themselves. The United States funds both sides of this battle, both the ruthless drug industry with money and guns, and the US government with taxpayer dollars that bankroll the Border Patrol and prison industry. Reform

of US drug policy could end this self-inflicted and self-destructive war. But instead, the United States has pledged $1.4 billion in military aid to help the Mexican government fight drug cartels. The United States has also given billions of dollars in aid to Columbia for its attempts to curtail Columbian cocaine cartels, money that may as well have been piled up and burned, as cocaine continues to flow generously to US drug consumers.

September 11, 2001

Overall, the trend of the 1990s was an increased demand in the United States for drugs and labor, and an increased labor supply in Mexico to feed these desires. By the start of the new millennium, the situation had become severe. In his campaign for the presidency, Texas Governor George W. Bush promised to work with Mexico to create an orderly, mutually beneficial relationship. As a governor in Texas, he had some knowledge of the complex and rich economic and cultural relationship the two countries share, and he appeared determined to get the relationship back on track. He also understood that migrant labor and immigrants played an important role in the US economy. During the 2000 presidential campaign he was quoted saying, "Immigration is not a problem to be solved, it is a sign of a successful nation."

There was much evidence to back up this claim. Foreign-born immigrants comprise half of the nation's Ph.D.-level engineers; corporations like eBay, Google, and Sun Microsystems were all founded by immigrants; almost one quarter of all new patents are filed by immigrants; and in general, studies have shown that immigrants are 50 percent more likely than non-immigrants to start new businesses. What's more, a welcoming immigration policy has spread the influence of the United States far and wide as scores of world leaders have been educated in US universities—

including Israeli Prime Minister Benjamin Netanyahu and former Secretary General of the United Nations, Kofi Annan, both of whom attended MIT; and former Pakistani Prime Minister Benazir Bhutto and Mexican President Felipe Calderón, both of whom attended Harvard.

Bush also recognized that due to the US reliance on inexpensive labor to produce low-cost food and other goods, and due to the billions of dollars that undocumented immigrants pay into the social security system without seeking like-valued services, undocumented immigration results in a net gain for the US economy. While it is true that some states lose money providing services to people in the country illegally, on a federal level, undocumented immigrants have a *positive* impact on the economy. Some state governments fare as well as the feds. In particular, Bush's home state benefited from a $500 million net gain in 2006 because undocumented workers paid more in taxes than they used in social services.

Perhaps for all of these reasons, during the 2000 presidential campaign, Bush distanced himself from fellow Republican Pete Wilson, who had in 1994 helped win passage of Proposition 187 and remained an outspoken anti-immigrant force within the party. Bush also pledged to make immigration agencies friendlier to immigrants, and to lift immigration caps on both high-tech and low-skill labor.

When Bush began his presidency in 2001, events on the border heightened the urgency for action on immigration policy. That summer, a large group of migrants was found dead in the Sonoran Desert, prompting talks between President Bush and Mexico's President Vincente Fox. Within those negotiations, Bush and Fox determined to create an immigration process that guaranteed humane working conditions and legal rights for migrants. In 2001, Fox traveled to Washington, DC, to visit Bush at the White House, where Bush declared that "the US has no more important relationship in the world than the one we have with Mexico."

This visit took place on September 5, 2001. Six days later, all hopes for a smart border policy and immigration reform would dissolve in the dust of the World Trade Center. After the terrorist attacks, the federal government began a grueling debate about how to operate in a post-9/11 world, and, most pointedly, how to protect the country from another attack. As Edward Alden reported in *The Closing of the American Border*, there were significant disagreements about how that would best be accomplished. While those discussions were taking place, the initial response was to shut down entry to the country. At the borders, closures and long delays in the weeks following the attacks brought intercontinental commerce to an expensive, slow grind. On the Canadian border, auto parts suppliers blocked from moving their goods into the United States lost more than $1 million per hour. The delay of those components reaching US automakers caused a 15 percent loss of production, causing auto stocks to plummet in the week after 9/11. In Mexico, understaffing at US ports of entry and increased security measures caused slowdowns of commercial vehicles that resulted in massive layoffs in agriculture and manufacturing.

This early economic fallout highlighted the problems with isolationism as a counter-terrorism strategy. In 1998, the Hart-Rudman Task Force on Homeland Security had cautioned that there was no way to heighten border and immigration enforcement enough to attain a measure of safety without seriously undercutting the US economy. Instead, the bipartisan commission recommended a well-informed network of intelligence that could whittle the work of customs and immigration agents to target only *likely suspects.*

Based on Hart-Rudman guidance—and common sense—it was clear that simply opening a net and arresting anyone who looked Muslim or foreign would not only lead to widespread civil rights violations and hurt the economy, it would not increase the nation's safety. Regardless, the approach the Bush administration chose was to use the nation's immigration laws to snare thousands of people

from Muslim countries. In 2002, using tactics similar to migrant deportation raids in the 1950s, the Bush administration targeted Muslim communities and looked for any minor infractions of immigration status. More than 10,000 were arrested and deported. Of those, about 750 were imprisoned, some enduring harsh interrogation, but not a single person was ever charged with a terrorism-related crime. Imagine the time and human resources wasted on such an effort, combing through every member of an ethnic community, none of whom turned out to have had any ties to terrorism. In fact, most of these people were in the United States because they saw the shining city on a hill and wanted to learn and work here. These were not terrorists. They were heart surgeons, oncologists, students, and scientists working to find cures for infectious diseases, inventing the next wave of technology, saving American lives, boosting our economy, widening our talent pool, and creating bridges between the Muslim world and the West. And not only did we not let them help us, we beat, imprisoned, and deported them.

With the sharpening of the immigration axe for Muslims, some in the Bush administration wanted to wield that same axe on the southern border, where undocumented immigration had been nettling the right wing for years. Using the buzzword of terrorism, they hoped to lock down the US-Mexico border. There was—for a while—dissent within the administration. There was no logical connection between terrorism and the southern border, and in fact the 9/11 terrorists had come to the United States legally. Secretary of Homeland Security Tom Ridge echoed Bush's belief that undocumented immigrants were not a threat to national security. In fact, giving legal status to immigrants would likely help attain greater national security because those in hiding could come out, be identified, and go to work legally. The fiscal benefits of such a plan would have helped the ailing post-9/11 economy.

And despite everything that had happened since 2001, Bush was

still hoping to achieve immigration reform. In 2004 he introduced legislation for a guest worker program that could have revolutionized the broken immigration system. The day he released the plan to the American public, he spoke at the White House of the enduring importance of immigrants to American heritage and the economy, and the need to change our current approach. "Workers who seek only to earn a living end up in the shadows of American life—fearful, often abused and exploited," he said. "When they are victimized by crime, they are afraid to call the police, or seek recourse in the legal system. They are cut off from their families far away, fearing if they leave our country to visit relatives back home, they might never be able to return to their jobs. The situation I described is wrong. It is not the American way."

Bush's reform plan would have provided a means for workers to enter the country legally through a guest worker program, and (like Reagan's earlier plan) it would have imposed sanctions on employers continuing to hire undocumented immigrants. The plan would have also allowed people already in the country illegally to pay a one-time fee, then enter the worker program. The policy could have raised revenues and invigorated the economy, and it would have alleviated a serious financial drain at the southern border: the $2.5 billion dollars being spent annually on border enforcement.

But Bush's window for real immigration reform had passed. The national focus had shifted to fighting wars in the Middle East, and mending our relationship with Mexico was no longer a priority. And, as had happened with Reagan, Bush's own party blocked him. Anti-immigrant Republicans in Congress decried the Bush plan and cried wolf—which in modern immigration policy parlance is pronounced "amnesty" and "terrorism." Ultimately, the federal government marched onward in a borderlands War of Attrition.

Befuddled by the continuing failure to contain immigration, and unwilling or unable to craft real solutions, in 2003, Congress began seriously considering the construction of a wall along the entire

southern border. The plan was tabled when Interior Secretary Gale Norton said she was troubled by the idea of a wall, which Border Patrol had admitted would result in "extensive habitat destruction and significant wildlife mortality." But in a post-9/11 nation, feelings of vulnerability had taken hold, and the ability of walls to offer comfort was exploited by politicians and interest groups to push the policy forward. In 2005, a conservative group called Let Freedom Ring bought $100,000 in air time on Fox and CNN for ads that claimed the security of the United States was at risk due to crossings by Muslim people through its southern border. Of course, there are many reasons why a Muslim might cross this border; for economic opportunity and religious and cultural freedoms, many people from many nations cross the southern border every year. The ad's assertion was true: people from Muslim countries had been caught trying to cross the southern border, but many more had been caught trying to cross the Canadian border. According to the Annenberg Public Policy Center, in the three years following the attacks, 946 people from Muslim nations attempted to enter US borders without documentation—320 were caught on the Mexican border and 472 on the Canadian border. If the concern was about people from Muslim nations entering the United States outside of legal systems, the Canadian border should have been the logical priority. But in fact, the primary focus of our security concerns did not belong on our land borders at all. The government had by this time learned that the terrorists involved in the 9/11 attacks were picked for the mission because of their ability to gain *legal* entry into the country and then blend in with the masses. So the main focus should have been on the legal immigration system. But misleading conservative campaigns quickly succeeded in blending the very separate issues of migration due to labor demands and terrorism. In 2005, Congress passed the Real ID Act. Among many other provisions, hidden away in section 102 was a provision that granted the Secretary of the Department of

Homeland Security the authority to exempt the agency from all federal, local, and state laws when constructing border infrastructure. Supporters of the provision claimed it was included to apply to a particular San Diego project, but the unprecedented authority ended up being applied much more broadly. The dismissal of law on the border and many other expansive powers granted to the federal government under the Real ID Act were passed with little fanfare as a rider on legislation funding wars in Iraq and Afghanistan.

The new authority was used immediately by newly appointed DHS Secretary Michael Chertoff to expedite construction of a wall at the border in San Diego. Subsequent anti-immigration legislation soon emerged, including a bill that elevated illegal entry to a felony crime, and furthermore made it a felony offense to assist an undocumented immigrant in any way. This legislation, cosponsored by congressional Republicans Tom Tancredo, Peter King, and Duncan Hunter, also called for construction of 700 miles of wall along the southern border.

Even as pressure for a border wall continued to mount from a few congressional Republicans and right-wing conservatives, the Bush administration and immigration policy experts recognized that the course was—at best—not going to work; for years, the general consensus had been that a narrow focus on walls and enforcement on the border was a colossal waste of money.

In 2006, DHS Secretary Michael Chertoff himself stated, "When you try to fight economic reality it is at best an extremely expensive and a very, very difficult process and almost always doomed to failure."

But having failed to quiet the right wing of the Republican Party, which was clamoring for walls and uninterested in reform, the administration began to acquiesce to their demands. And so it came to be that the president who came into office pledging to reform the immigration system and build a stronger relationship with Mexico became the president who doubled spending on

immigration enforcement from less than $5 billion to more than $10 billion; deployed the National Guard to the border; increased the capacity of prisons for incarcerating migrants; and began construction on the US-Mexico border wall.

In 2006, Congress passed the Secure Fence Act, which mandated the construction of about 700 miles of border wall and other infrastructure along the US-Mexico border. Later that year, DHS Secretary Chertoff began waiving the nation's most critical environmental safeguards, seizing private land in South Texas, and militarizing sovereign native lands—all for a policy that everyone involved knew was doomed to be a very expensive failure.

In 2009, the Council on Foreign Relations panel on US Immigration Policy, which was cochaired by former Florida Governor Jeb Bush, reported: "No amount of enforcement can eliminate the underlying problem, which is that aggressively enforcing a broken regime does not fix it." The report went on to say, "The Task Force believes that US immigration laws are enforced poorly not because of inadequate funding or a refusal to take tough measures but because they are overly complex and unenforceable as a practical matter."

The director of the task force was Edward Alden. In his book *The Closing of the American Border*, he assessed the wider impacts of an antagonistic immigration policy on the long-term economic outlook of the United States. Alden noted that since 9/11 and the escalation of the United States' overall hostility to immigrants, fewer people from around the world saw the United States as a place where they would want to study, make a home, or even visit. In 2006, a survey found the United States at the top of a list of the world's most unwelcoming places, with the next worst being the Middle East. In 2008, a study done by the Council of Graduate Schools found that many prospective students viewed the United States as a "dangerous and unwelcoming country." All over the world, the reputation of the United States has diminished. The

economic repercussions of this reduction in status were quick to manifest. Immigration laws and negative public opinion have made it onerous for major corporations like Google and Microsoft to attract and obtain visas for skilled workers from a global pool. For Microsoft, the impact was significant enough that the company decided to locate its new research facilities in Vancouver, Canada, rather than Washington State.

Is not the closing down and off of America—the land of opportunity, whose historic shores are presided over by the Statue of Liberty—exactly the outcome al-Qaeda hoped for? Since 9/11, rather than seize a historic opportunity to ask the world for assistance in fighting terrorism and protecting the ideals of freedom and opportunity, the United States has shunned some of the brightest minds in the world and begun erecting walls that obstruct travel to our shores. We have been on a freefall in the minds of the world's citizens, who are now less likely to want to come here and get to know America and help us prosper.

By the end of the first decade of the twenty-first century, the balance of power and influence in the federal government had shifted to the Department of Homeland Security, an agency whose sole purpose is to close the country off from perceived threats, to build walls, and tighten borders. By its very definition, the department is suspicious, guarded, and unwelcoming. This says a lot about where we as a country are headed. Economic decline and global political strife have often caused segments of society to advocate for the United States to shut its doors. And since 9/11, a small, vocal group has succeeded in setting the nation's political discourse on a foundation of fear. In the immigration policy arena, those who motivate others through fears of job loss, race, and terrorism offer scapegoats and walls as a path to safety. But as panel after panel of the nation's experts have found, security is not achievable through barriers, be they set in concrete or legal ink—and these barriers come with significant consequences. Most

economists and foreign relations experts agree that an orderly and welcoming immigration policy would strengthen both the nation's economy and its standing in the world. Moreover, physical walls and a focus on border enforcement without immigration reform have not only been extremely costly, they have produced only negative results. Environmental scientists agree that walls and the militarization of the border have led to irreversible degradation of habitats, and it is clear that human communities along the border have suffered because of this policy.

In 2010, congressional Republicans continued to block immigration reform—vowing that reform would not move forward until the southern border had been secured. But expert after expert after task force after commission have found that securing the border is not possible without first reforming immigration policy in a way that takes account of the positive impact immigration has on the nation as well as the great demand that US businesses have for foreign labor. The past twenty years of unsuccessful enforcement is proof of the need for such reform. Between 1993 and 2008, the number of Border Patrol agents increased from 4000 to 20,000 without making a noticeable dent in undocumented immigration. And we have spent billions on a wall that doesn't work and would be irrelevant if we just addressed the underlying issue. It is not a question of chicken and egg here. The egg has been identified: jobs. Demand for cheap labor comes first, and immigration follows. Given this reality, we have several options: Either nurture the egg and direct an orderly system of migrant labor; or get rid of it with real employer sanctions, which would spike the cost of associated goods and have major fallout in the US economy. Or, we continue the course we have been on and accept extreme measures that would succeed in walling off the United States—build a dome around the entire country and shut off all travel in and out; create a national ID card and mandate that every resident carry one at all times; use random checks and severe punishment for infractions;

establish a shoot-to-kill order on every border, be it land or water. As a result of such measures, we might be secure from foreign terrorist threats, but the loss of global trade would cripple our economy. Security costs would bankrupt the treasury. And in the end we would still face the threat of domestic terrorists.

The borderlands situation has come to a climactic edge: either we learn to respect the role immigrants play in the economy and craft policy that regulates appropriately, or we face an inevitable decline by choking off the lifeblood of innovation and competitiveness and draining taxpayers dry with expensive measures that will not fix the problem. Those who would close off America to outsiders will then have what they wanted, but only by draining the beckoning life and light out of Reagan's shining city on the hill.

Monument in Cabeza Prieta
National Wildlife Refuge.

The Rio Grande forms the international boundary from El Paso to Brownsville, Texas. So far, much of this rugged country remains unimpeded by barriers, but plans for double-layer wall along the entire 2000-mile border have been introduced in the US Congress.

*A Border Patrol marker fallen
in the Imperial Sand Dunes
in southern California.*

In some urban areas, the wall has become a memorial to those who died venturing into the desert in an attempt to make it to the United States. More than 5000 people have died in the last decade trying to get to the United States from Mexico.

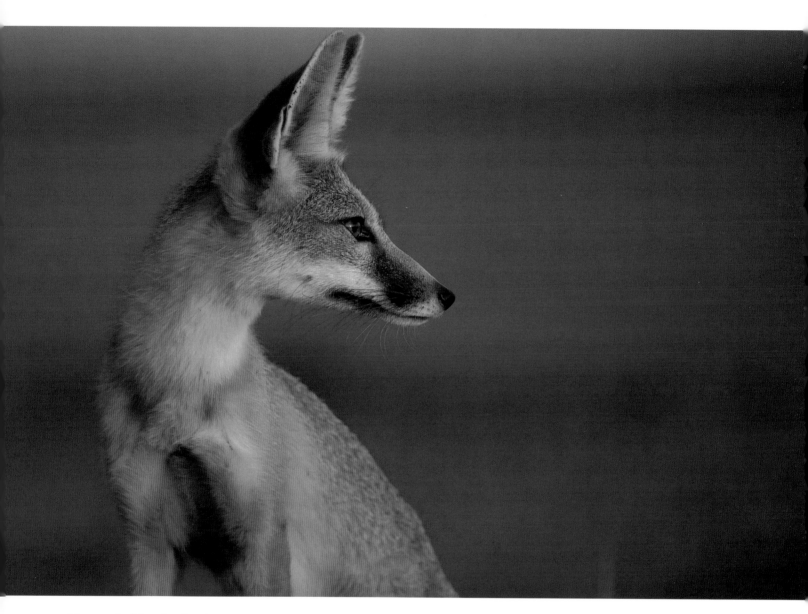

Mammals like this kit fox have started feeling the impacts of climate change in the borderlands. They may soon need to start moving north to find hospitable habitat.

(At right) About 700 miles of wall and other barrier have already been built along this 2000-mile border. Most of it was built without respect to wild species or environmental law.

Blackbirds and the wall in
South Texas.

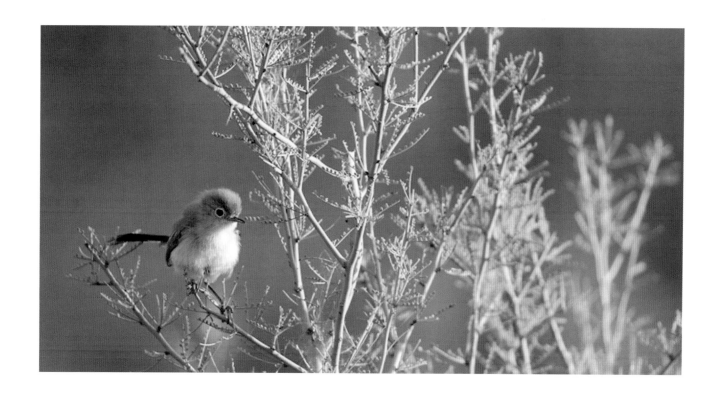

Desert trees provide shelter, perches, and food to many desert species.

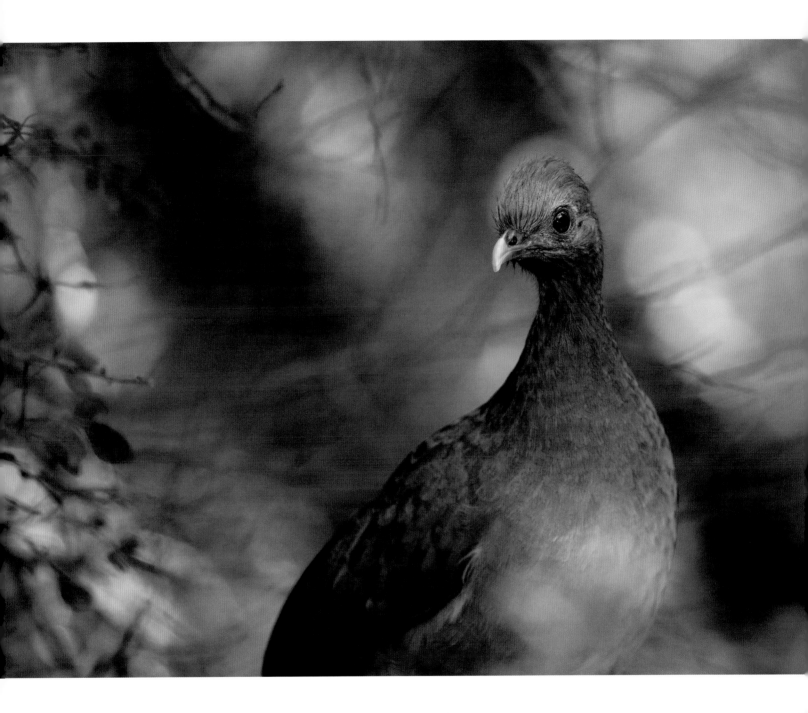

Species like this plain chachalaca are rare in the United States. The last remnants of habitat in South Texas remain a haven for them. Wall construction will put the preserve where it lives in a no-man's-land between the border wall and the Rio Grande, the legal boundary between the United States and Mexico.

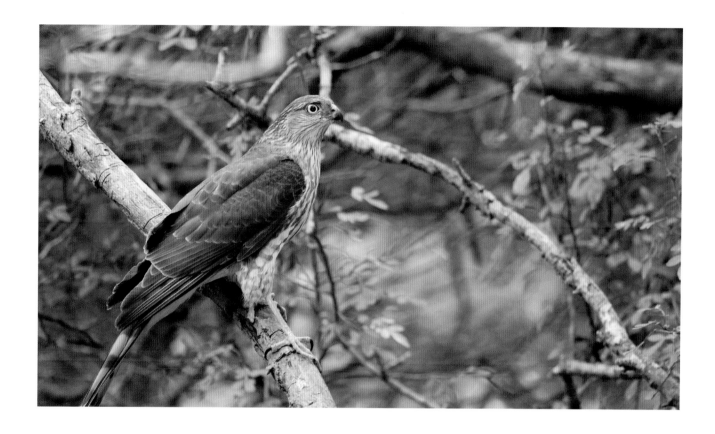

A sharp-shinned hawk in the Lower Rio Grande Valley.

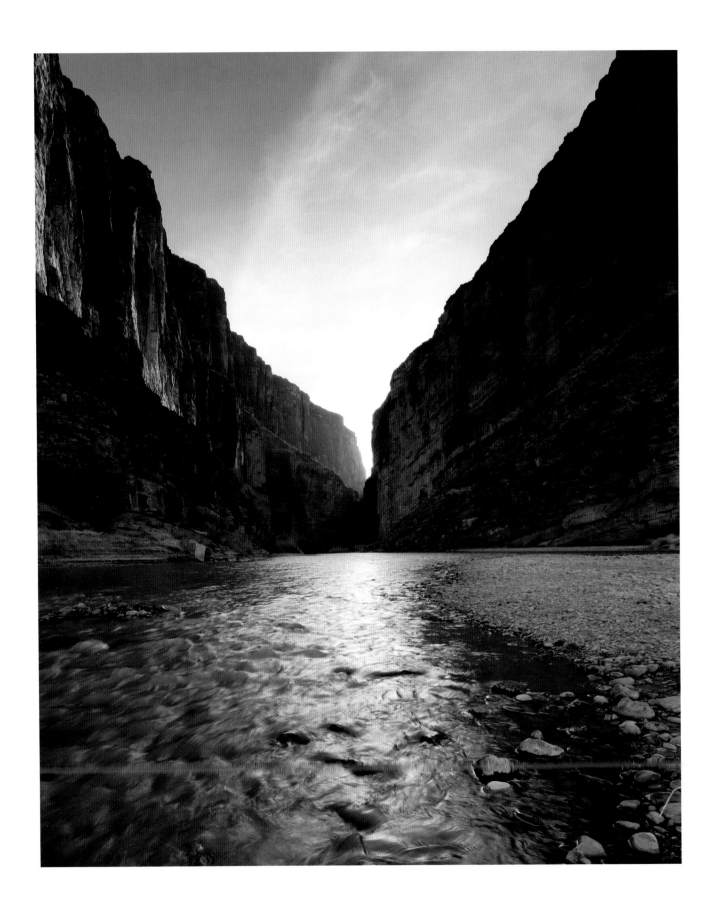

(At left) *Santa Elena Canyon on the Rio Grande, where the convergence of the political boundary separating the United States and Mexico is almost imperceptible at the vanishing point of the canyon.*

A wildflower on a bank of the Rio Grande.

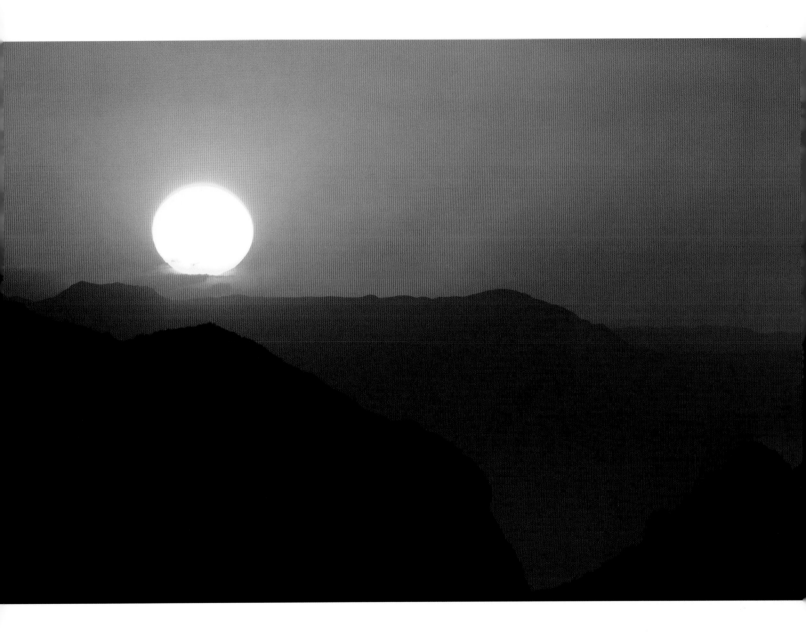

*Sunset over the Chisos
Mountains in Big Bend
National Park, with Mexico
in the distance.*

APPALACHIAN RAIN

A little more than 150 years ago, having won the Mexican-American War, the United States sent a team of surveyors to San Diego to meet their Mexican counterparts and go about setting the newly adjusted boundary lines for the two nations. Rather than travel by land from the East Coast, the surveyors set out by steamship, some going through Panama, and the rest going all the way around Cape Horn, one of the most unpredictable sea passages in the world. So uncharted were the new borderlands that the wild waters of the Horn were preferable to the wilds of the new US-Mexico border. Since then, much in the borderlands has changed, but much has stayed the same. Roads and other development now make the region easily accessible; few would choose a water route to San Diego from the East Coast. But the region remains enigmatic to the nation at large. The perceptions many Easterners held in 1850 about the borderlands—that it was an uninhabited void, begging to be tamed—have carried over to today, though the borderlands were not uninhabited then, any more than they are now.

On any given borderlands day, an ocelot steps lightly through a fog that has settled on the Rio Grande Valley. A desert tortoise emerges from his burrow, blinking into the mid-morning sun, and plods to a nearby desert dandelion for breakfast. A kit fox pup

paws at her mom for food, while a burrowing owl nabs a lizard for a snack. Rain falls lightly on the blossom of a saguaro cactus, while a lesser long-nosed bat quietly sips its nectar. A jaguar heads south through the Peloncillo Mountains, headed to Mexico to find a mate, while a javelina troop noses around a prickly pear cactus, laden with ruby-colored fruit.

Every day, the wild world that existed at the time of the US-Mexico boundary survey endures in the lower mid-section of North America. It is much diminished by large-scale loss of habitat and fragmentation by roads, farms, and fences, but many of the same species, grown rare over the decades, continue to bloom and mate, give birth, and wither and die.

Alongside these natural communities live dozens of human communities, from those whose ancestors arrived 2000 years ago, to those who only recently escaped the cold winters of the Midwest. They are the Tohono O'odham and Kumeyaay people, who have been connected to this land longer than any living peoples; they are the ranchers of Arizona and Sonora; they are the birdwatchers of South Texas, the cyclists and winemakers of the high desert grasslands, the hunters and hikers, scientists, and entrepreneurs all along both sides of the border.

Every resident of this land lives in a tapestry of connection, woven of countless threads: a blade of grass, a cactus thorn, the needle of a Douglas fir, a torn piece of migrant clothing bleached by the sun, a crimson feather from a northern cardinal, an emerald feather from a green jay, the string from a guitar, the pungent fibers of a creosote bush, an eyelash of a pronghorn, seeds from a chile, a line of prose from a Tohono O'odham myth, a fine fur from a jaguar, and a coarse hair from a beaver, wet with the water of the San Pedro River.

This tapestry of life took years beyond reckoning to develop, with each of its thousands of species woven in year by year over

the eons, since before the time of the Mexican-American War, before the arrival of Europeans to North America, before even the evolution of the modern human species.

As a photographer and writer I have studied and pondered the predicament of the borderlands for nearly a decade. The future dwells in uncertainty largely because those who would decide the fate of borderlands ecosystems and people occupy a space far distant from the lives that hang in the borderlands balance. But in reality, that divide is not so broad.

Not far from my home in Maryland, one of the last old-growth hemlock forests in the Eastern United States sits in the Appalachian Mountains of West Virginia. During a winter rain I have watched drops making depressions in the snow that covers the forest floor. Depressions become bare patches of wet earth, and rivulets begin to flow to the streambed below, which swells from the melting snow and falling rain and moves hurriedly downhill, on its way to the Blackwater River, then into the Ohio and the Mississippi Rivers, and finally into the Gulf of Mexico. I have met the same Appalachian raindrops and snowmelt again and again, when I travel to the mouth of the Rio Grande emptying into the Gulf in South Texas. There, I have looked across the river to see fishermen in Matamoros, Mexico, casting their nets while brown pelicans dive for fish that have been fed in part by the waters of West Virginia. This Gulf water merges with the water of the Rio Grande, a collection of raindrops from the Chisos Mountains and the Sierra del Carmen that have for millions of years traveled the river's path through the Lower Rio Grande Valley, forming mists of fog that collect in citrus groves in Brownsville, where a migrant worker from Nuevo Leon has earned enough to keep his daughter in school for another month. The fruits of his labor will make their way to supermarkets all over the United States, perhaps one in Minneapolis, where a grandmother will buy a bunch of lemons for her granddaughter, who will squeeze them, add several

*Brown pelican fishing in the
Gulf of Mexico at Boca Chica,
the mouth of the Rio Grande.*

spoonfuls too much of sugar, and sell as lemonade on a suburban cul-de-sac.

These waters, fruits, laboring hands, and pelicans, the hopes of a migrant worker, the produce bought cheap in the upper Midwest, the running of rivers and rising of fogs over valleys, and mountains too old to comprehend are all threads and linkages to a complex question that has bedeviled us for more than a century. The answer has evaded us not because the question is so hard, but because those generating the loudest public discourse have yet to ask it in the right way. The question is not: How do we keep people out of the United States who are poor and desperately need work? But rather: How do we best share a border with a country whose economic realities are different from our own, and how do we protect the natural world that connects us and is precious to both nations?

Perhaps we have not begun to ask the question this way because we lack perspective. Few have visited the borderlands or have much connection to it, which makes it easy for one-minute news stories to create distortions suggesting that this is just a land of violence and desolation, not one of brilliance and beauty. Wherever there are borders—whether they exist between nations or between rich and poor, old and young, or black, white, and brown—it is easy to amplify fears to the point that they distort reality. Borderlands, whether in the mind or on the map, are always vulnerable to misperception, so much so that at times reality becomes unrecognizable.

The reality is this: the borderlands are one of the richest ecoregions on the continent and also one of the safest places a person could live within the United States. It isn't that there are no dangers here—there are always dangers, everywhere, from the street where I live in the Washington, DC, area to the front lines in Afghanistan. As drug, border, and economic policy failures continue to fester in Mexico, the south side of the border will become more and more dangerous, and the north side may begin to see

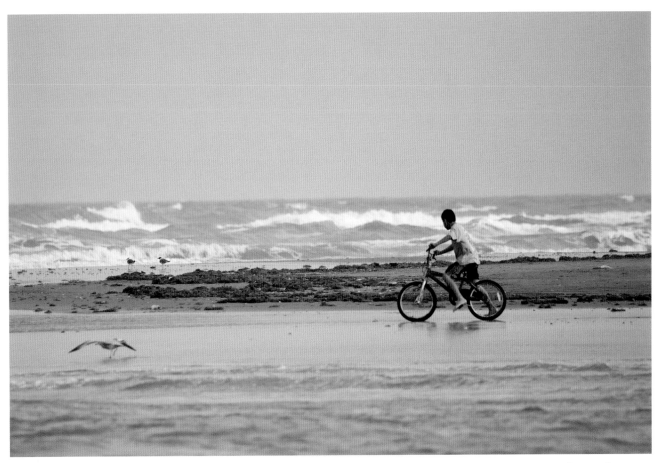

Young Mexican boy riding his bike at Boca Chica, the terminus of the US-Mexico border at the Gulf of Mexico.

spillover violence. But drug and immigration policy reform could spare the borderlands this fate.

According to the Secretary of Homeland Security, Janet Napolitano, "It is inaccurate to state, as too many have, that the border is overrun with violence and out of control. This statement often made only to score political points—is just plain wrong. . . . Studies and statistics have shown that some of the safest communities in America are right here at the border."

Perhaps the most absurd distortion is that a wall along this border will stop the flow of migrants and drugs or do anything to keep the nation safe from terrorism. Neither is true—the wall is plain

and simply a waste of billions of taxpayer dollars. Both the current and past secretaries of the US Department of Homeland Security have said so. In a statement she made while governor of Arizona, Secretary Napolitano said: "You show me a 50-foot wall and I'll show you a 51-foot ladder."

Though ineffective as a border deterrent, the wall *has* been very successful as a wedge for politicians and pundits to further sever the United States into divisive factions. We need not be divided on this issue. Both Democrats and Republicans are responsible for the mess we are in. And both parties will have to be involved in crafting sensible immigration and border security policy.

We should wake up, fall out of the Wonderland hole we have created, and work in concert to take a handful of steps that would actually make us safer: strengthen our ports of entry; create legal means for laborers to enter the country temporarily; provide real sanctions for corporations that hire outside of the legal worker program; work with Mexico to strengthen its economy; reach out to other countries in a spirit of cooperation to identify potential threats and deal with them before they get to our borders; and craft a sensible drug policy that does not have us spending billions of dollars trying to defy the laws of supply and demand.

Our economic stability and relationship with Mexico depend on our ability to revise immigration and border policy and turn this tired page in history. We can never be completely safe, as scores of domestic terrorism events illustrate, including the 2011 shooting in Tucson of US Rep. Gabrielle Giffords and nineteen others. This violent act was perpetrated not by some faraway threat in the Middle East, but by one of our neighbors and countrymen. And, regarding the very real threats from outside our borders, it is a simple truth that walls can be climbed, breached, or tunneled under. Even if we erected double-layer wall and stationed armed guards all along it, people could still enter through the Canadian or coastal borders. There is always a way in, both for the people that

will ultimately benefit our society, and for the extremely few who mean it harm.

But perhaps more importantly, the wall and anti-immigrant essence of the current policy cuts to the heart of how we define ourselves as a nation and it begs an important philosophical question that we as a society must answer: What are we willing to sacrifice for the *perception* of safety?

If the best we can do is fabricate symbols of safety, how much are we willing to sacrifice for them? Are we willing to waste $50 billion for 700 miles of wall on the border? Are we willing to waste three times that amount for a wall along the entire border? Or six times that amount for a double-layer wall? Are we willing to sacrifice the human communities that live in the borderlands, their connections to their heritage and family, their cross-border cultural ties, the religious ceremonies of the Tohono O'odham? Are we willing to ruin the tourist economy of the already impoverished borderlands?

Are we willing to sacrifice wild species? Ultimately, the answer to that question centers on what is relevant to our lives as human beings. Does the quiet movement of an ocelot through the last stand of brushland in South Texas have relevance, even if these creatures are now so rare that none but a few determined scientists will ever lay eyes on them?

The course we choose now matters more gravely than the general discourse communicates. It matters to the jaguar. It matters to the ocelot and the Sonoran pronghorn. It matters to a handful of dust that holds a legion of delicate creatures patiently awaiting their turn at life. It matters to the spadefoot toad and the Ajo lily, sleeping beneath the earth, waiting for the kindness of rain to bring them forth so they can bloom in radiant perfection for one . . . brief . . . moment.

This is what's at stake in the borderlands. We face a moment where we must look in the face of the jaguar, one of the most beau-

A green jay flying in South Texas.

tiful creatures on Earth, and decide whether this wall—a wall that offers no hope of solving anything—is worth the loss of something so exquisite. We worked as a nation to save the bald eagle because we saw how the loss of this one precious creature would diminish us and the world we live in. We can find that same resolve for the jaguar, the ocelot, the jaguarundi, and the hundreds of others that will be impacted by this wall cutting through their only home and hope for survival.

Selected Works Referenced

Alden, Edward. *The Closing of the American Border.* New York: HarperCollins, 2008.

Bowden, Charles. "The War Next Door." *High Country News* March, 2010.

Bowden, Keith. *The Tecate Journals: 70 days on the Rio Grande.* Seattle, Wash.: The Mountaineers Books, 2007.

Broyles, Bill. *Our Sonoran Desert.* Rio Nuevo Publishers, 2003.

Bush, Jeb, and Thomas F. McLarty III, chairs. *US Immigration Policy, Independent Task Force Report No. 63.* New York: Council on Foreign Relations, 2009.

Canby, Peter. "Retreat to Subsistence." *The Nation* June 16, 2010, http://www.thenation.com/article/36330/retreat-subsistence?page=0,1.

Childs, Craig. *The Secret Knowledge of Water.* Sasquatch Books, 2000.

Clarke, Chris. "The Battered Border: Immigration Policy Sacrifices Arizona's Wilderness." *Earth Island Journal* Autumn, 2006.

Ellingwood, Ken. *Hard Line: Life and Death on the US-Mexico Border.* New York: Pantheon Books, 2004.

Griswold del Castillo, Richard. "War's End: Treaty of Guadalupe Hidalgo." Accessed December 21, 2011, http://www.pbs.org/kera/usmexicanwar/war/wars_end_guadalupe.html.

Longoria, Arturo. *Adios to the Brushlands.* College Station: Texas A&M University Press, 1997.

McCorkle, Rob. "Wildlife and the Wall." *Texas Parks and Wildlife Magazine* August 2011, http://www.tpwmagazine.com/archive/2011/aug/ed_3_borderwall/.

Phillips, Steven J., and Patricia Wentworth Comus, eds. *A Natural History of the Sonoran Desert.* University of California Press, 1999.

Public Broadcasting System. "The Borderlands: The Borderlands on the Eve of War. A Conversation with David J. Weber." Accessed December 21, 2011, http://www.pbs.org/kera/usmexicanwar/war/borderlands_on_the_eve.html.

Segee, Brian. *On the Line: The Impacts of Immigration Policy on Wildlife and Habitat in the Arizona Borderlands.* Washington DC: Defenders of Wildlife, 2006.

Krista Schlyer photographing a water hole in the Sonoran Desert. © Chris Linder

Index

Photos are indicated with *italic* type.